THE NEW PANAMA CANAL

THE NEW PANAMA CANAL

A JOURNEY BETWEEN TWO OCEANS

New York · Paris · London · Milan

*The publisher is grateful to Salini Impregilo
for its contribution to this editorial project.*

Project coordination
*Salini Impregilo Corporate Identity
and Communication*

Editorial consultant
Angelo Ponta

Texts
Angelo Ponta

Editor
Cristina Scalabrini

Book design
Andrea Lancellotti

Technical coordination
Sergio Daniotti

Photographs
Edoardo Montaina

Sketches
Cristiano Lissoni

Translation of the Italian texts
Sylvia Adrian Notini

Editing
Gail Swerling

First published in the United States of America in 2017
by Rizzoli International Publications, Inc.
300 Park Avenue South
New York, NY 10010
www.rizzoliusa.com

Originally published in Italian in 2016
by Rizzoli Libri S.p.A.

© 2016 Rizzoli Libri S.p.A. / Rizzoli, Milano

All rights reserved. No part of this publication may be reproduced, stored
in a retrieval system, or transmitted in any form or by any means, electronic, mechanical,
photocopying, recording, or otherwise, without prior consent of the publishers.

2017 2018 2019 2020 / 10 9 8 7 6 5 4 3 2 1

ISBN: 978-0-8478-5964-1

Library of Congress Control Number: 2016956679

Printed in Italy

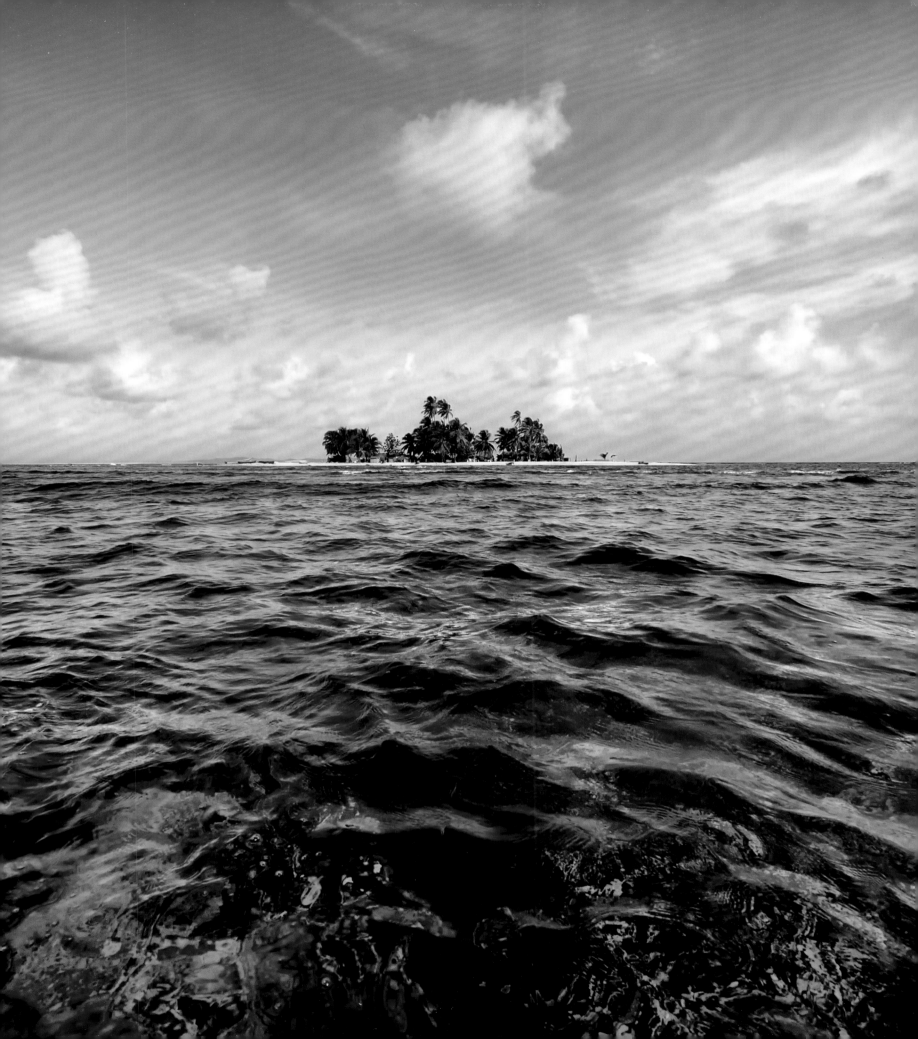

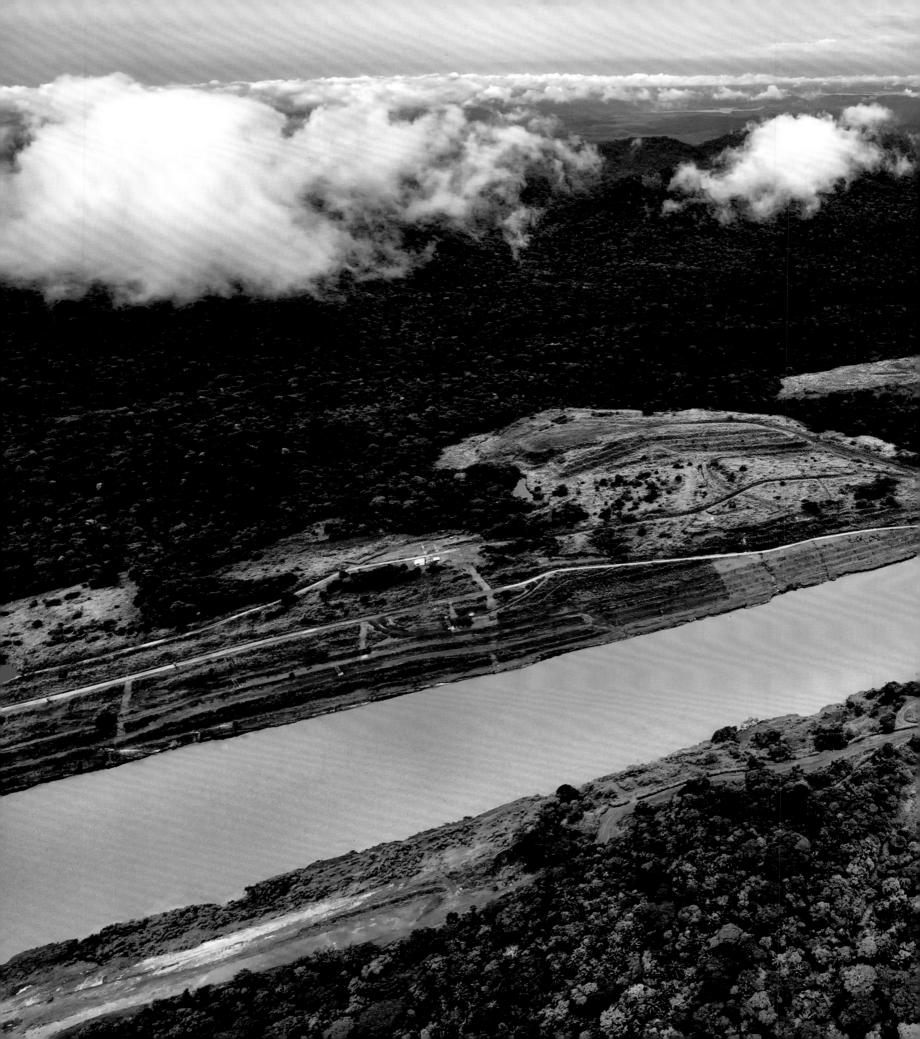

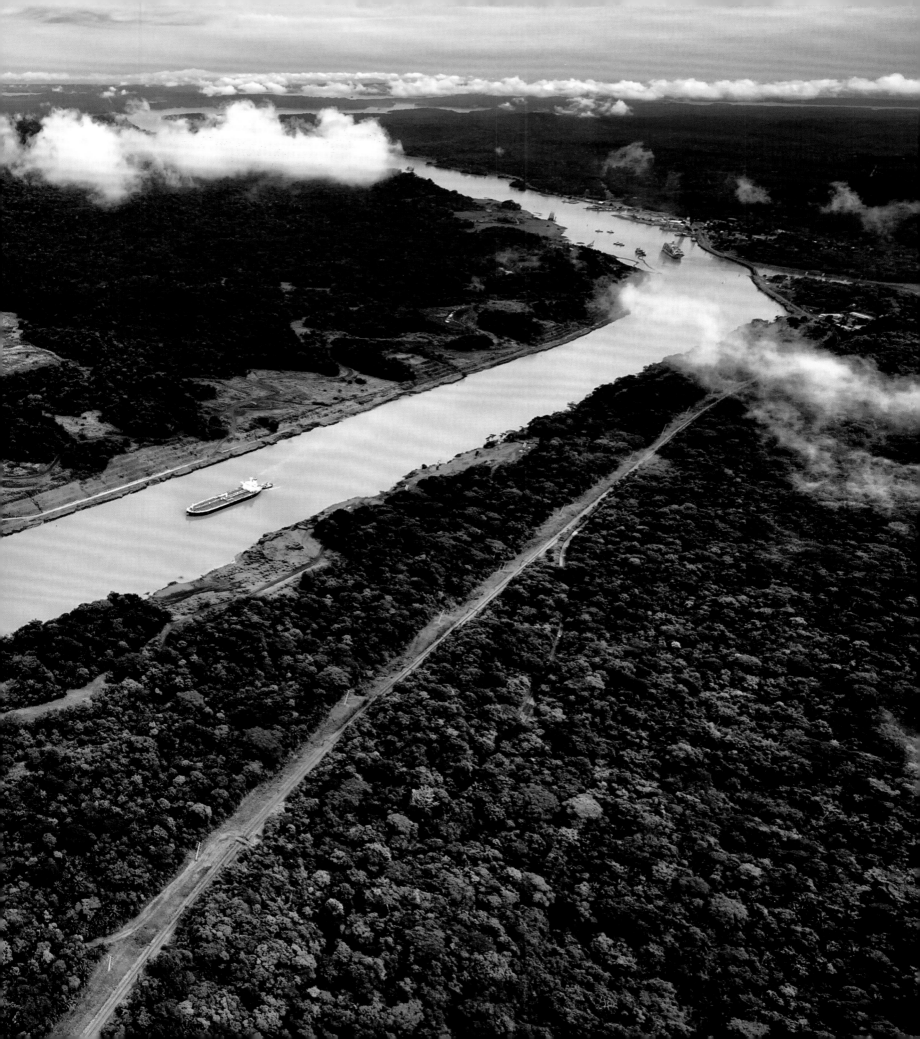

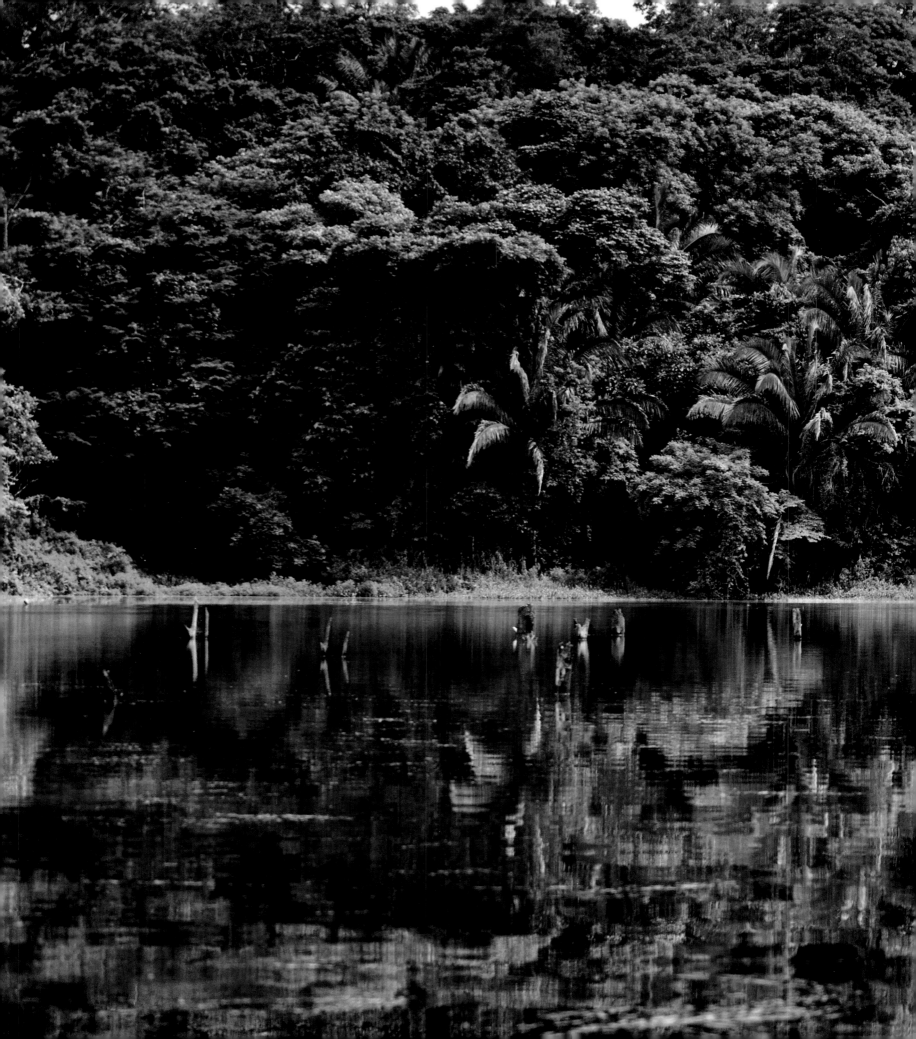

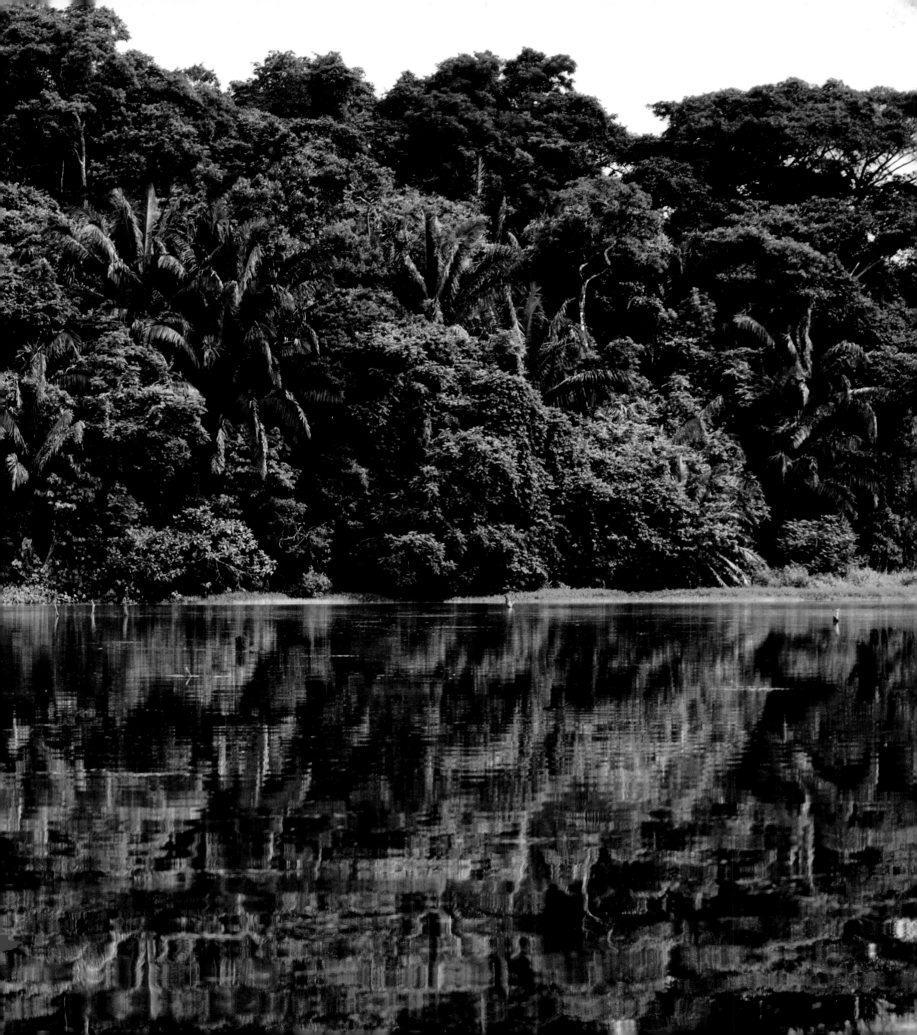

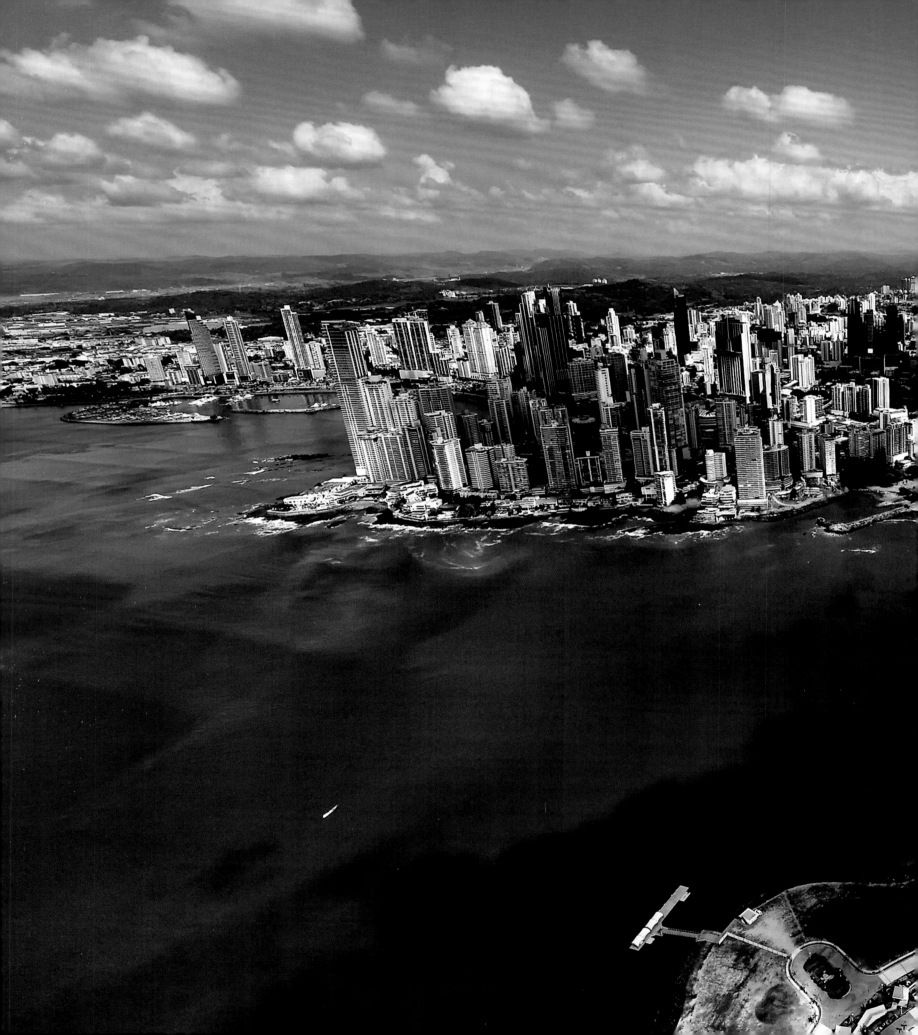

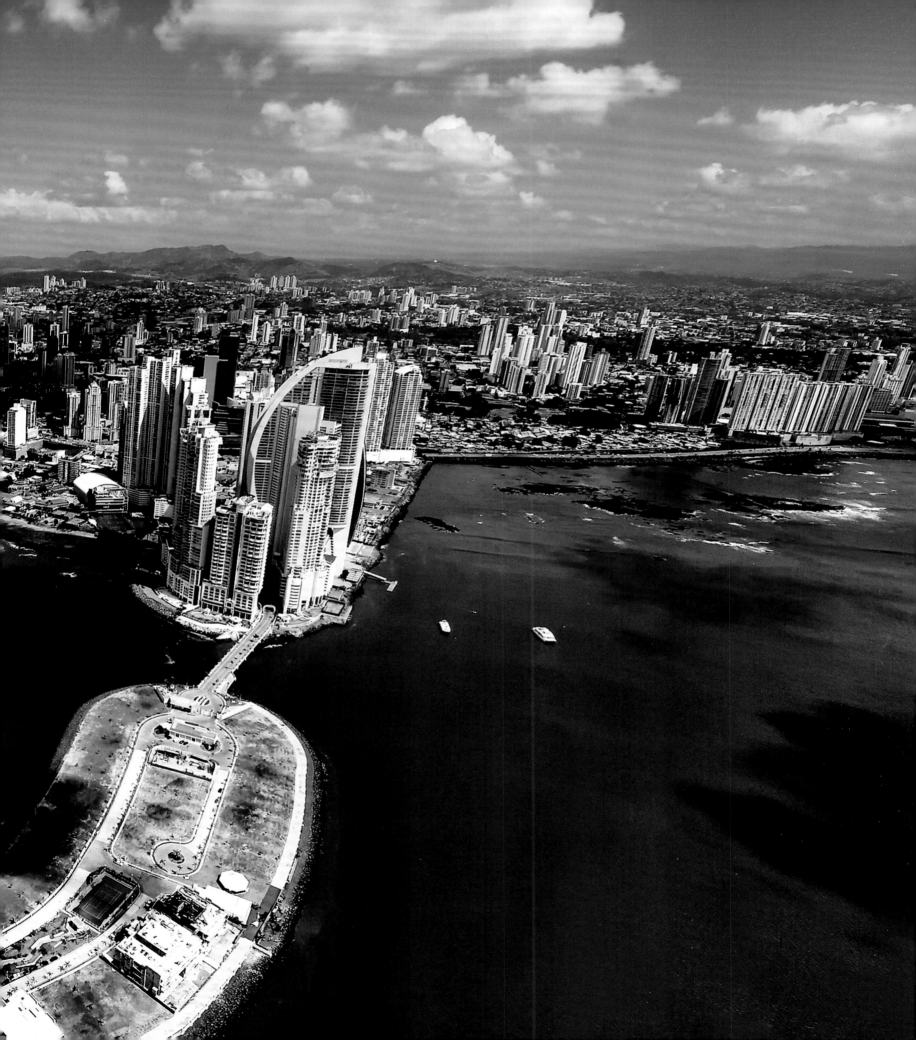

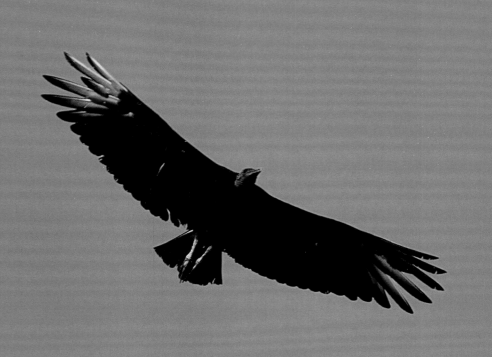

Forever Changing What We Are

Rosa María Britton

In 1905 a small country called Panama began to be divided in two halves to open up a canal between two oceans, forever changing what we are. Numbering 90,000 throughout the entire territory, Panamanians had to adjust to the presence of more than 30,000 workers who came to work on the excavations for the Canal. Although most of the workers were African descendants from the Antilles, they were joined by Spaniards, Portuguese, Scots and other nationalities from around the world, in many ways changing the social and cultural make-up of the country. Once the work was completed, they gradually integrated into the exploding isthmus population in a kaleidoscope of languages, customs, foods, and religions. Long before this, since the construction of the intercontinental railroad in the mid-nineteenth century, Chinese workers and many adventurers—trying to get to California—stayed on the isthmus and began to sow the seeds of what is Panama today. The Chinese introduced rice, which became the staple food of Panamanians, unlike the rest of Central America who resort to corn.

> Since the days of the American administration the Canal has been an equal opportunities employer, not discriminating on the grounds of sex or race.

After the construction of the Canal, the country remained split in two for over forty years, connected by ferry for crossing vehicles along the Canal with all the inconveniences and delays that this entailed.

To the east of the capital is the Darién Gap, and to the west, the country's productive area. In small boats and cutters, some farmers managed to bring their products to the city market—avoiding the strong Pacific tides and inclement weather. It was not until 1960 that the Bridge of the Americas was completed, connecting the two sides of the isthmus that had been separated for half a century. It is a country whose citizens made many concessions and sacrifices for the Canal. The nationalist struggles over the following years, demanding the return of land occupied by the Americans and strong geopolitical maneuvers by General Torrijos in the 1980s, culminated in the signing of the Torrijos-Carter Treaties, which returned full sovereignty to Panama in 1999. Military installations in the Canal Zone were gradually closed and in the 1990s, for the first time, a Panamanian administrator took over the operations of the Canal. Many at home and abroad voiced the opinion that Panama would not be able to run the Canal with the same efficiency as the Americans, but they were proved wrong. The Canal employees were prepared to continue working with dedication and enthusiastic pride for many years. The loyalty to the Canal from the time of its US administration is notorious. Most Canal workers devote their whole professional lives to the Canal. Many have exceeded fifty years on the job, including Cecil B. Hynes, who worked on the Canal for seventy-two years, making him the oldest US federal employee, duly decorated by President Clinton.

In 1997 its enlargement was extensively discussed at the Universal Congress on the Panama Canal, organized to commemorate the twentieth anniversary of the signing of the Torrijos-Carter Treaties. They immediately began to study the possibility of expanding the Canal. Both domestic and international experts carried out over one hundred studies. At

the end of the investigation, the Panama Canal Authority estimated the project would cost about $5 billion. According to the Panama Constitution, the project would first have to be approved by the Asamblea Nacional de Diputados [Panama National Assembly] before being proposed to the people in a national referendum. An investment of this magnitude would boost the economy for many years, but such a momentous decision required the approval of the electorate.

The proposal was submitted to the people of Panama on April 24, 2006, and so an intense campaign immediately began by the different groups in favor, as well as the nationalists who questioned the government's cost estimates and claimed that corruption would spoil the successful completion of the project. The government was not authorized to support the "Yes" vote. Campaigning was intense and different groups got involved in television commercials supporting the project, including artists, intellectuals, several descendants of Afro-Antillean workers—citizens from all over the country.

The referendum took place in October 2006 and the proposal passed by a majority. For many years, the Americans maintained a visitors observation area at the Miraflores locks with open-air stands and information about the locks delivered by megaphone.

In 2002, after Panama had taken over the Canal, they began building a four-floor visitor center with terraces next to the locks, restaurants, cafés, a biodiversity museum, and a theater hosting video installations and other shows for visitors arriving daily from all over the world. Since then efforts have been made to attract young students and other groups so they can learn more about the Canal. The thousands of Panamanians who travel every day over the Canal via the Bridge of the Americas and the new Centennial Bridge look on at this narrow expanse of water, along with the ships of all sizes that glide across it, unaware of the efforts made to take them across the isthmus.

Once the extension was approved, the Canal Authority began an intensive training program to meet the huge volume of skilled labor required in the excavation areas—the first phase of the project. Indeed, since the days of the American administration the Canal has been an equal opportunities employer, not discriminating on the grounds of sex or race. Since the 1980s, there are women who scale the dangerous ladders to join the crews from the Canal Authority that take over ships from their pilots in order to guide them through the Canal. Women started to take control of some of the mules, the small locomotives that pull ships, soon replaced by a large fleet of tugs. The consortium Grupo Unidos por el Canal (GUPC) was responsible for the design and construction of the third set of locks.

The foreign influx was immediately felt. New hotels and restaurants opened their doors, shopping malls, office buildings and condominiums rose up from one day to the next, and a metro system was built extending from one side of a precipitously changing city to the other. The eyes of the world were on this expansion. Feverish work began immediately to bring the ports of Miami, South Carolina, and Georgia to the standards of the large Post-Panamax freight ships, requiring billions in investment.

Since 2007, the expansion work has created more than 40,000 jobs and 90% of them have gone to Panamanians. The remaining 10% was made up of an international force from eighty countries across five continents, especially from Italy, Spain, Belgium, Portugal, Mexico, and the Philippines, to name but a few.

The purchasing power of the Panamanian worker drove the construction and expansion of large districts of family homes to the west, middle-class condos in the capital, and also led to a significant increase in private vehicle ownership. In short, the economic boom was caused by this notable expansion. It is important to note that 10% of the workforce involved in the expansion of the Canal was made up of women.

> The Panama Canal
> is an inseparable part of our history;
> this expansion has, once again,
> been highlighted as one
> of the wonders of the modern world.

The ACP [Autoridad del Canal de Panamá] continued to offer training programs to improve skills and create career opportunities both in the technical and administrative areas for temporary workers to incorporate them into the ACP workforce.

El Niño resulted in a significant decrease in rivers and lakes in the Canal basin once again, provoking cause for alarm once more. The new Canal has largely contributed to reducing water waste, with a new system aimed at reuse of the water for each ship's passage. Moreover, the ACP is making significant efforts to conserve water resources in order to ensure both supplies to the population and the passage of ships. Due to the extensive deforestation affecting the central areas, especially Azuero Province, rivers, lakes, and streams have been drying out despite the many efforts made by the authorities requesting that citizens conserve water.

In these years, the Canal has brought much prosperity to the country thanks to an economic boom. Panama has been visited by the rich and famous from around the world and millions of tourists. Artists from all over have come to showcase their lavish exhibits, attracting thousands of foreign visitors. Once more, as in the early twentieth century, many foreigners who came to work on the extension have integrated into the country in a mix of races. But others will return to their lands, with the beat of the tamborito ringing in their memories.

The Panama Canal is an inseparable part of our history; this expansion has, once again, been highlighted as one of the wonders of the modern world.

Rosa María Crespo Justiniani de Britton, born in Panama in 1936, is the country's most prestigious and internationally acclaimed writer. She is also a highly esteemed oncologist and gynecologist.

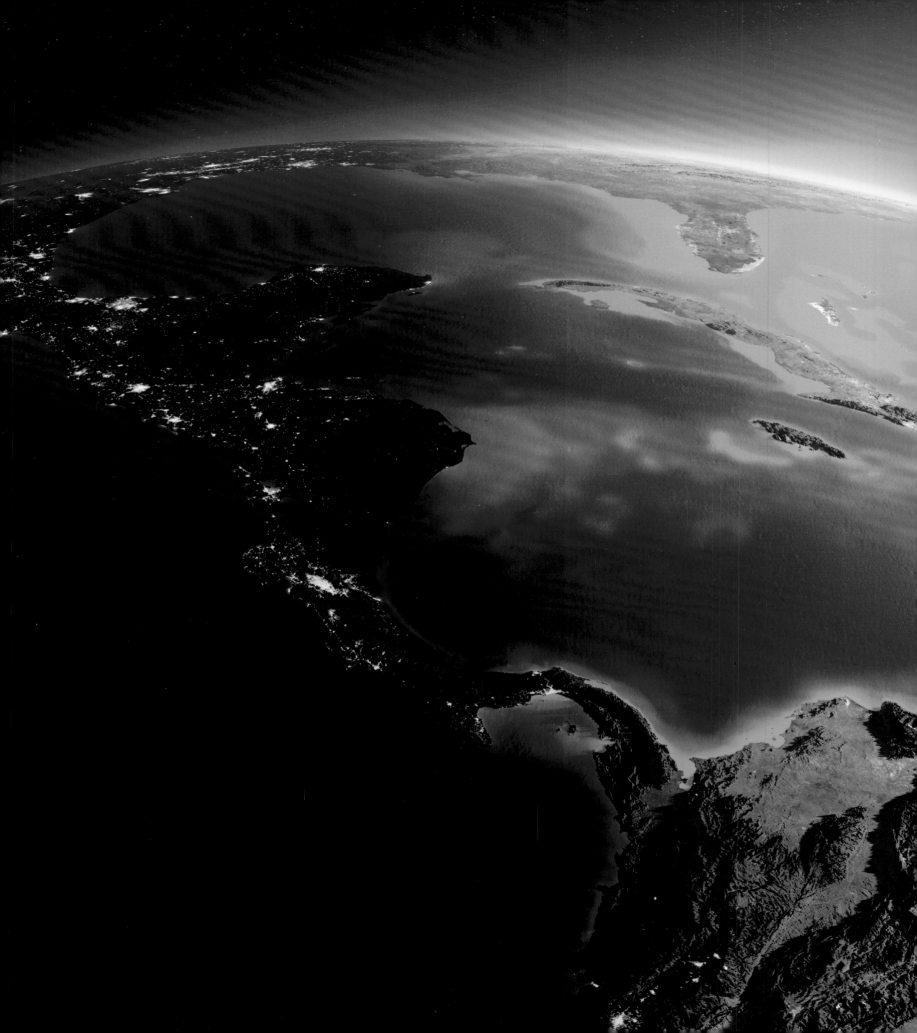

A Strip of Land

Panama is a strip of land stretching between four giants of the earth. The two halves of the Americas would seem to be on the verge of separating, were it not for this thin bow connecting them; the endless expanses of the Atlantic and the Pacific would instead seem destined to merge, if only they climbed over this isthmus that at its narrowest point measures just a few dozen miles.
This miracle of geography, for those who observe it from the sky or on a planisphere, may thus seem like a bridge or a border, a dam or a gate, at the crossroads between lands and oceans. Apparently, Panama was destined from the outset to be something that unites or something that separates. And it has chosen to unite. Its story is the story of explorers, dreamers, and the challenges of men and women who wanted to overcome the limits imposed by nature. The Panama Canal is a water highway between the shores of the two oceans: the alternative, created by man's intelligence and skill, to the interminable circumnavigation of South America. A shortcut, of course. But the road to make it was indeed a long one.

A story that started over three million years ago, when the clashing of two tectonic plates created that bridge of rocks, sand, and mud that separated the oceans, but united the Americas.

When in 1513 the Spanish *conquistador* Vasco Núñez de Balboa left the Atlantic behind him and set off toward the inextricable forest, in search of that great sea the natives talked about (and the immense treasures they found down there), his was a journey toward the unknown. He had about 200 men accompanying him, soon to be decimated by battles and diseases, several guides, and a pack of dogs to keep the wild animals at bay. After nearly a month of adventures and torments, Balboa entered up to his knees in what, in the name of the ruler of Castile, he called "The South Sea," and that today we know as the Pacific Ocean. He had—the first European to do so—crossed the continent.

On those shores of the Pacific the *conquistadores* built the city of Panama, which soon became the transit site for all the riches of the New Continent (the treasures of Peru, above all). Transported by mule across the isthmus toward the Atlantic, when they reached Portobelo they were finally loaded onto ships heading for Spain. That thin strip of land became the real El Dorado. And it wasn't long before the marauders showed up as well: in spite of the Spanish fortifications, Portobelo and Panama City were attacked and looted many times by pirates, so that by the end of the seventeenth century, the longer navigation around Cape Horn was preferred, circumnavigating South America lest the ships and sailors be exposed to the ferocity of the swashbucklers. Panama's importance rapidly declined, and for a long time its existence was almost forgotten. But the fate of the isthmus was written in gold letters, and so, more than 300 years after Balboa, what brought Panama back onto the international scene was the renewed mirage of fabulous treasures: those of California, this time, where the Gold Rush had begun in 1848. So once again the dream of wealth and riches drove men from all over the world toward the West coast, the furthest of all: but how could they get there? The railroad didn't cut across the plains of the United States yet, and the passage from Cape Horn was no less arduous: like three centuries before, the most prac-

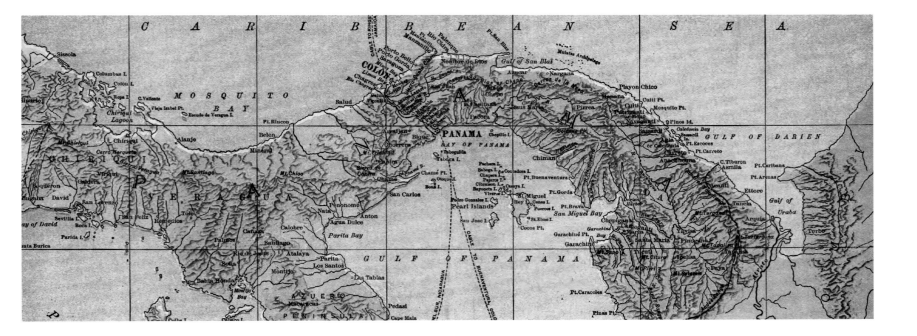

ticable option involved crossing the isthmus, the narrowest point of the Americas. And once again, for some time, on mules weaving between the thick forests and the tropical marshes, following the ancient tracks of the Spanish, along the paths oppressed by the torrential rains or the suffocating heat, where cholera, malaria, and yellow fever took a heavy toll. But soon, a project for a faster and safer way that could permanently join the two oceans was envisioned: a railroad line. Building it was no laughing matter, and the work cost more than 10,000 lives. However, in 1855 the Panama Railroad was inaugurated: with its mere 48 miles in length (the distance between the stations of Panama and Colón), it was the first transcontinental railroad ever.

It was after that accomplishment, and along that trail, that the idea of building a canal and making the route navigable began to take shape. This was not a new idea: crossing the continent by cutting the Mexican isthmus, or exploiting Lake Nicaragua and the San Juan River for the same purpose had already been suggested in the eighteenth century. But nothing was ever done and now it seemed the time had come to give it a try. The French entrepreneur and diplomat Ferdinand de Lesseps, a veteran of the building of the Suez Canal, bought the necessary rights from Colombia (of which Panama was then a province) and began raising the funds required for this titanic enterprise. His project was to excavate a canal across the isthmus at sea level, flanking the railroad. It was the simplest idea, apparently: but it turned out to be suicidal. Concealed along those fifty or so miles were dangers even greater than the ones the Spanish had had to face. The impenetrable forest, naturally: more intricate than the Amazon rainforest, filled with deep marshes, a breeding ground of deadly diseases, bent over by the torrential rainfall and the debilitating humidity, and set on fire by the sun. But there was also the river, the Chagres River in which the slopes of the land caused tons of water to flow during the rains, which led to indomitable flooding. The works, which began in 1881,

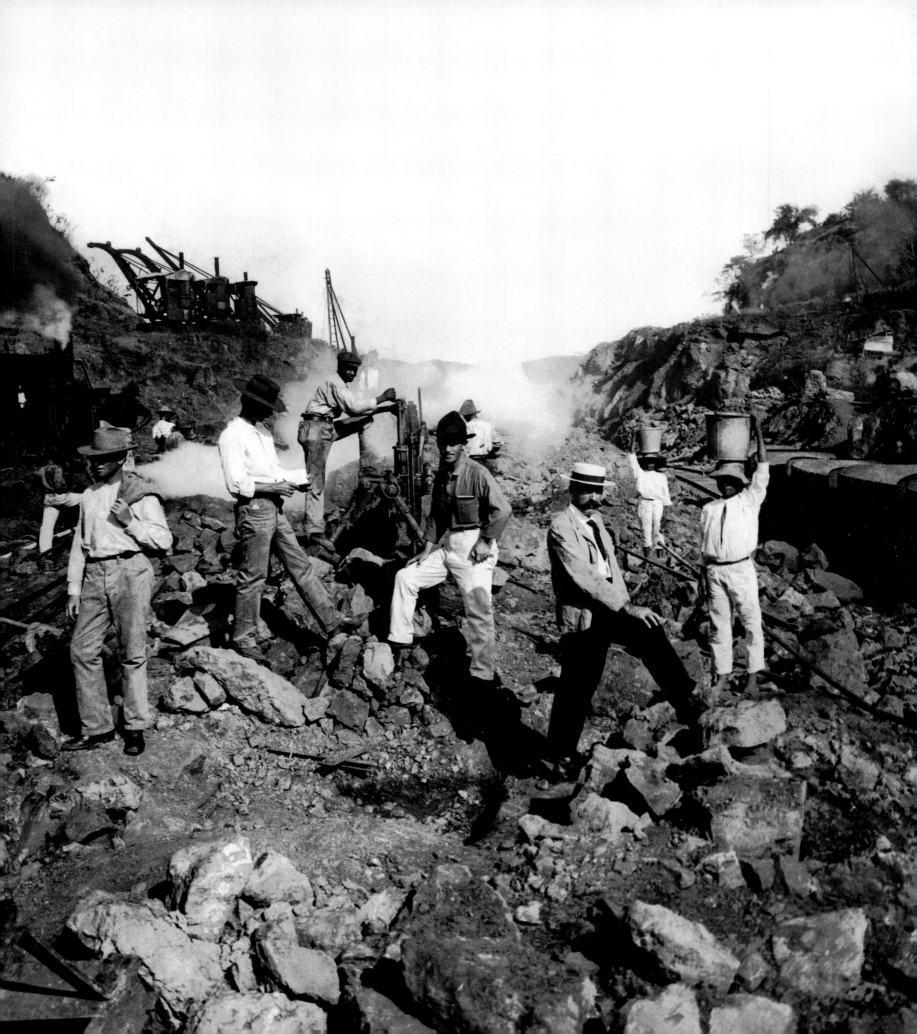

Left: workers, foremen, and engineers at work in the excavations of the Canal, 1906. Below: the elevation profile of the Canal in a 1904 map.

On the right hand side of the map, just before the land merges with the Pacific Ocean, is the mountain ridge where Culebra Cut was excavated.

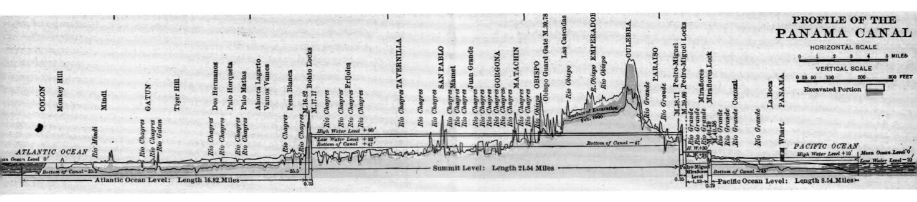

were interrupted eight years later with the bankruptcy of the company created by Lesseps. Along the route some 20,000 people had lost their lives.

But uniting the oceans was by now a strategic, commercial, and military necessity, above all for those who nurtured ambitions of becoming major powers: abandoned by the French, the idea was soon revived by the United States. As soon as he was elected president, in 1901, Theodore Roosevelt declared the construction of a canal in Central America to be essential. In Panama? Not necessarily: the French disaster was still too vivid in the memory of the public opinion. The North Americans were rather more inclined to build the canal in Nicaragua, but fears linked to the local volcanic activity ultimately persuaded the Senate to again turn its attention to Panama.

Colombia, which the region still belonged to, seemed unwilling to come to an agreement with the United States, but the political turbulence and the diplomatic pressure ended up solving the situation in favor of the latter. In 1903 Panama declared its own independence, and in the space of a few days a treaty was underwritten granting the United States the right to build the canal and the perpetual concession of its management, along with the ownership of a strip of land along the whole of its route.

The work could be started up again. On the condition, however, that what needed to be done to avoid a new disaster was understood beforehand. In the meantime, the discovery was made that what had caused the yellow fever and the malaria were the mosquitoes: hence, the first step involved launching a great reclamation campaign, a real war against the deadly insects so that the entire area where the work was to be carried out could be restored: the marshes and bogs had to be drained, the villages relocated, and the infected houses burned down. In 1905 the war on yellow fever was declared to have been won; malaria took a few years longer to eliminate but, at last, the death rate in the construction site drastically declined.

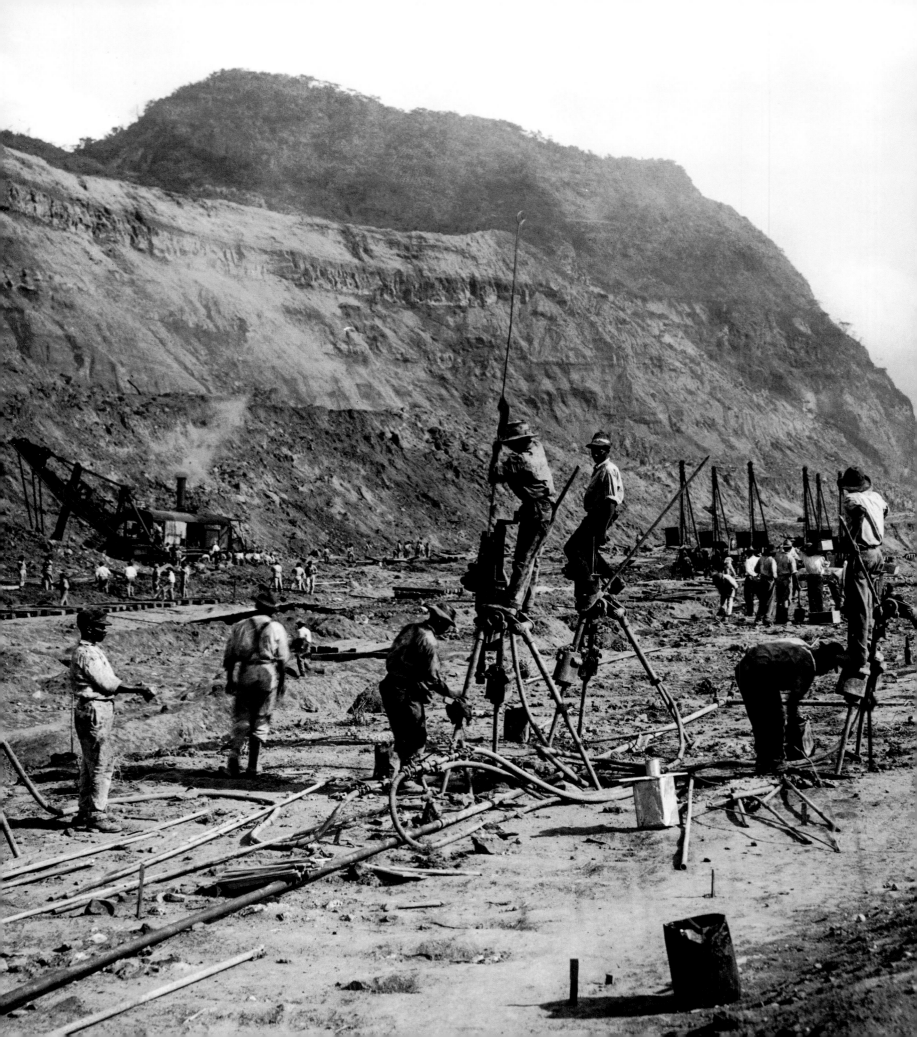

> The Chagres River was not to be dealt
> with as though it were the enemy,
> but exploited like an ally.

A second great turning point marked the destiny of the works: the United States were convinced that the Canal should be built with a system of locks, and not at sea level as the French had thought of doing. Consequently, the Chagres River was not to be dealt with as though it were the enemy, but exploited like an ally. The solution, a radical one, thus entailed traveling with the ships *on* the river, taking advantage of the abundant rainfall to feed the Canal. The central area of Panama presented a chain of reliefs that had developed to form a near-perfect basin around the river, from which the Chagres River emerged to flow its one last stretch toward the Atlantic. That was where the engineers suggested a waterproof wall be built: Gatun Dam, which would create a gigantic artificial lake 88.5 feet above sea level. By crossing that lake, the ships would cross the jungle and, thanks to the system of locks, they would pass from one ocean to the other, "climbing the steps" at the entrance, as far as the lake level, and descending at the exit, as far as the sea level.

And so it was. The morning of August 15, 1914, the American cargo and passenger ship *Ancon* crossed the Canal, inaugurating it, and forever changing the world's trade routes. Thirty-three years had gone by since the French had begun working on this gargantuan task, an adventure worthy of their Jules Verne. But the story was not yet over.

If its geography had made Panama such a special place, the canal made it unique. Over the course of a century, the planet's new riches have crossed that strip of water splitting the continent, tearing the country, in spite of the countless contradictions, from the poverty that afflicted many other Central America countries. But the Canal does not just mean transits, arrivals, and departures: from the outset, its economic vitality has made Panama quiver with unexpected vibrancy. The Colón Free Trade Zone (the largest of the Americas), the skyscrapers of Panama City, the spectacular yachts anchored in the tourist ports: all this is due to the canal. And, as clearly described in these pages by Rosa María Britton, the tens of

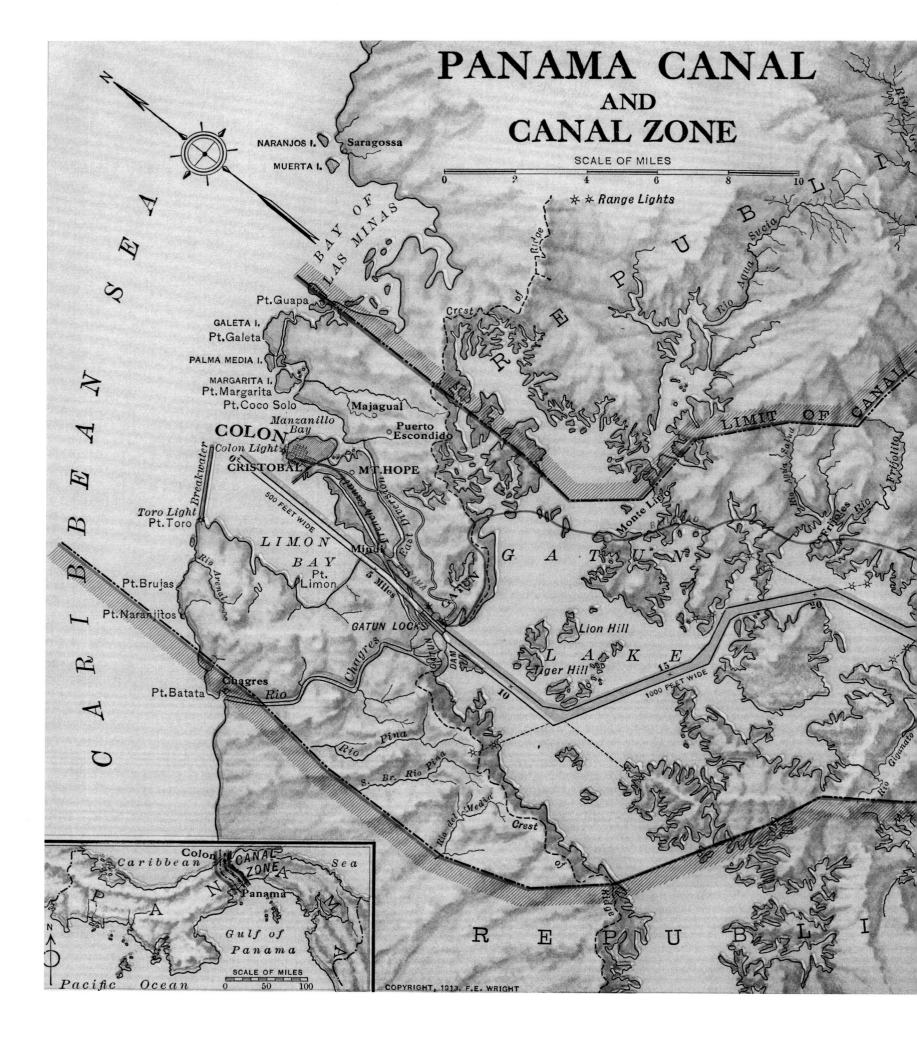

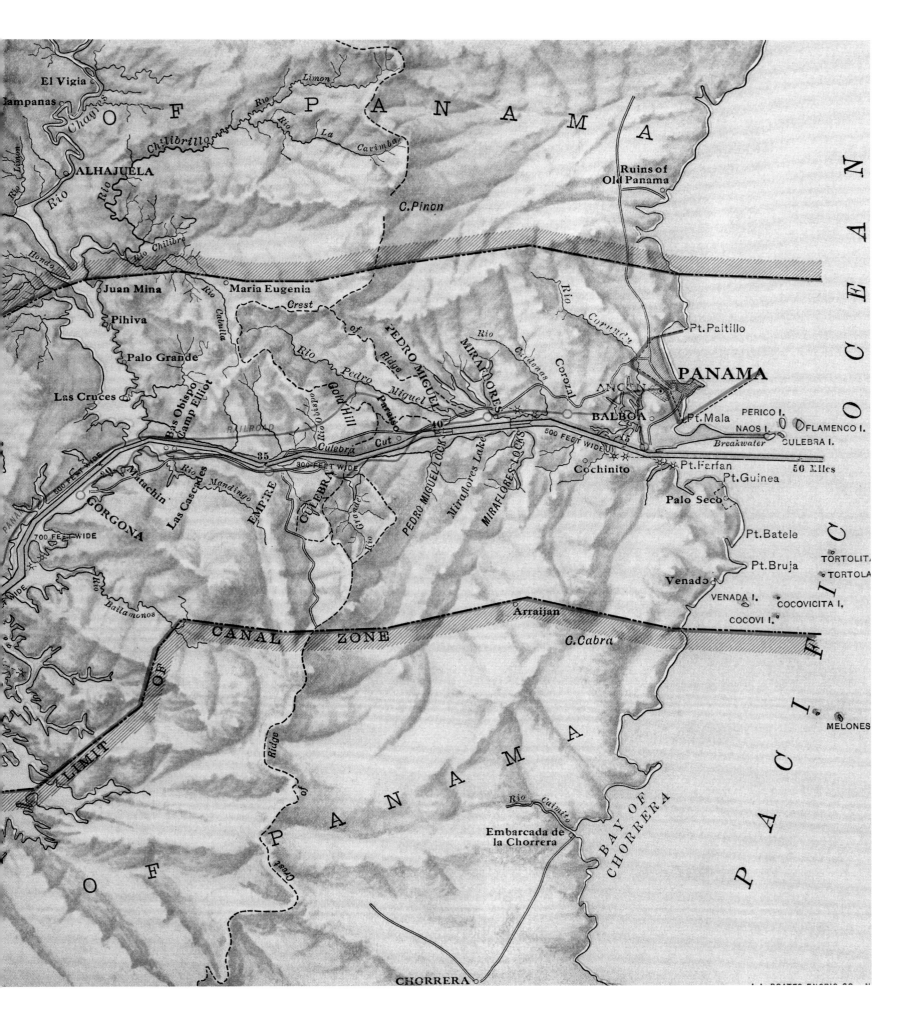

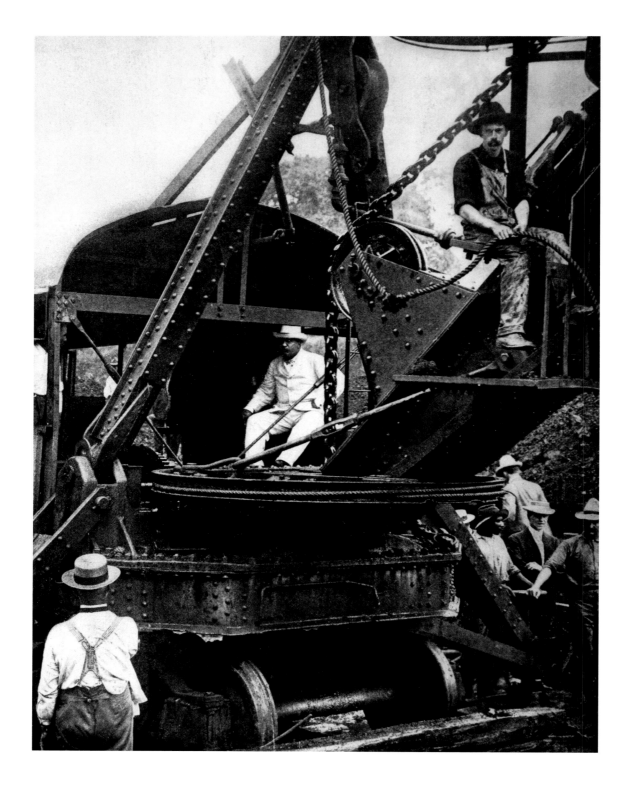

In November of 1906, President of the United States Theodore Roosevelt visited Panama to check on the progress of the Canal. In the photo on the left, Roosevelt is seated inside a huge digger used to make Culebra Cut. On this page: a phase in the construction of the locks (1912). Each "gate" is over 79 feet high.

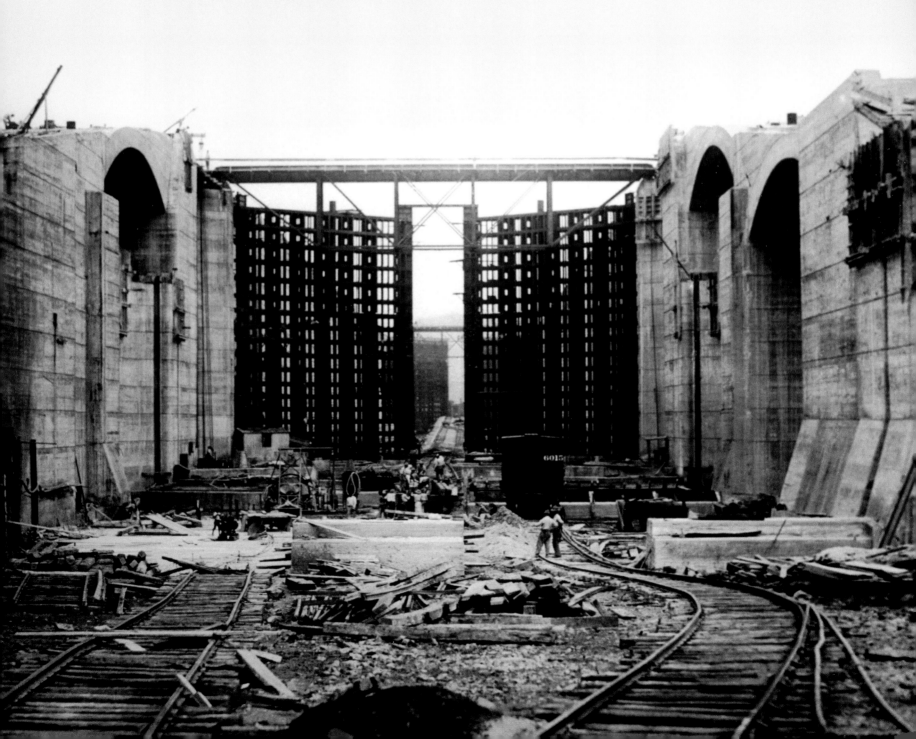

Thirty-three years had gone by since
the French had begun working
on this gargantuan task,
an adventure worthy of their Jules Verne.
But the story was not yet over.

thousands of foreign workers who for decades labored to build the Canal, have modified, hybridized and enriched in cultures, races, and traditions a land that has always, because of its position, been a land of passage and migration. A country in motion, capable of adapting to the winds of history. In 1999, by virtue of the new agreements with the United States, the area of the Canal and the Canal itself were returned to Panamanian sovereignty. And the challenges began once more. Maritime transport was changing, the sizes of the ships were growing, the Canal was by now at the limit of its capacity, and the country's economy risked being negatively influenced by this. Furthermore, what for years had represented a resource risked turning into a problem: indeed, each time a ship crossed the Canal, about 52,800,000 gallons of fresh water were released by the system of locks and ended up in the oceans. A waste that no one could afford. If the Canal had to be widened, then, this was going to have to take place without further waste: saving water was an imperative. The new task ahead was to build a larger and more sustainable intra-oceanic waterway, while ships continued to move between the locks dating back to 1914. And if ships measuring up to 108 feet wide and almost 924 feet long could pass through the "old" Canal, then ships measuring 1200 feet in length and that were up to 180.5 feet wide would be able to pass through the new locks, with a draft of over 50%. It may seem like a small difference, but it means that the new ships, known as "Post-Panamax," could carry three times the previous load: from the current 4400, to 13,600 containers in the future. Hence, Panama expected to double the canal's turnover, estimated at around 2.5 billion dollars per year.

In 2006, the national referendum promoted by the government decreed that 76.8% of Panamanians approved of the project and accepted the challenge. Thousands of men and women would find themselves working on a common dream for many years to come: that of repeating the achievement of a century before, of going back to the origins. The best of world

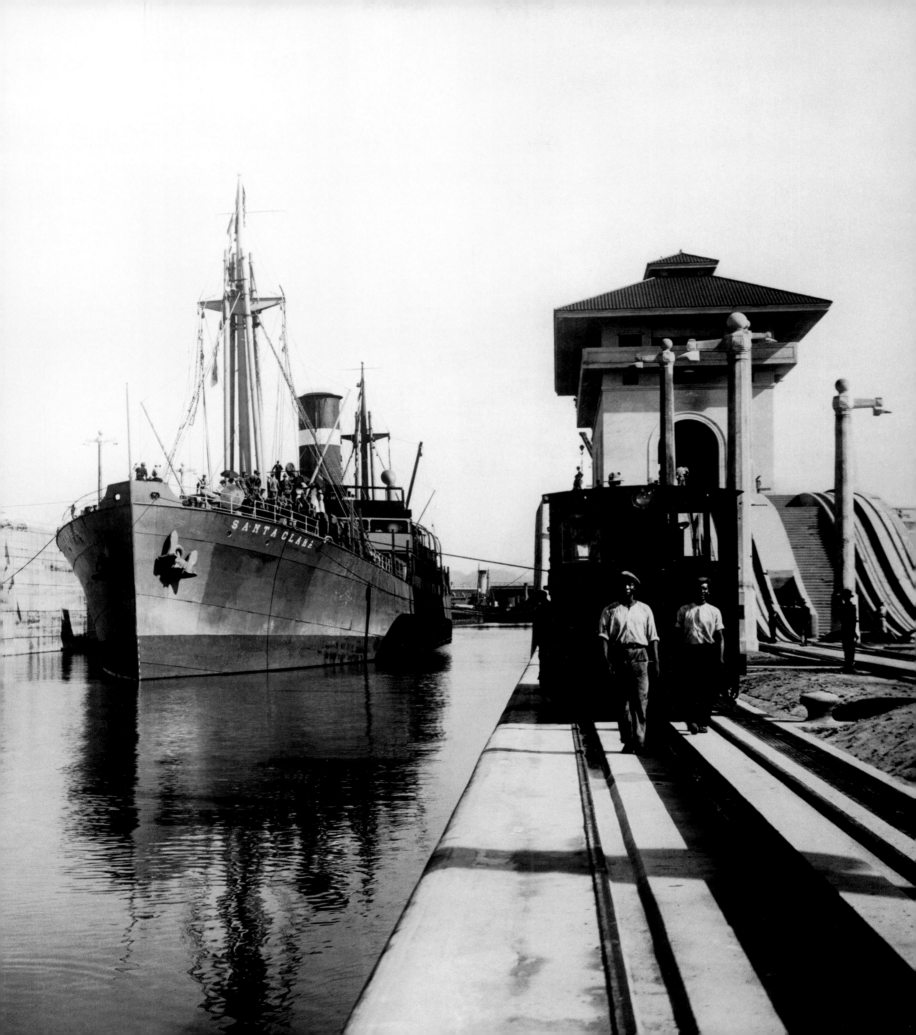

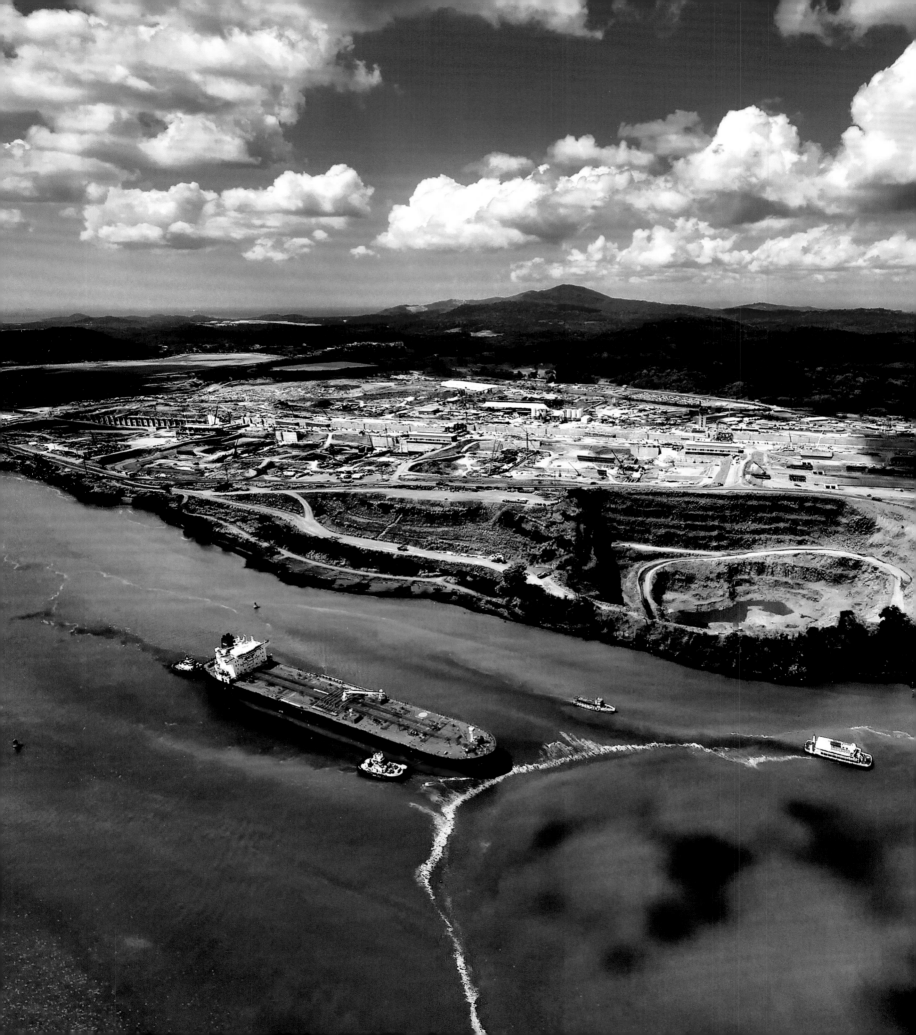

Each day the Panama Canal's old bulkheads are crossed by about forty ships. The third set of locks, inaugurated on June 26, 2016, after work lasting for seven years, allows for the daily transit of another fifteen giants of the sea, having a far greater capacity than the normal cargo vessels.

engineering and the best construction companies were invited to make their offers. The winner was the Grupo Unidos por el Canal (GUPC) formed by the Italian Salini Impregilo in a consortium with other companies. The contract was signed on July 15, 2009. The figures for the project were mind-boggling: 1,836 billion cubic feet of excavations, 290,000 tons of iron, 166 million cubic feet of concrete, 1.6 million tons of cement, more than 100 million hours of work: a gargantuan building site, the most imposing work that man had set his mind to in the past few decades. The Post-Panamax ships would cross the isthmus thanks to a system of locks delimited by huge sliding gates, designed and built in Italy: steel giants 115 feet in height by around 180 feet in length and 33 feet in width, for a weight of 4000 tons. Each gate could do its job in less than five minutes, for an operation destined to be repeated for at least another one hundred years. To reduce water consumption to a minimum, in the locks at the two extremities of the path, a tunnel system with huge lateral tanks contributes to feeding the locks themselves, subsequently recovering the out-flowing water.

In the spring of 2015, after six years' work, the gates were inserted into their sliding containers, and in June 2016 the new locks were inaugurated. The world's attention was once again turned toward Panama City.

For those arriving along the canal, the capital is announced by an immense metallic arch: that Bridge of the Americas that for forty-two years was the only one connecting North and South America, the two continents that the canal had separated. Seen from a ship's deck, Panama City shows all the peculiarity of this grandiose cross between new America and old Colonial Spain: the skyscrapers of Punta Paitilla; Avenida Balboa and the cafés overlooking the sea; Cinta Costera, the road built on water to protect the Casco Antiguo, the historic center that preserves the colonial legacy of a cosmopolitan and multiethnic city. It is also a spectacular blend of man-made creations and natural wonders, with those almost 655 acres

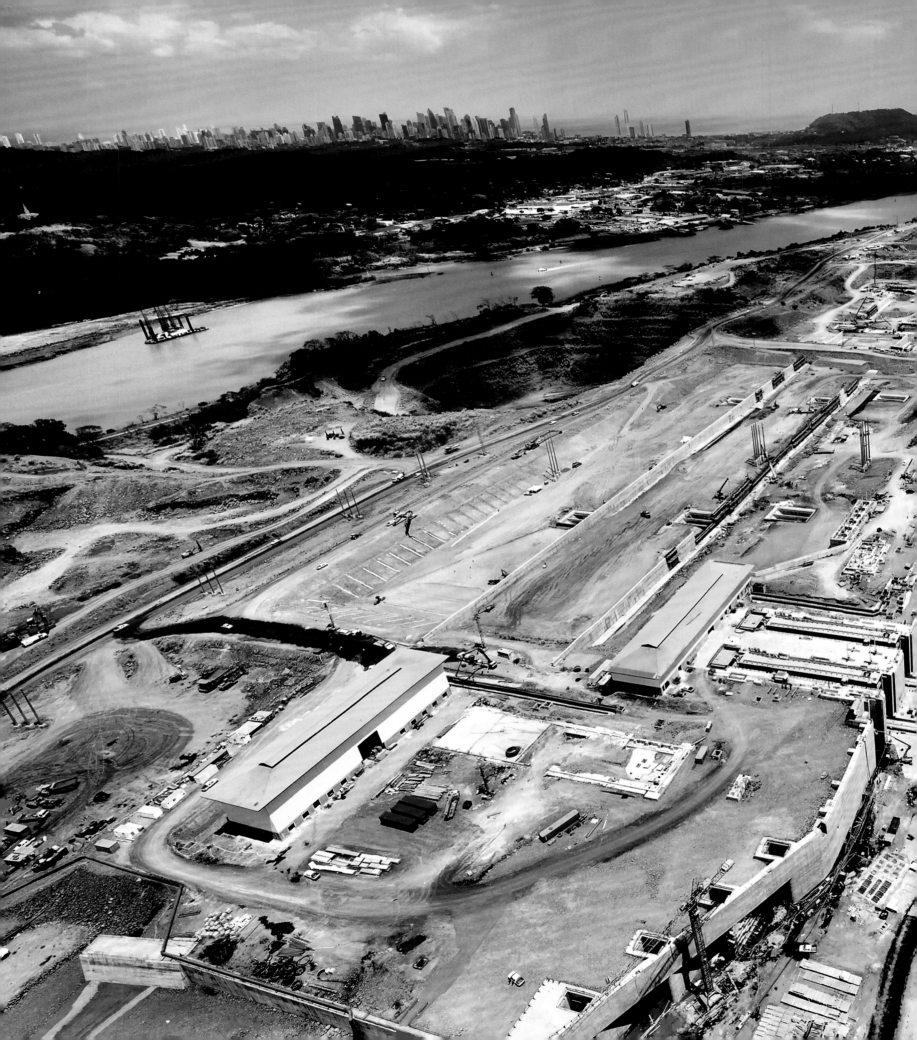

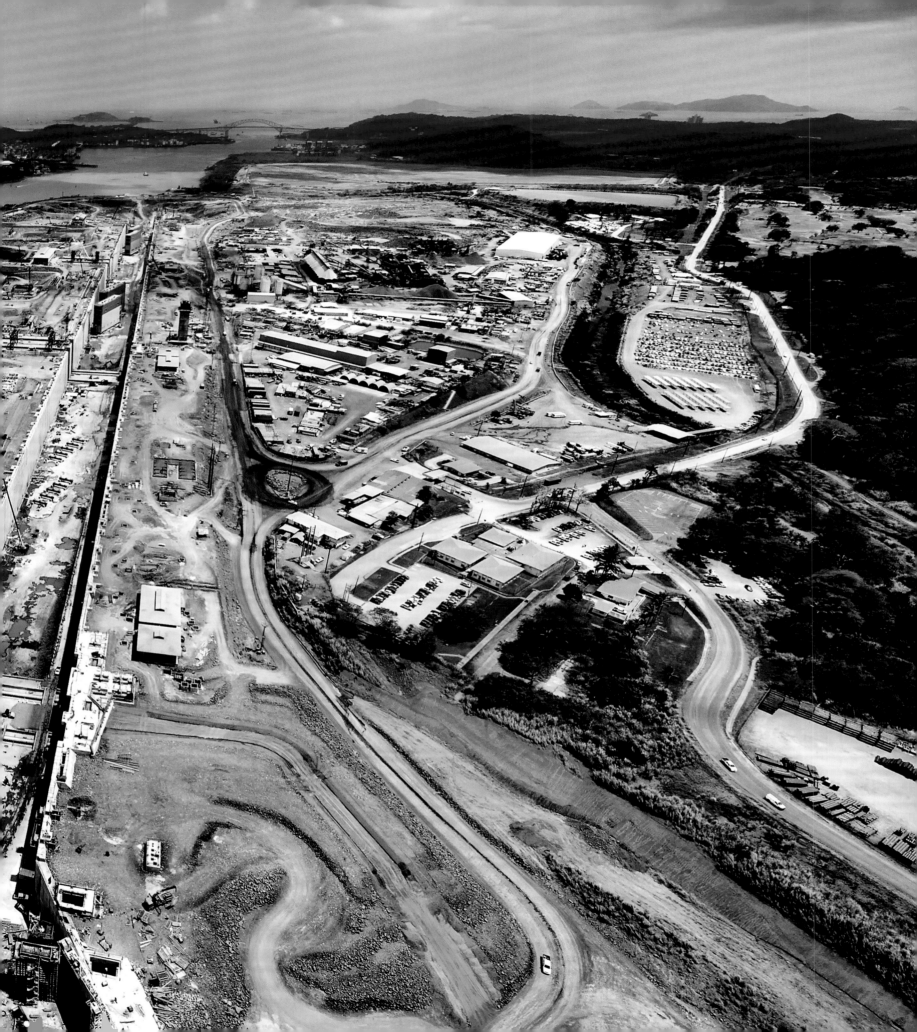

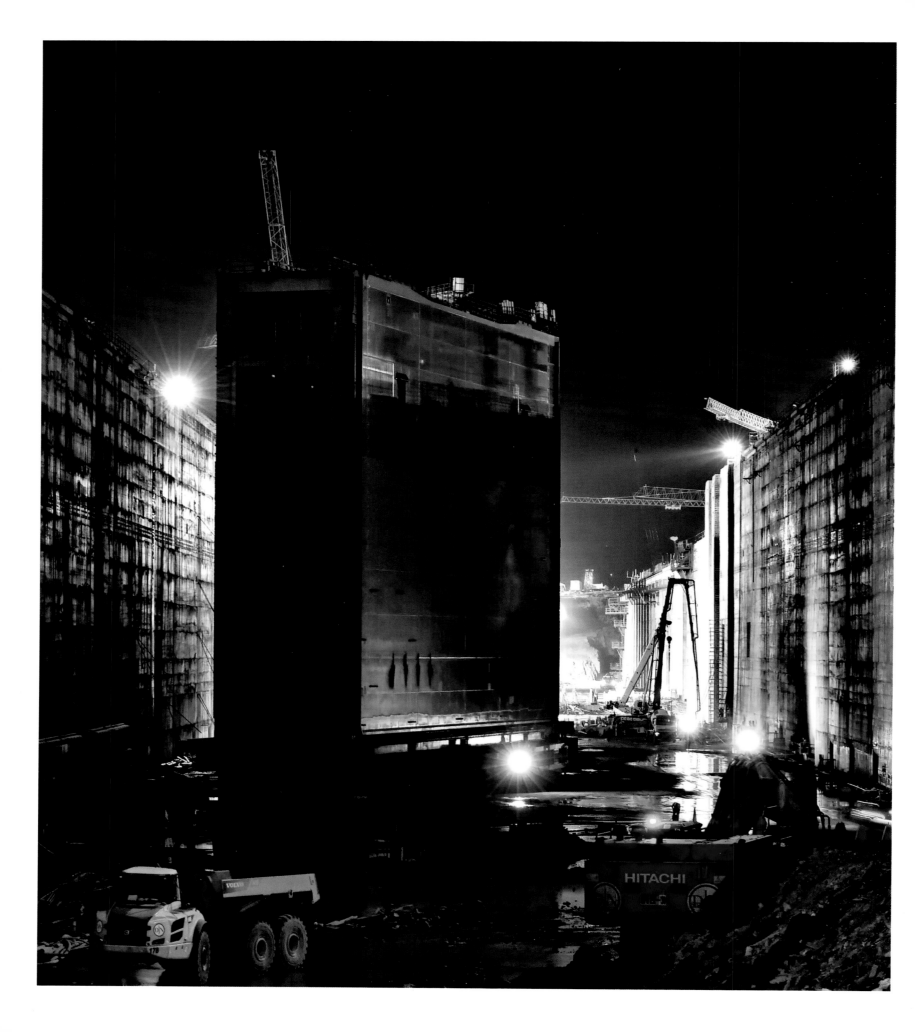

One of the sixteen gigantic sliding bulkheads of the new locks, built in Italy and transported to Panama by sea. These measure an average of up to 108 feet in height, about 33 feet in width, and about 190 feet in length, with an average weight of 4000 tons each. On the following pages: the transit of the immense Cosco Shipping Panama (984 feet in length with 10,000 containers on board) inaugurates the locks.

of tropical forest that survive in its urban territory thanks to the Parque Natural Metropolitano. And in Panama, again between land and sea, there is yet another place that tells of the canal's impact on man and on nature, as well as of the country, its evolution and the oceans surrounding it. It is a construction with a futuristic design, a colorful origami erected on the Calzada de Amador, before the entrance to the canal and the skyline of the skyscrapers of Punta Paitilla. It is the Biomuseo designed by Frank Gehry and first opened in 2014. On the inside, in 44,000 square feet the story that started over three million years ago is retraced, when the clashing of two tectonic plates created that bridge of rocks, sand, and mud that separated the oceans, but united the Americas, and opened a first passage to the living creatures of the two lands. It also laid the foundations for the extraordinary biodiversity that still characterizes Panama today, and that the canal and man's intervention has not erased: a large number of species inhabiting the Canal were saved during the expansion works, and today, even Lake Gatun, an immense artificial creature, has become an extraordinary natural laboratory, an inexhaustible treasure trove of flora and fauna.

The whole variety of the tropics is represented in the different regions of the country, and between beaches and forests, snorkeling and bird-watching, surfing and the nightlife, in the space of a few miles Panama reveals a colorful universe to the traveler. We too have crossed these regions—armed with notebooks, cameras, and curiosity—touching Portobelo and San Lorenzo before slipping into the canal and enjoying the paradises of the Gatun and the Chagres River all the way to the capital, and finally reopening the horizons in the Pacific. Two oceans, a thousand worlds, joining North and South, East and West: because this strip of land, stretching between giants so different from each other, was born to unite them. And its canal, crossed every day by thousands of tourists and thousands of tons of goods, is a peaceful bridge, which today is even broader, resting between the lands and the seas.

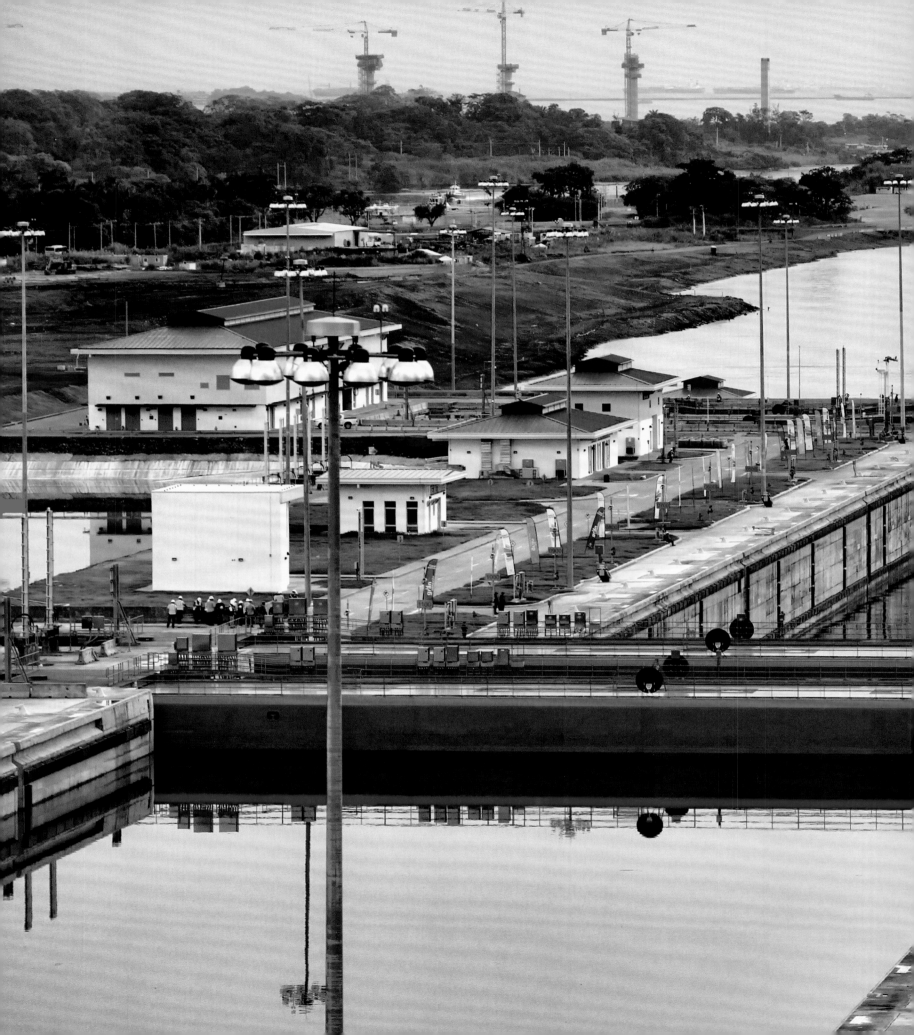

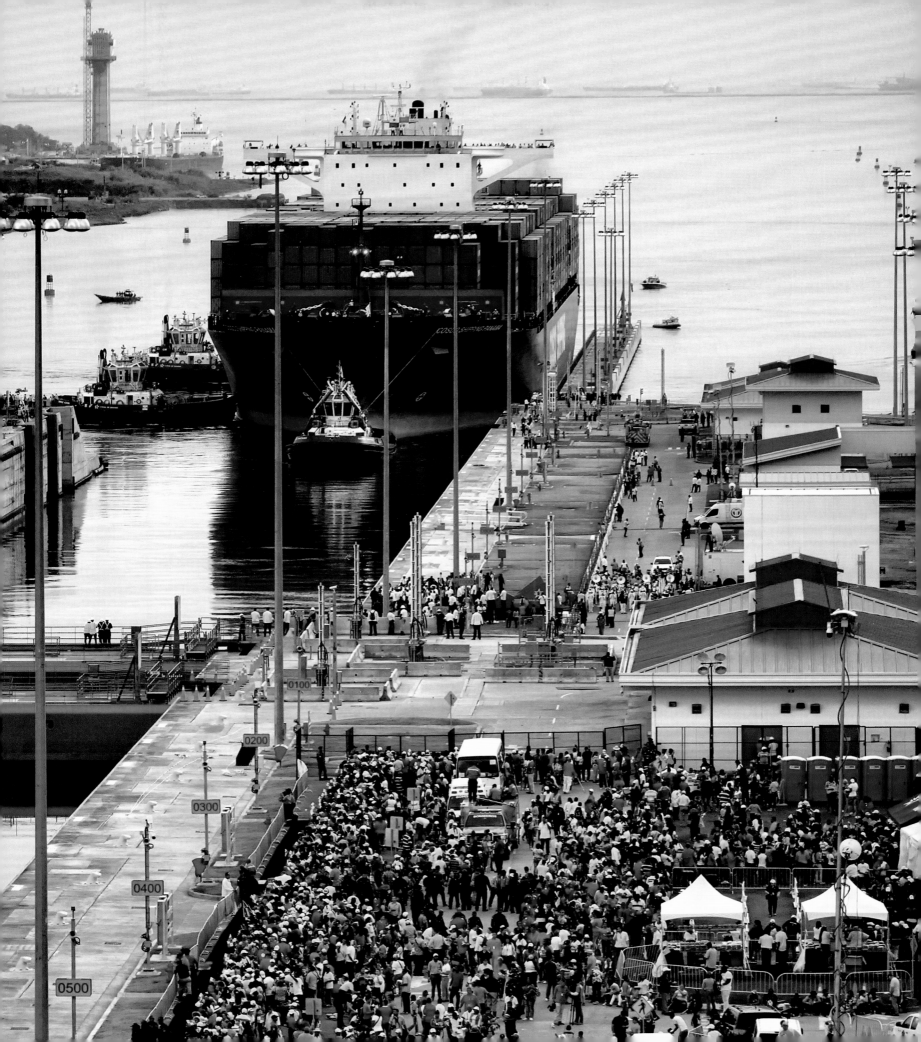

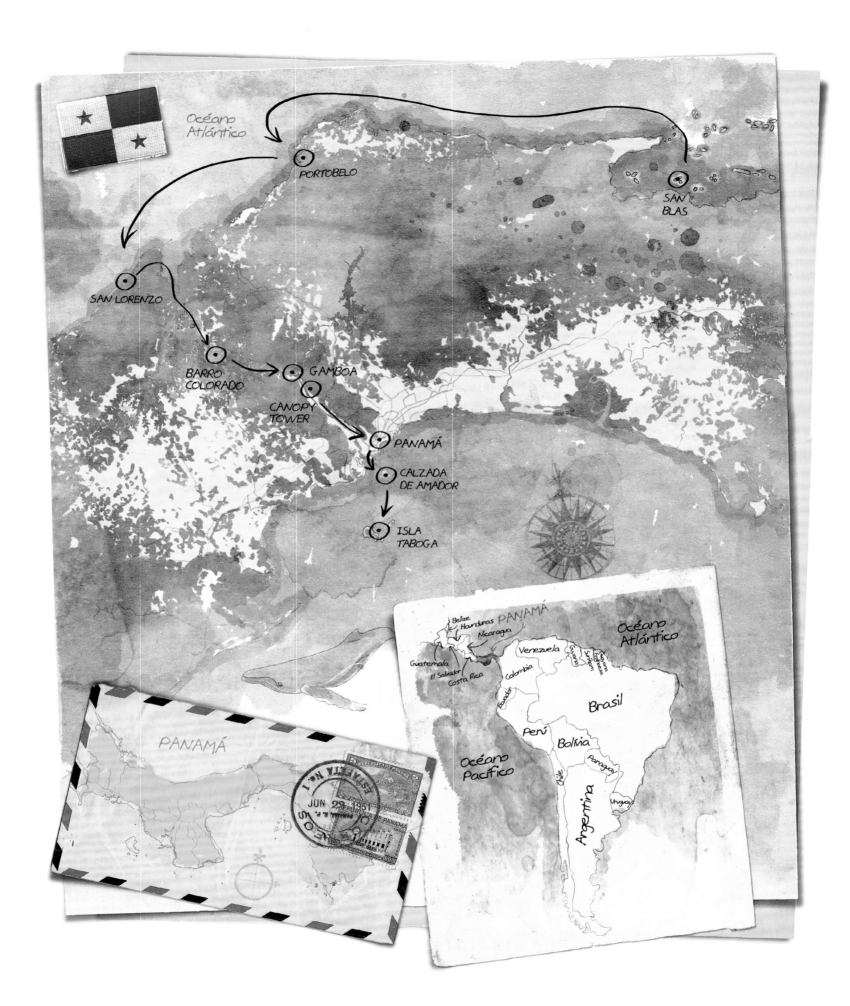

The Journey

The smallest "ship" to ever cross the Panama Canal was actually a man, the American adventurer Richard Halliburton. In August 1928, like any other ship, Halliburton registered with the port authority, declaring his weight and thus paying a transit fee: 140 pounds, that is 36 cents. Then he dived in, followed by a boat with a photographer and a man hired to protect him—especially from the curiosity of the alligators. The trip lasted nine days, including stops. This is just to say that the Canal is unique, and that it can be crossed in many different ways… We also took our time on this journey, even though we didn't swim across. After leaving one island in the Atlantic to reach another island in the Pacific, we traveled by boat, helicopter, on foot, and, naturally, on ships which each and every day cross the old locks and the new ones. We explored, discovered, asked questions: but most importantly, we were in awe at what we saw. We took pictures of our impressions. And in the evening, when our memories of the day resurfaced, offering new colors, we jotted down our feelings in a notebook and annotated our curiosities. Panama, here we come.

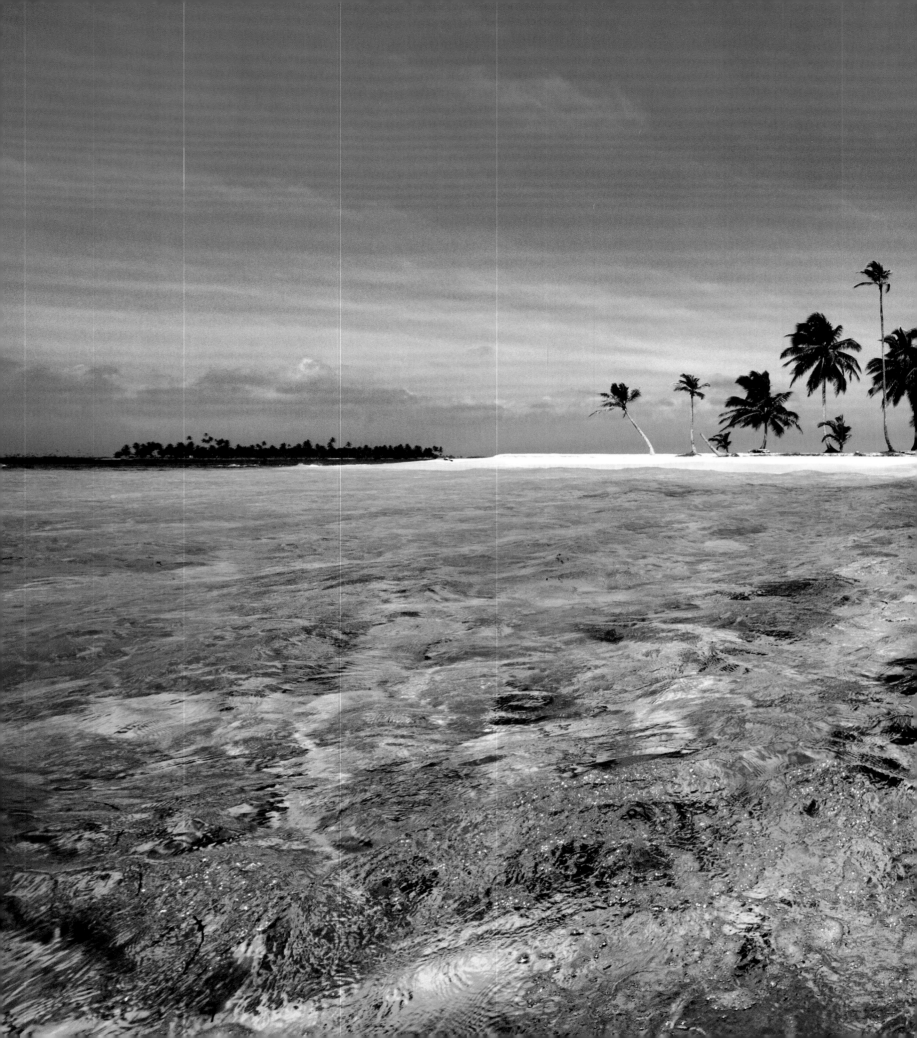

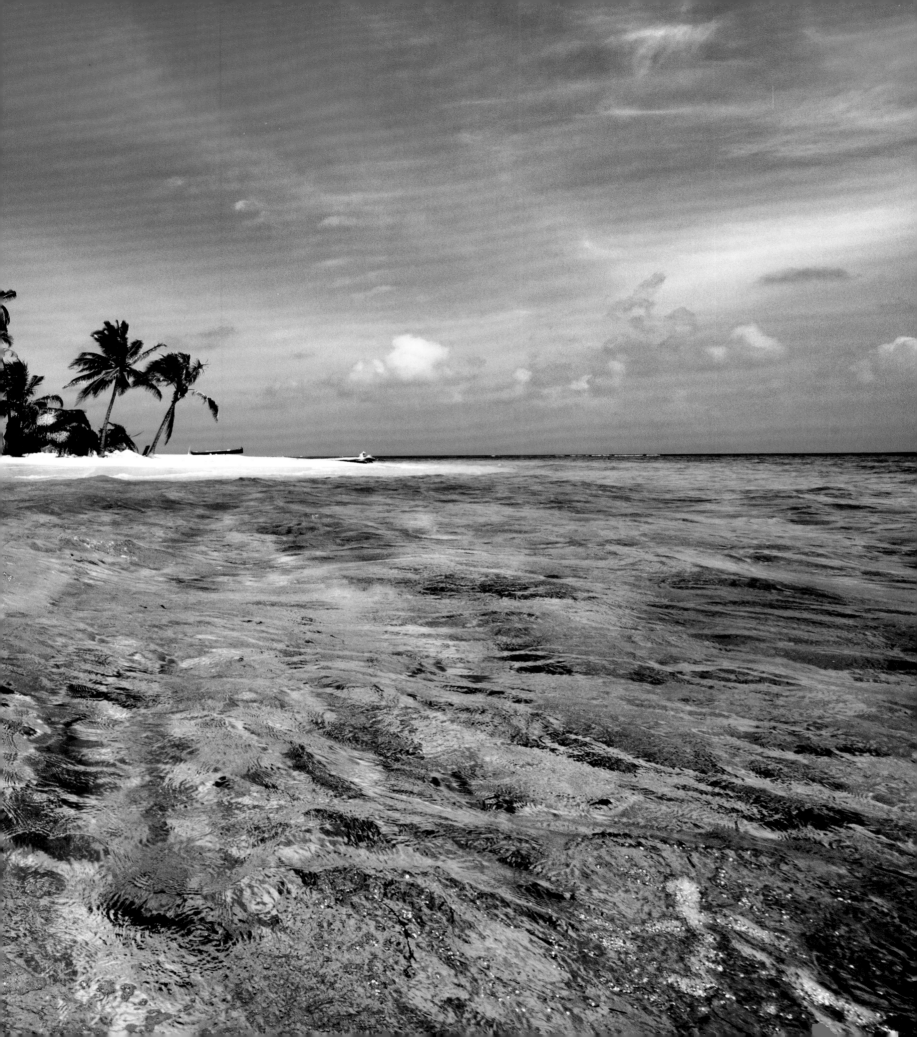

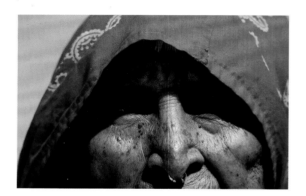 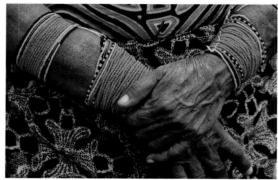

The coral islands scattered across the archipelago of San Blas number more or less four hundred. The number varies due to the emergence or submergence of the strips of land, and clearly climate change and the rise in the water level are cause for concern: for instance, Isla Pelicano, the first one we took pictures of (on page 46), might soon disappear...

The archipelago is part of the territory of the Kuna, the last indigenous people of Panama, who are proud of their identity and have preserved their language and traditions. The Kuna economy is prevalently based on crafts, tourism, and the sale of coconuts. Although these days it is easier to travel than it once was, we chose to get around on these marvelous waters in a slow *cayuco*, one of the Kuna's canoes. Our *cayuco* was brightly colored, like the clothes worn by the women.

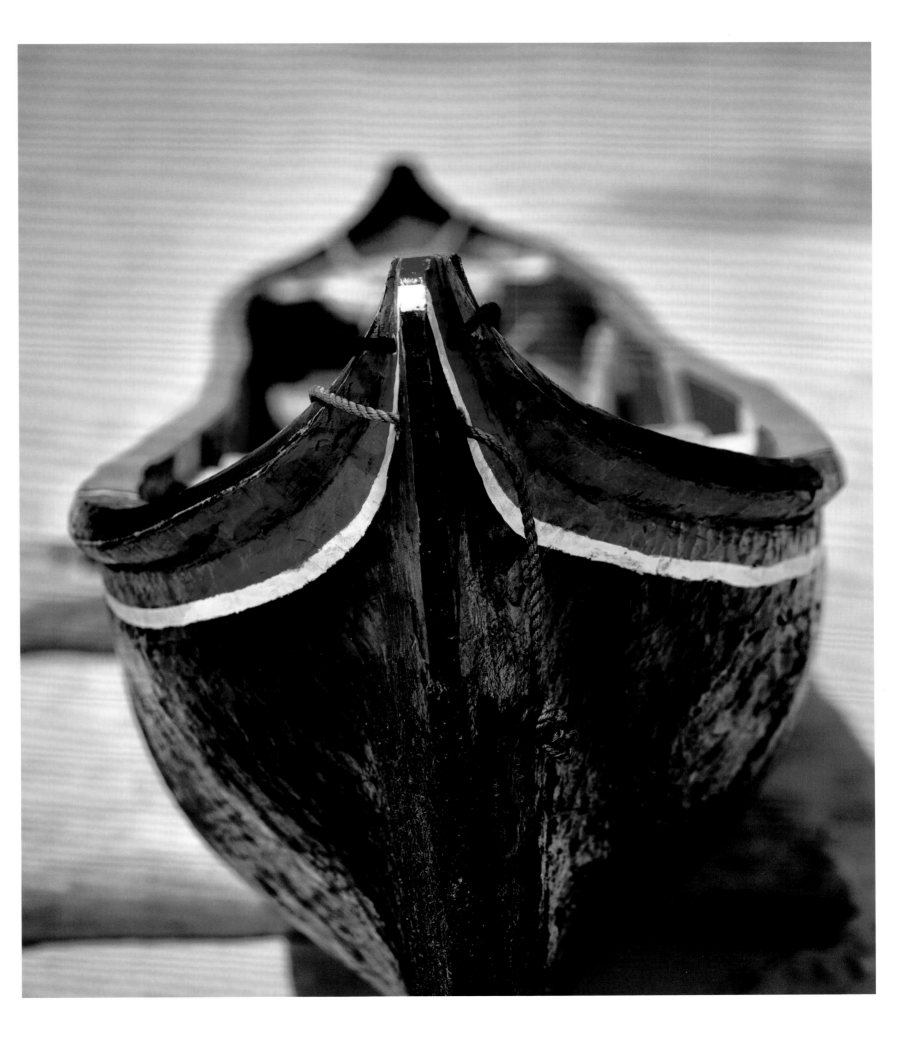

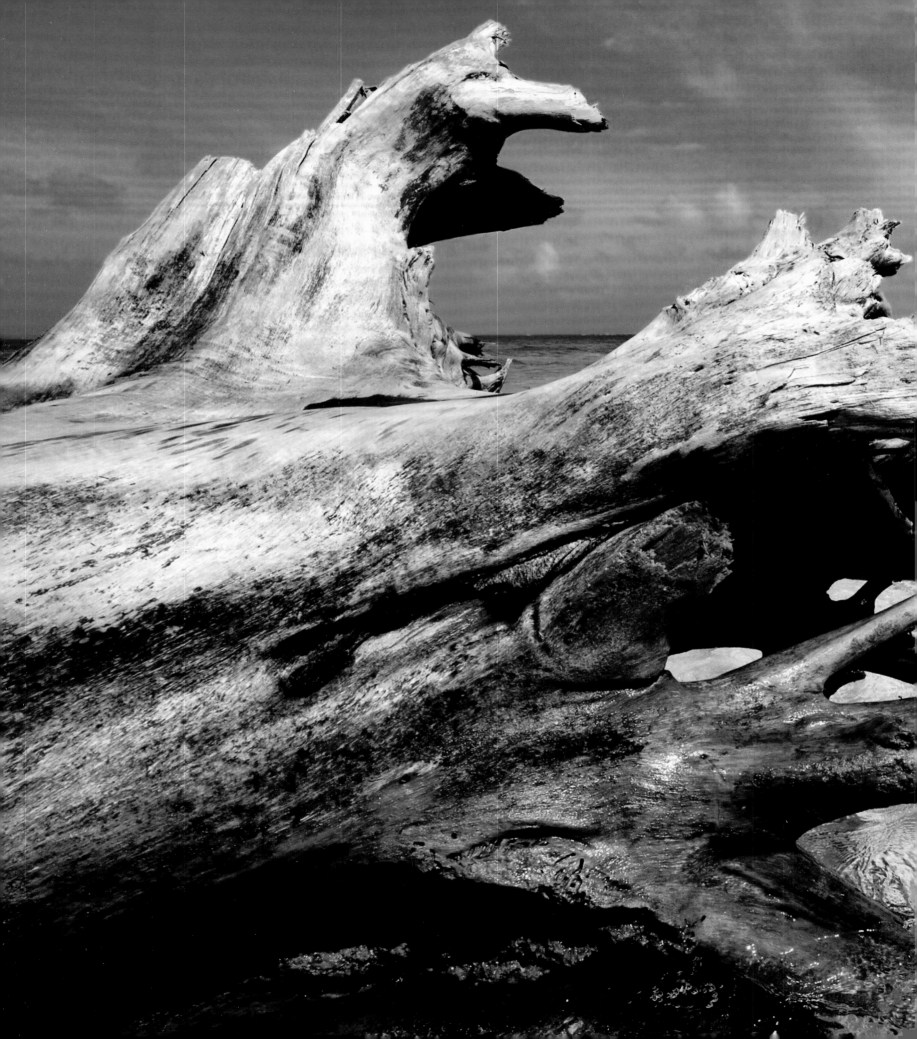

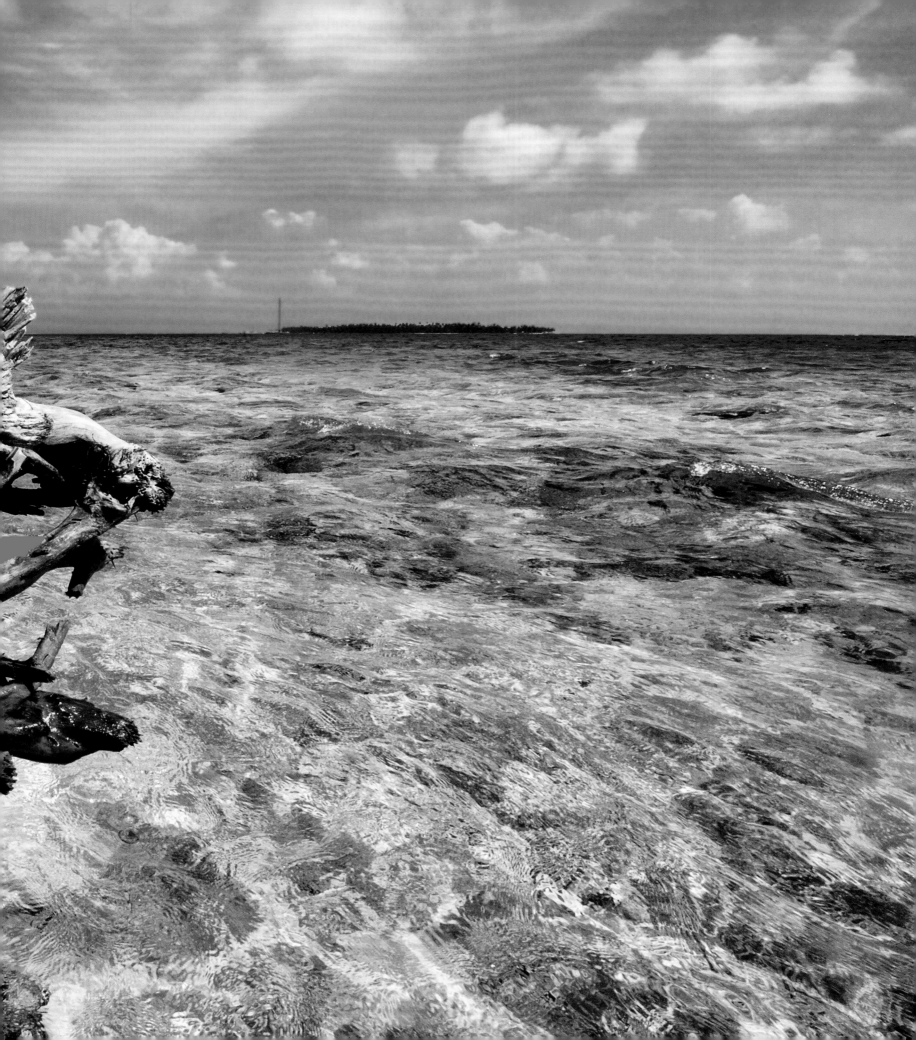

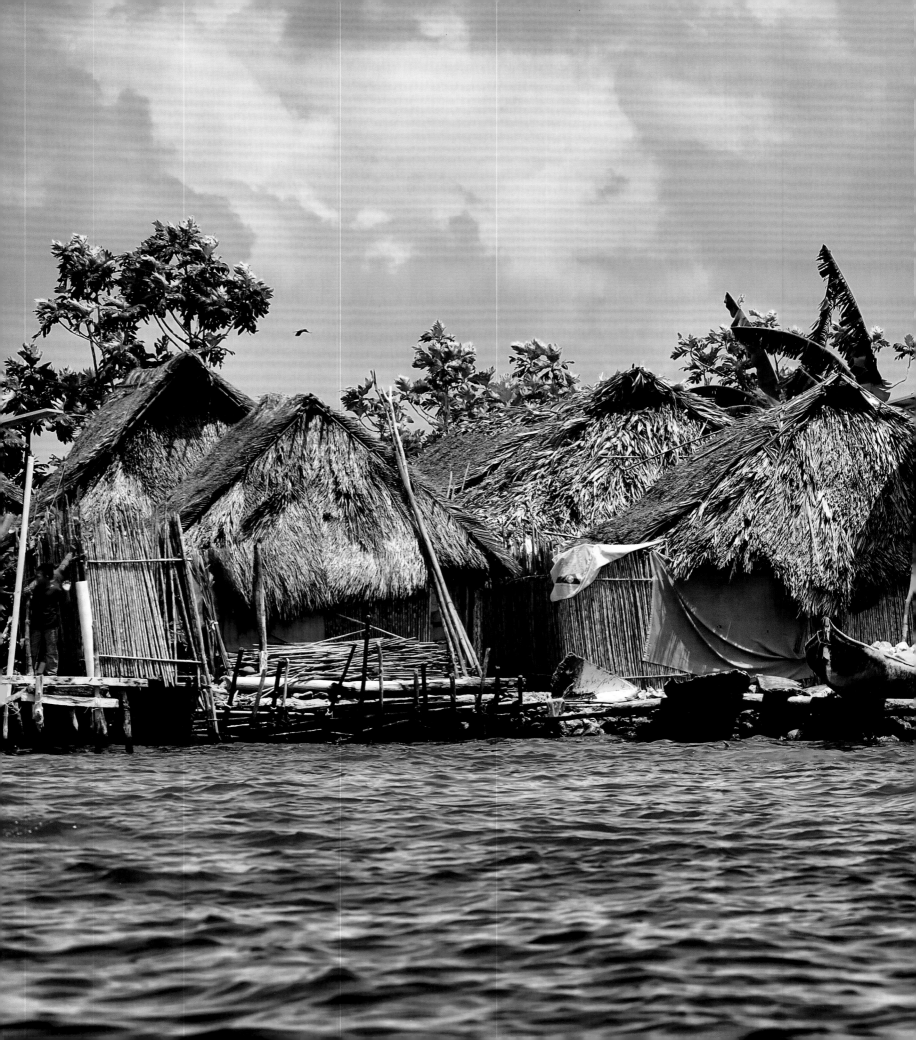

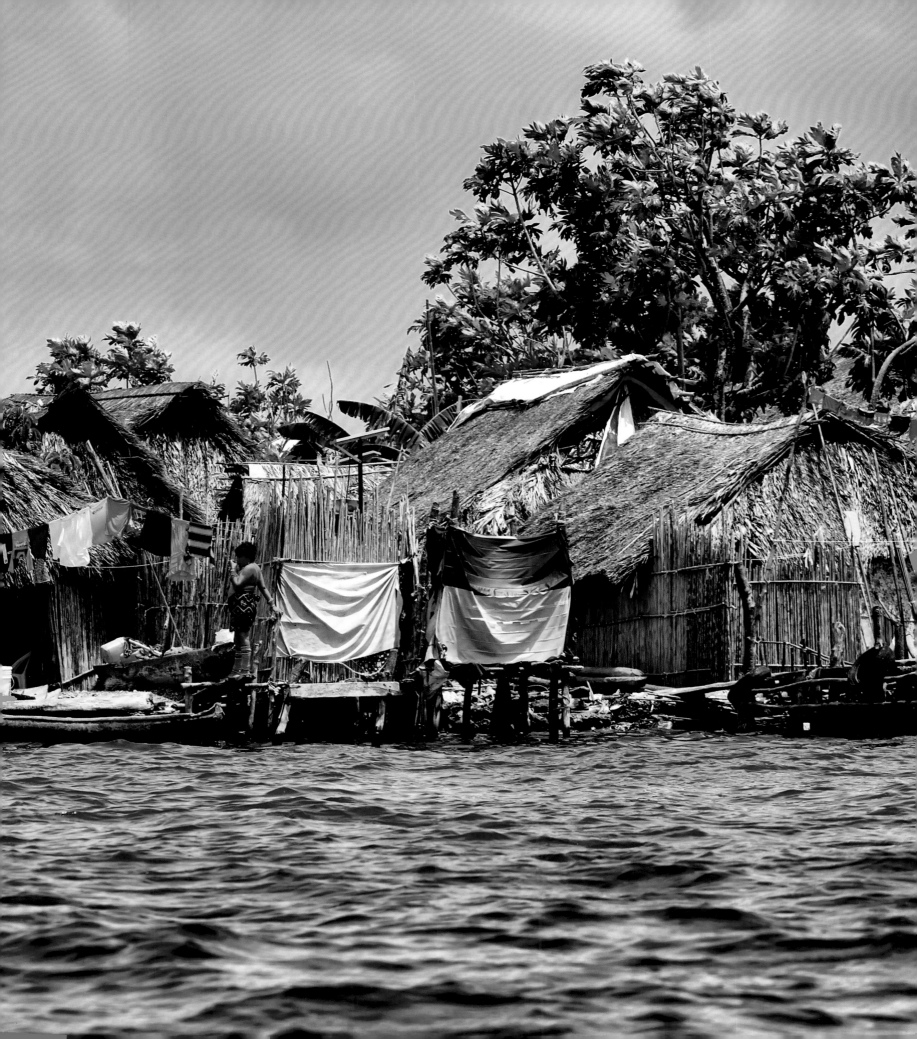

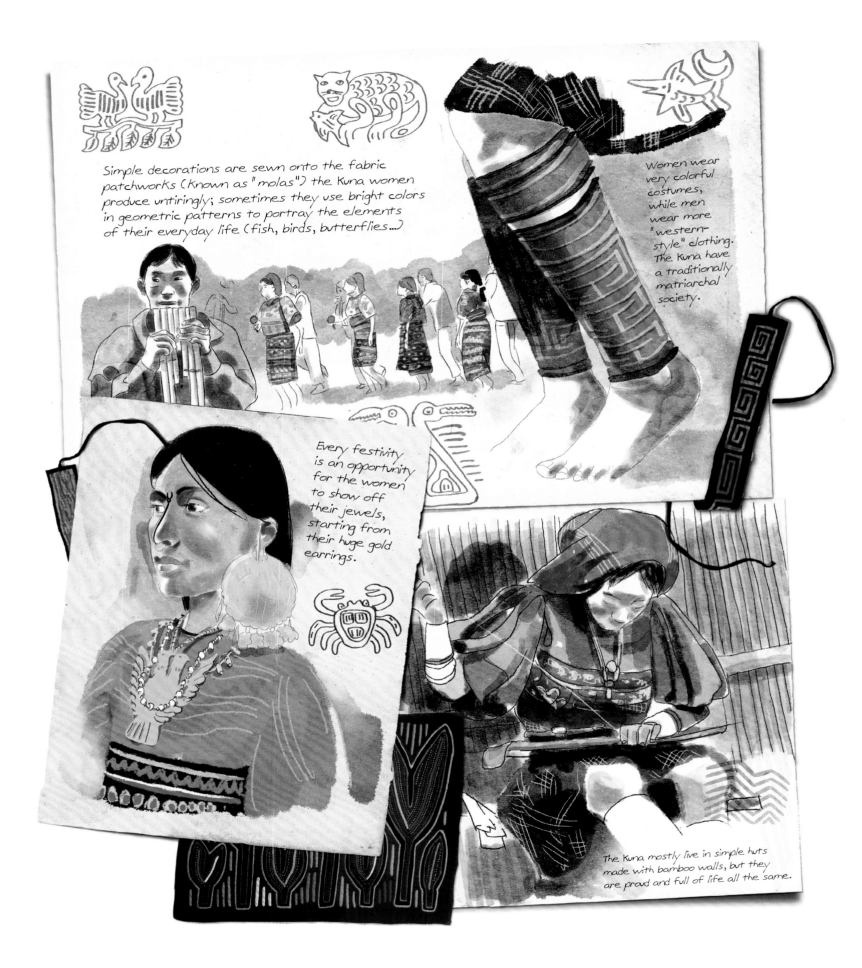

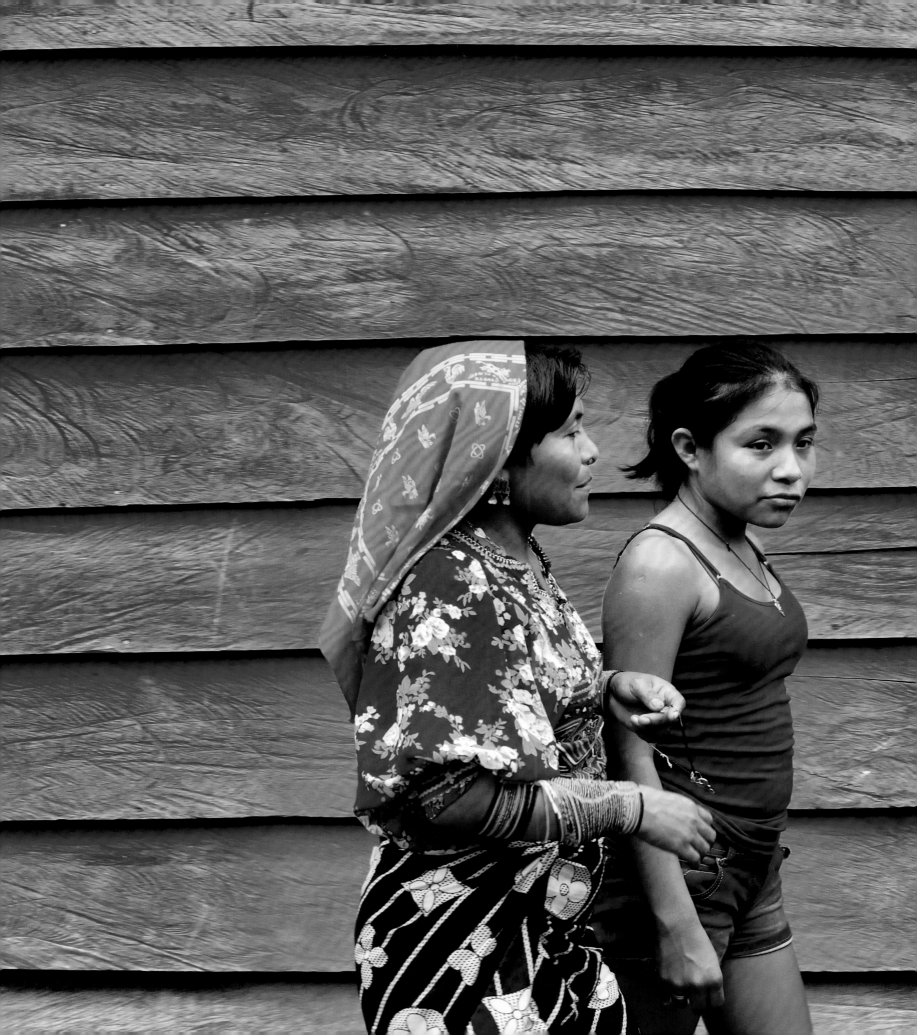

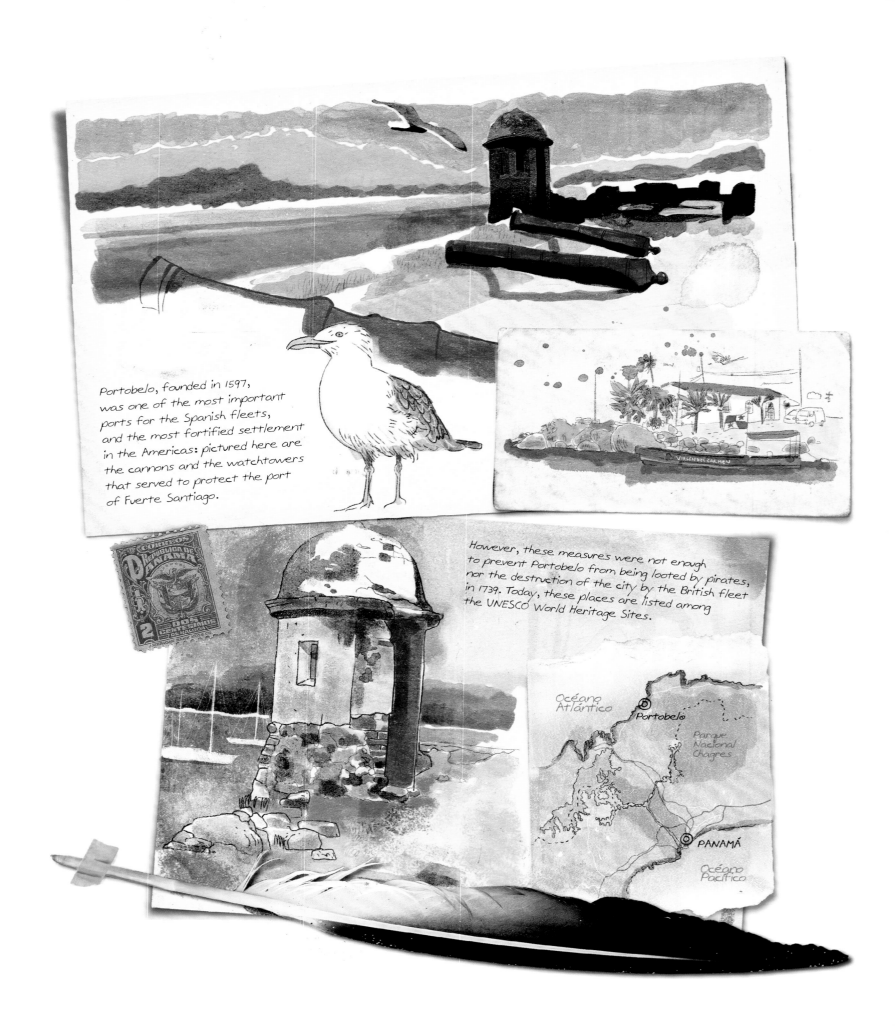

Portobelo, founded in 1597, was one of the most important ports for the Spanish fleets, and the most fortified settlement in the Americas: pictured here are the cannons and the watchtowers that served to protect the port of Fuerte Santiago.

However, these measures were not enough to prevent Portobelo from being looted by pirates, nor the destruction of the city by the British fleet in 1739. Today, these places are listed among the UNESCO World Heritage Sites.

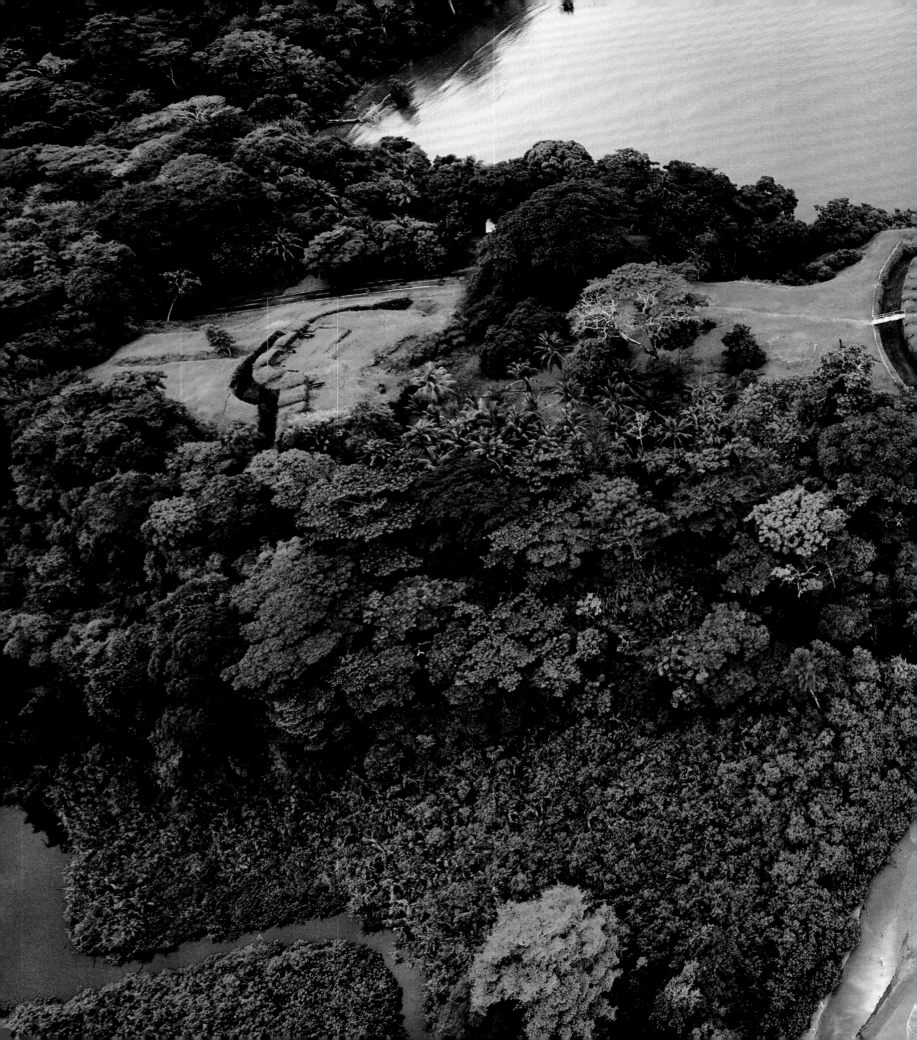

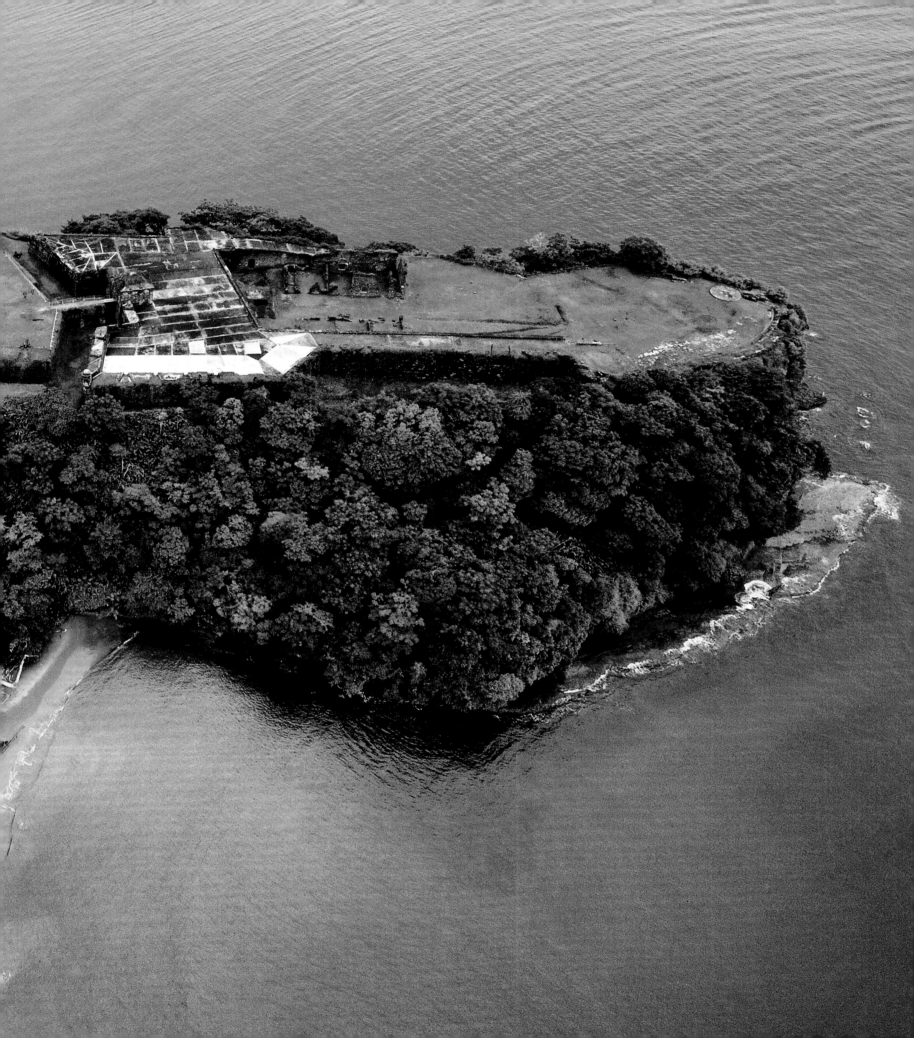

After visiting (and drawing) Fuerte Santiago, and before entering the Canal, we flew above the coast to discover another fort built by the Spanish: Fuerte de San Lorenzo which rises up on a promontory near Colon.
Although San Lorenzo was supposed to protect the Chagres River's mouth, where ships sailed out laden with treasures, it was taken over by Henry Morgan's pirates in 1670.
Morgan then set out to plunder the city of Panama on the other side of the country. This place is very peaceful, beautiful and immersed in nature. The walls and about forty cannons, which it is quite hard to believe at one time caused death and destruction, are all that is left of those cruel times.

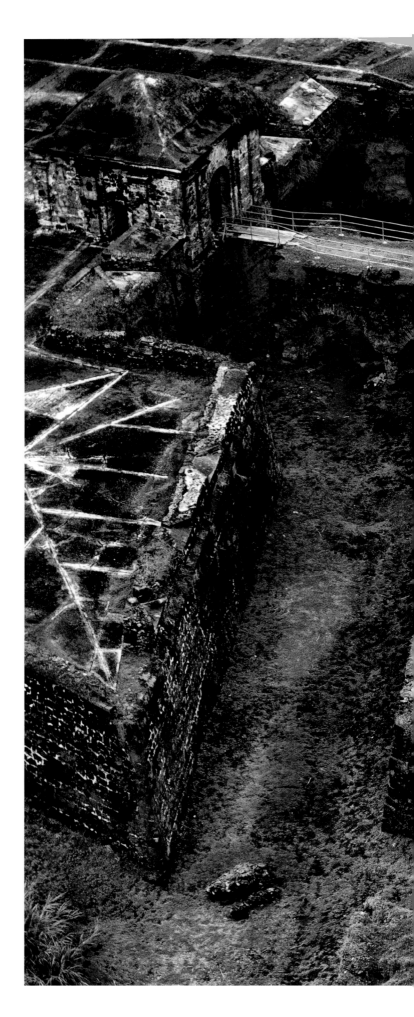

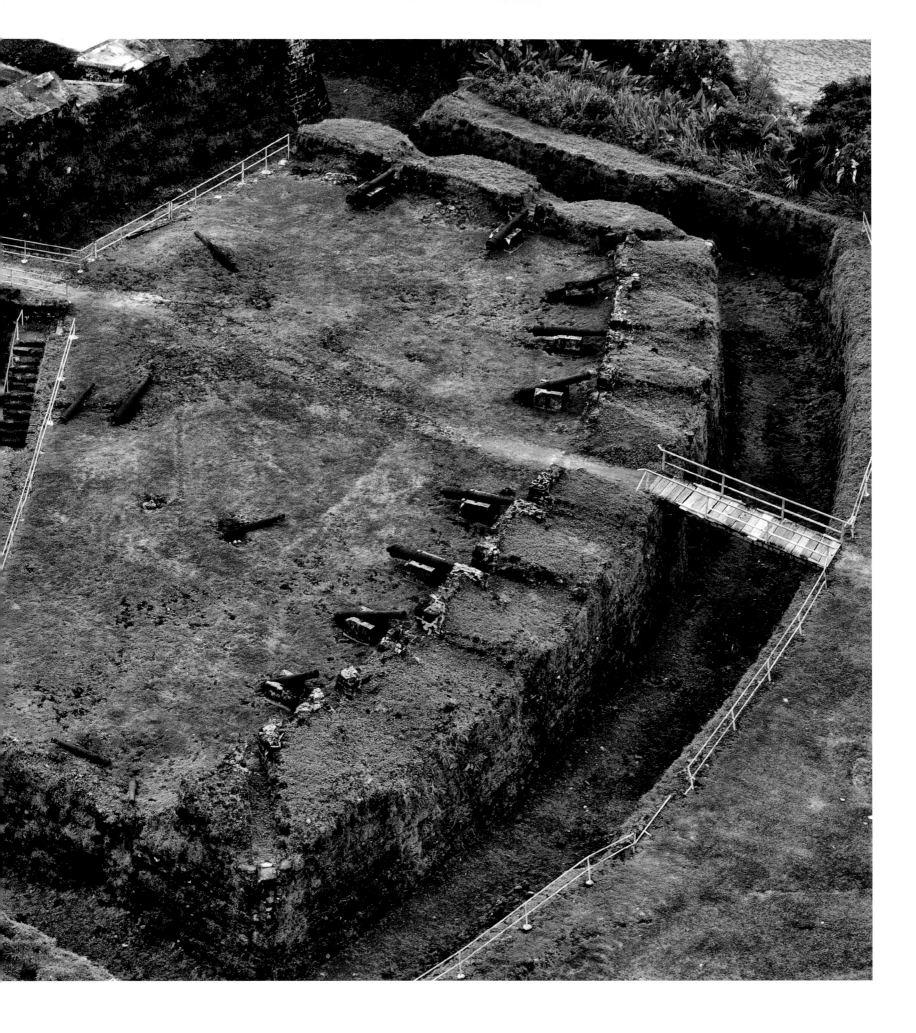

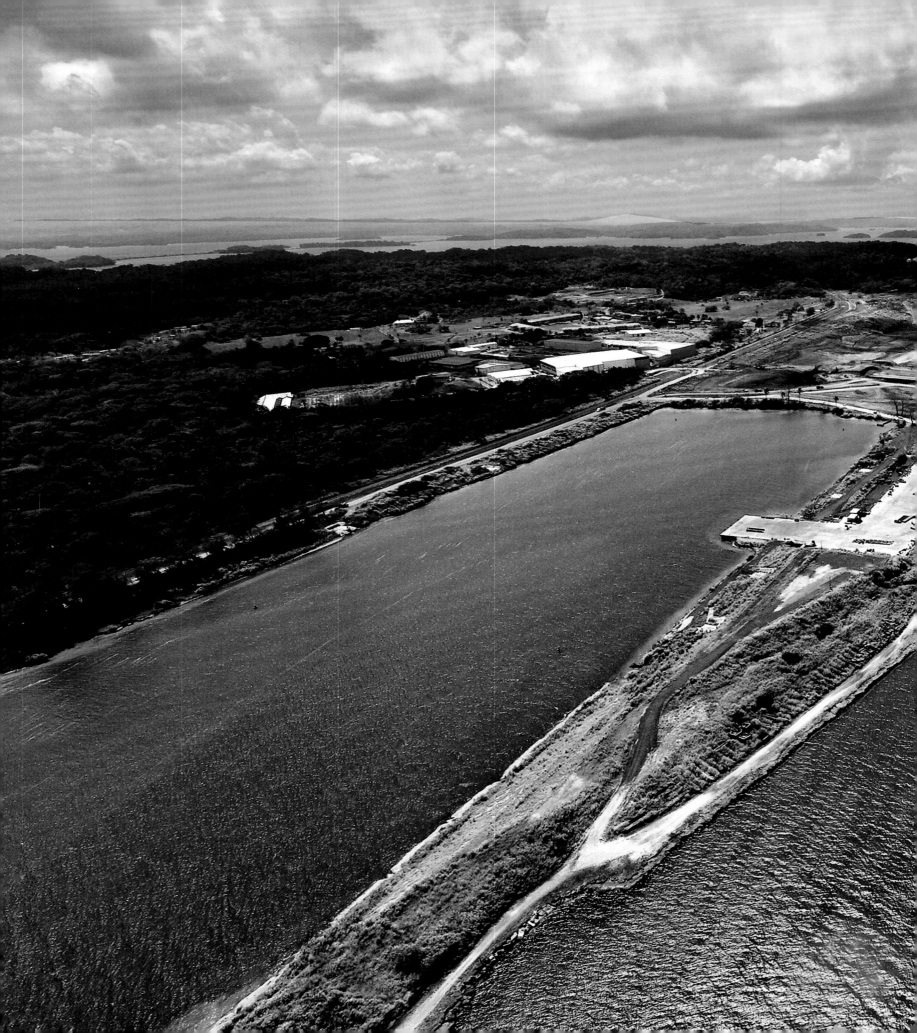

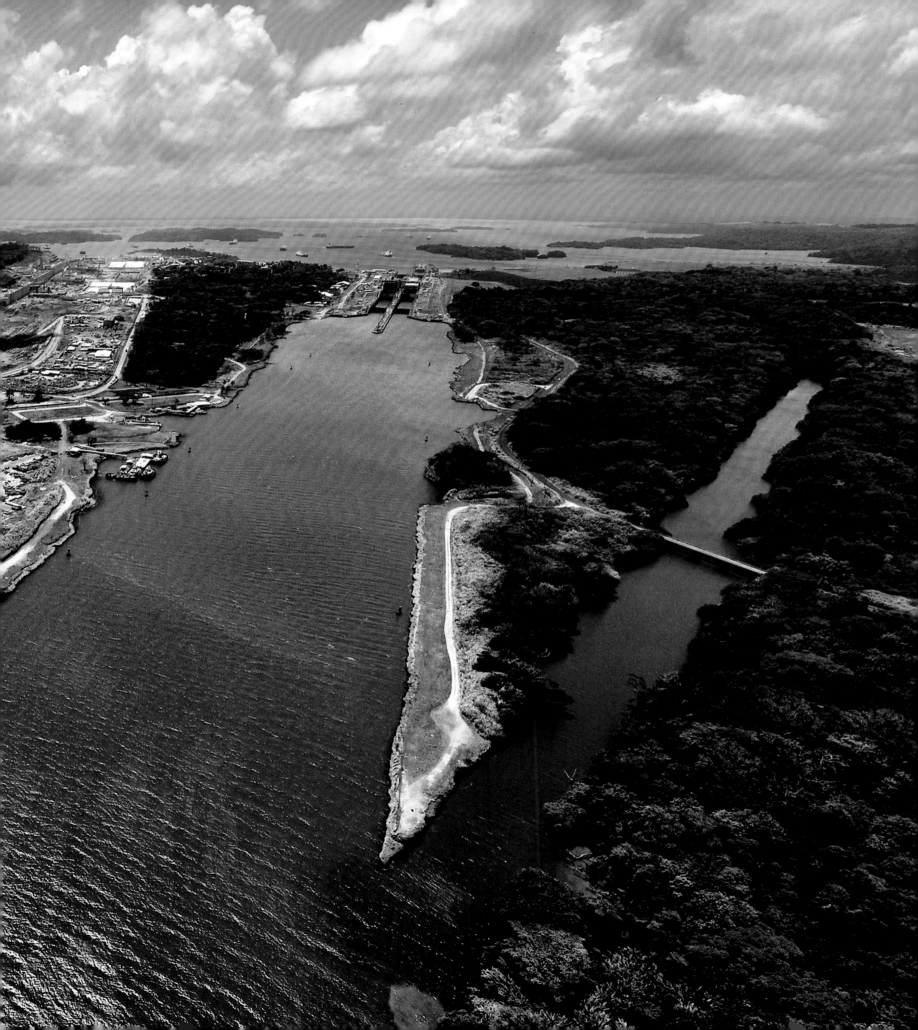

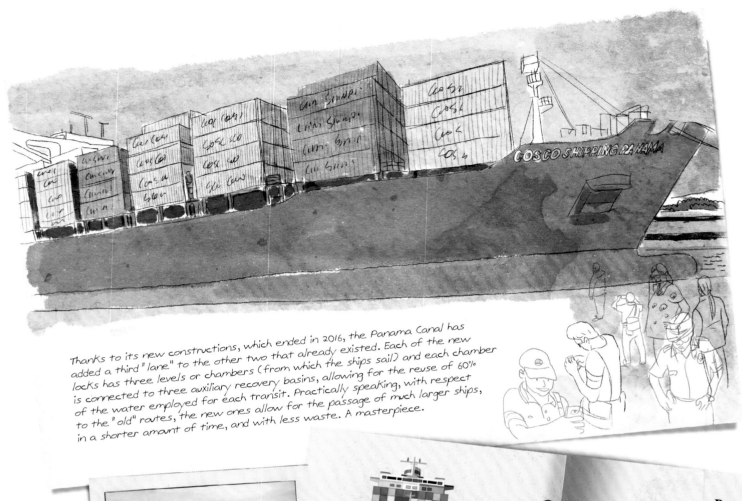

Thanks to its new constructions, which ended in 2016, the Panama Canal has added a third "lane" to the other two that already existed. Each of the new locks has three levels or chambers (from which the ships sail) and each chamber is connected to three auxiliary recovery basins, allowing for the reuse of 60% of the water employed for each transit. Practically speaking, with respect to the "old" routes, the new ones allow for the passage of much larger ships, in a shorter amount of time, and with less waste. A masterpiece.

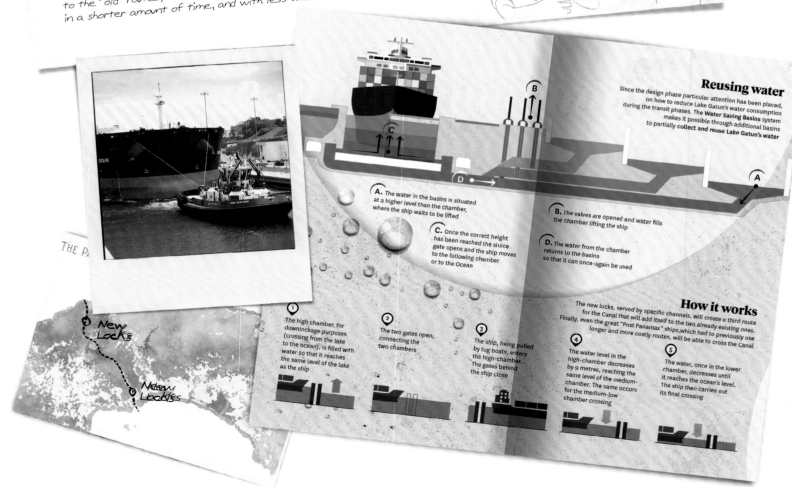

Reusing water

Since the design phase particular attention has been placed, on how to reduce Lake Gatun's water consumption during the transit phases. The **Water Saving Basins** system makes it possible through additional basins to partially collect and reuse Lake Gatun's water

A. The water in the basins is situated at a higher level than the chamber, where the ship waits to be lifted

B. The valves are opened and water fills the chamber lifting the ship

C. Once the correct height has been reached the sluice gate opens and the ship moves to the following chamber or to the Ocean

D. The water from the chamber returns to the basins so that it can once-again be used

How it works

The new locks, served by specific channels, will create e third route for the Canal that will add itself to the two already existing ones. Finally, even the great "Post Panamax" ships, which had to previously use longer and more costly routes, will be able to cross the Canal

1. The high chamber, for downlockage purposes (crossing from the lake to the ocean), is filled with water so that it reaches the same level of the lake as the ship

2. The two gates open, connecting the two chambers

3. The ship, being pulled by tug boats, enters the high-chamber. The gates behind the ship close

4. The water level in the high-chamber decreases by 9 metres, reaching the same level of the medium-chamber. The same occurs for the medium-low chamber crossing

5. The water, once in the lower chamber, decreases until it reaches the ocean's level. The ship then carries out its final crossing

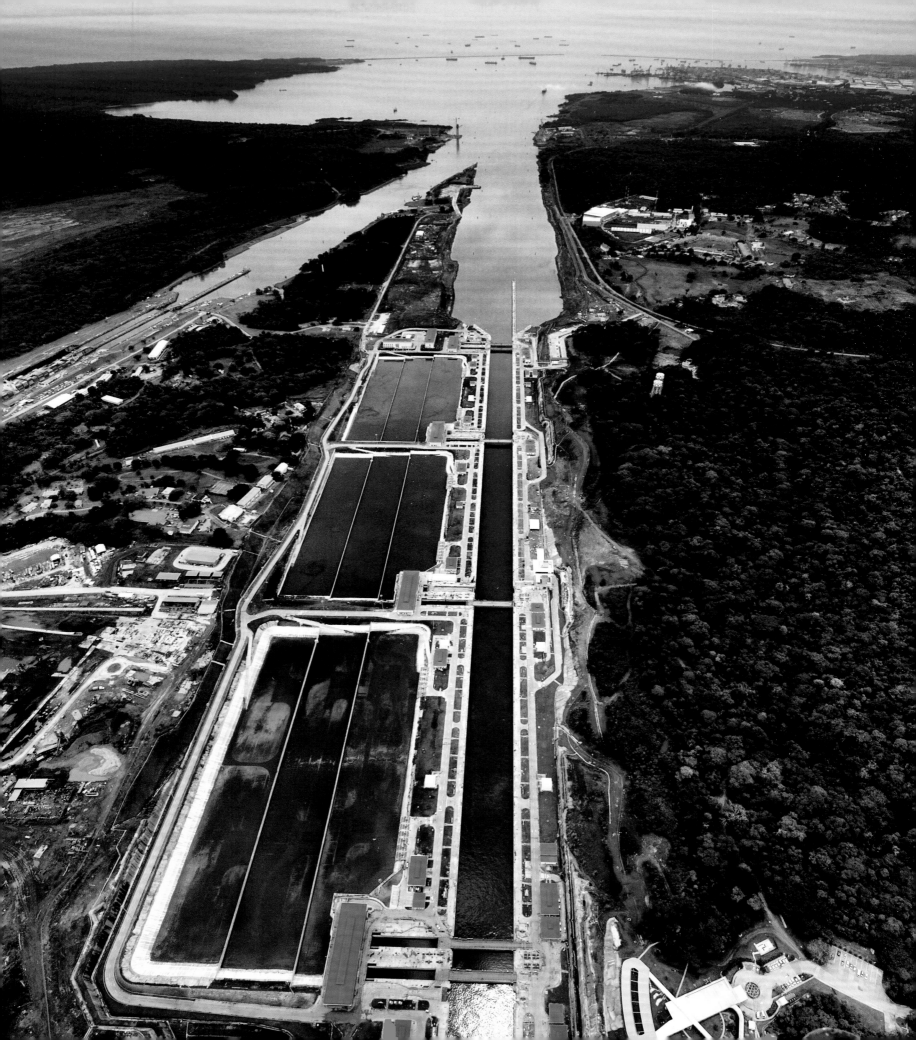

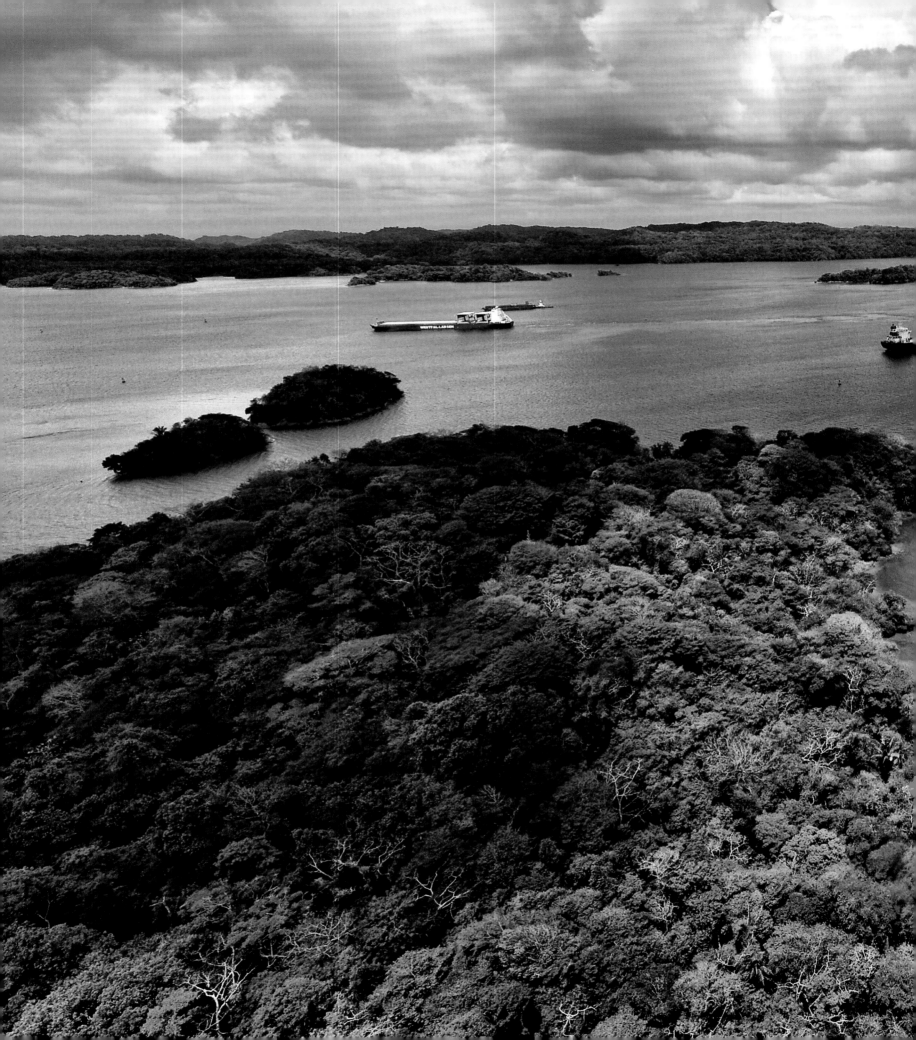

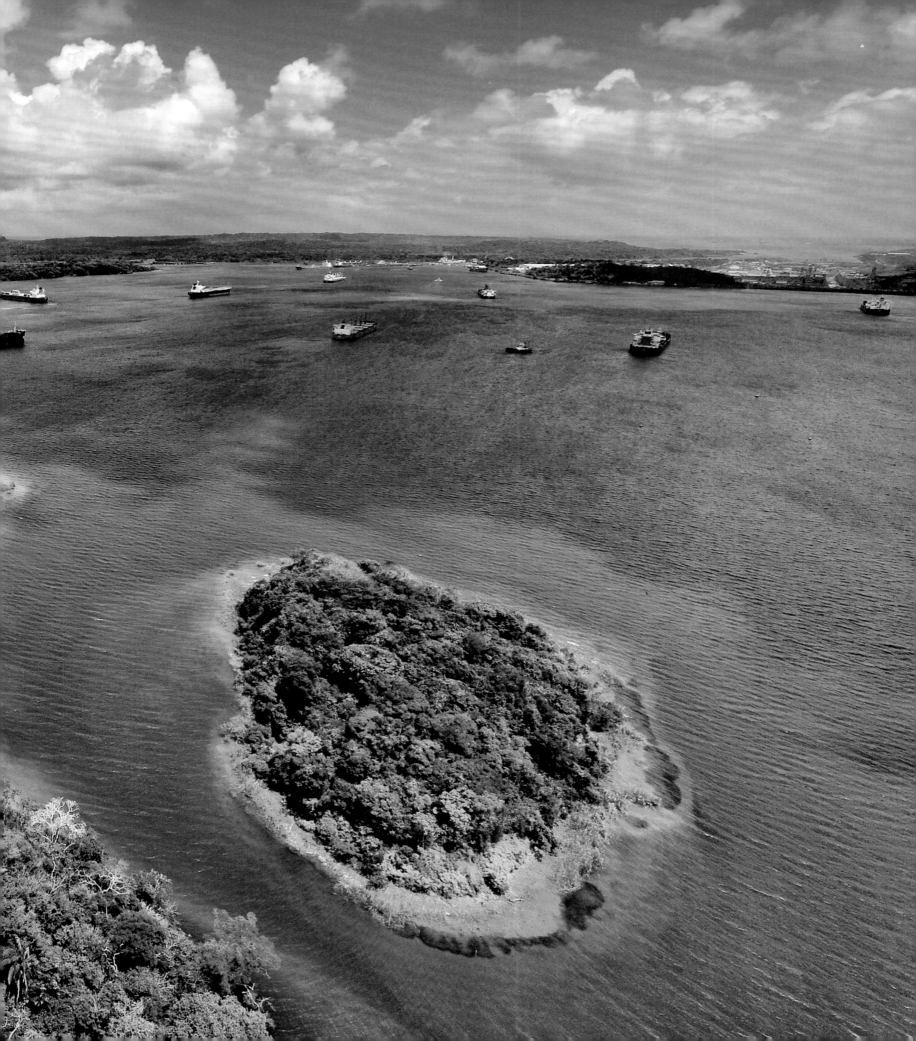

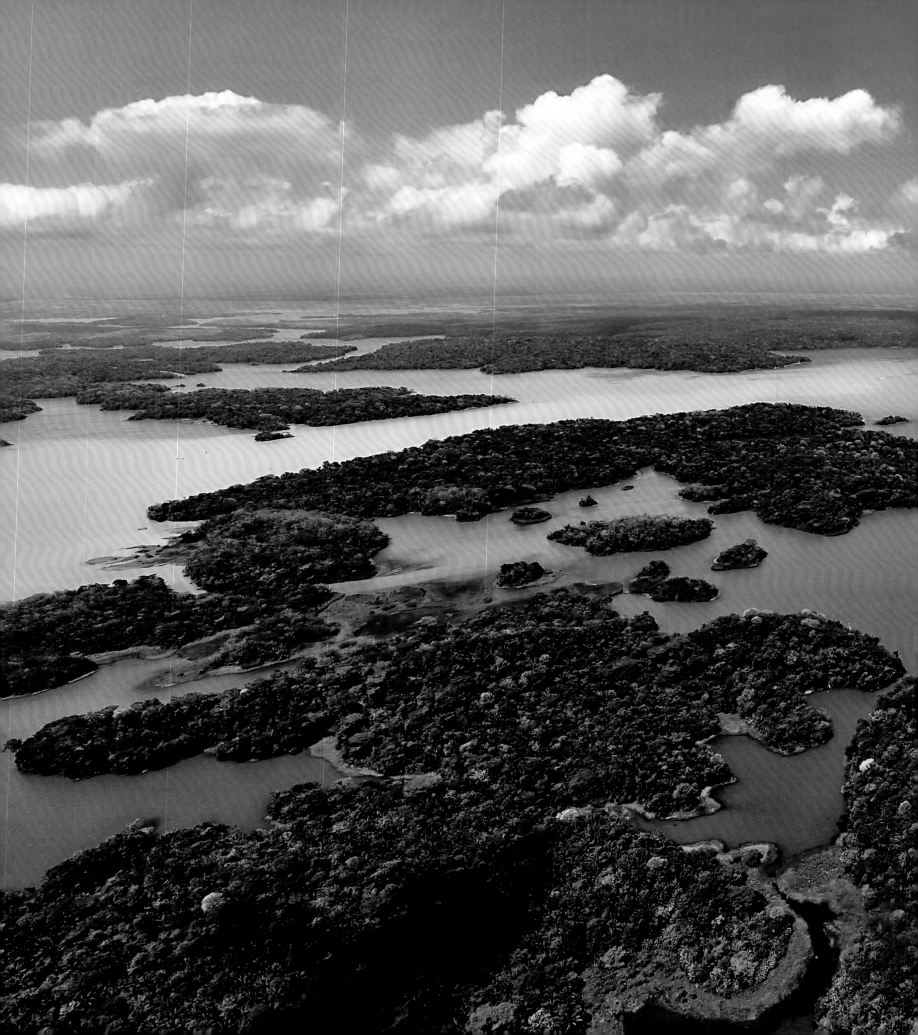

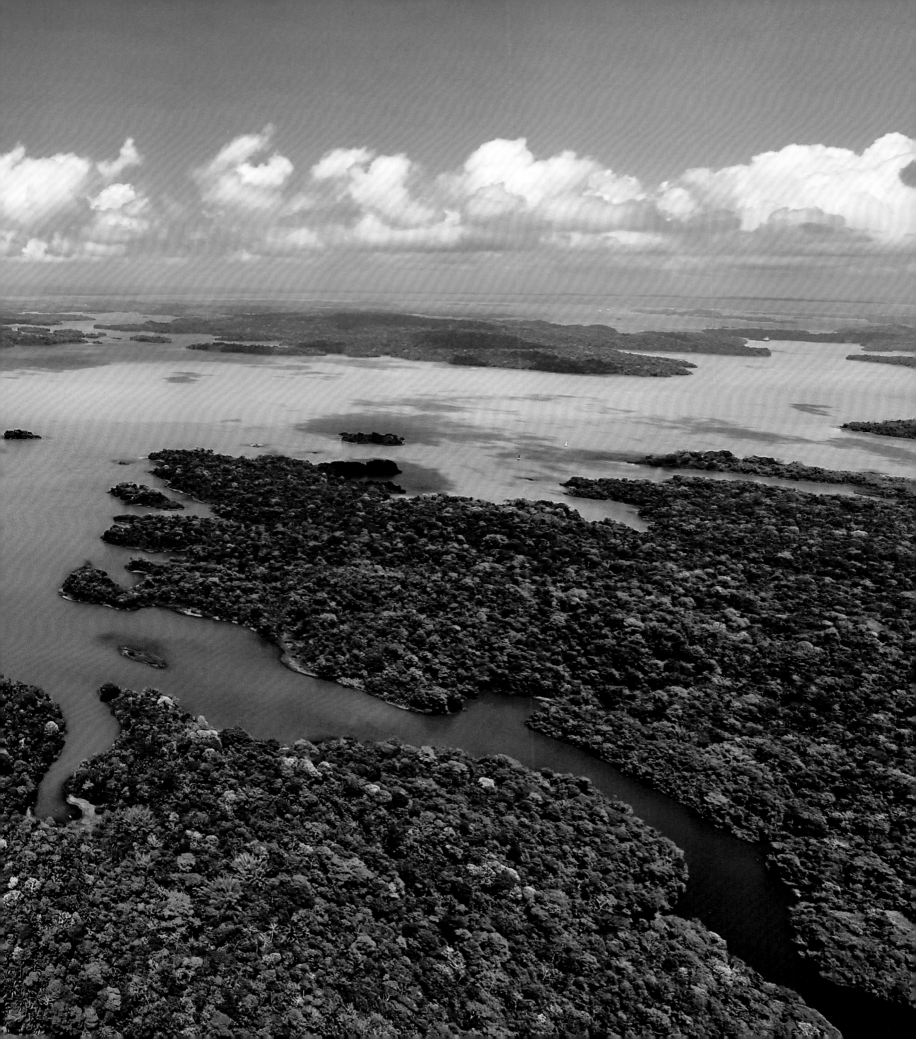

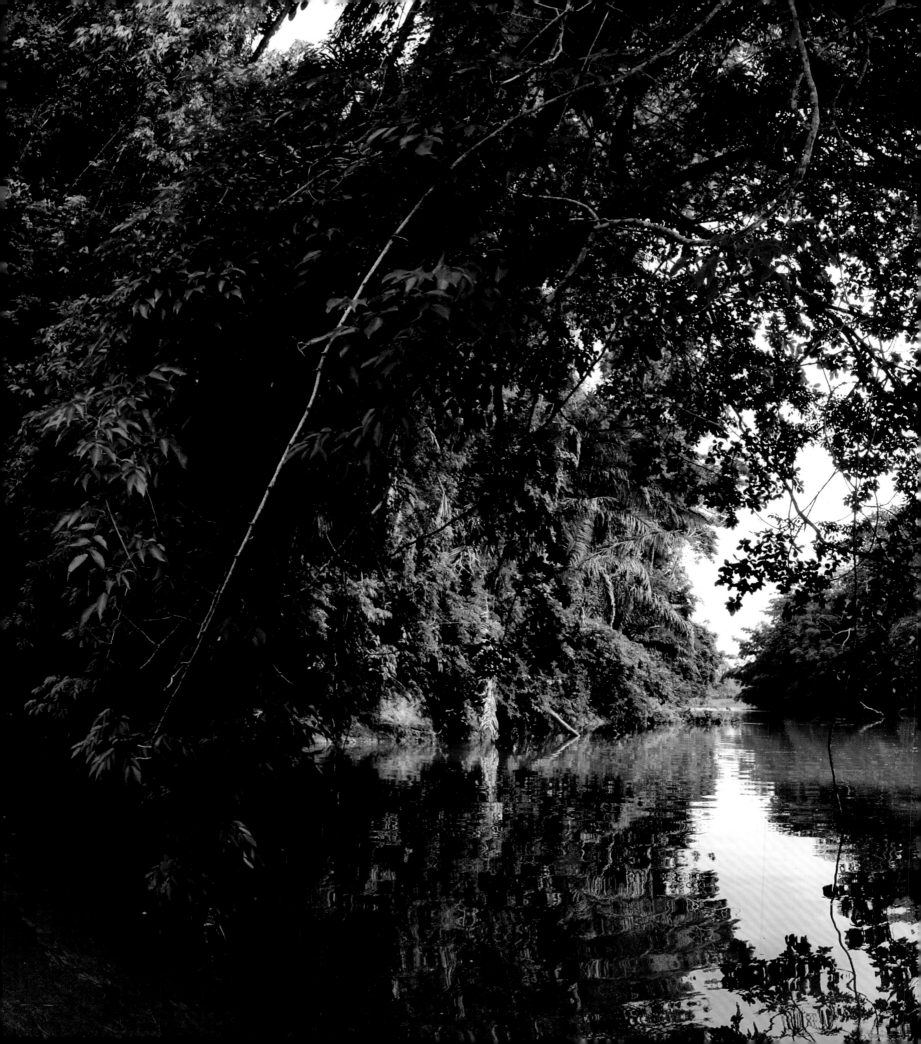

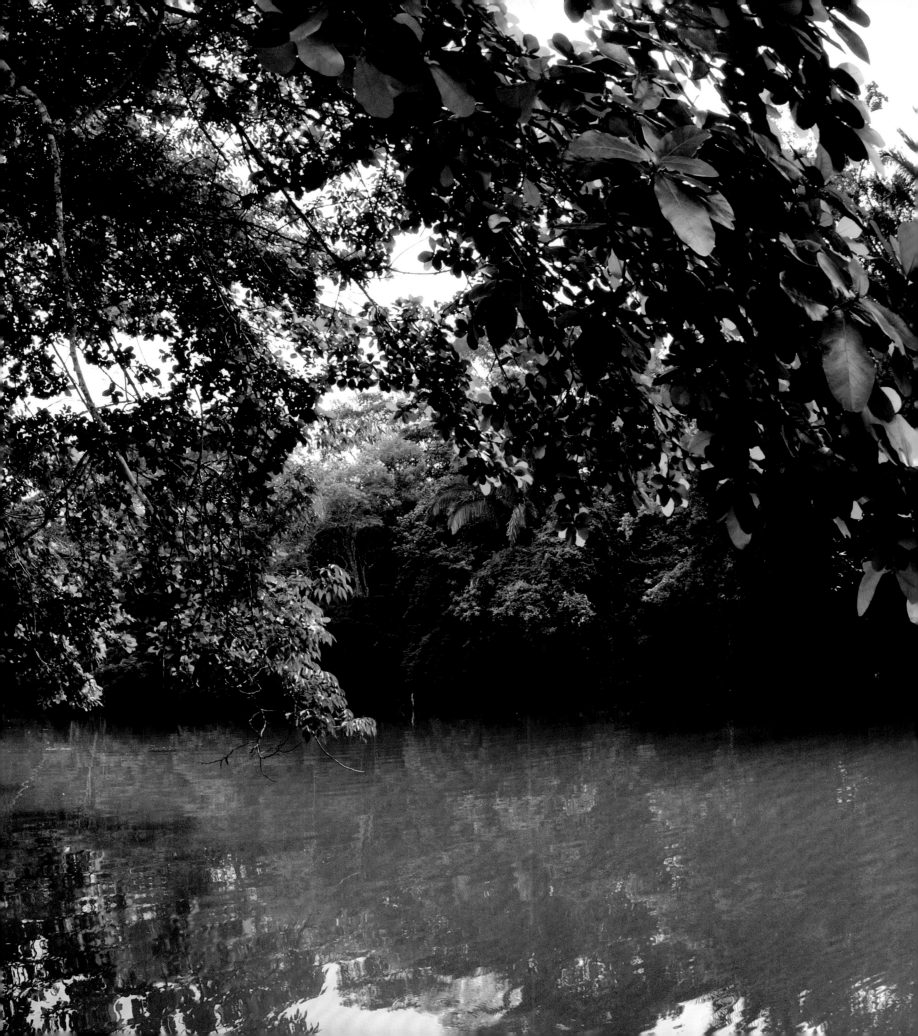

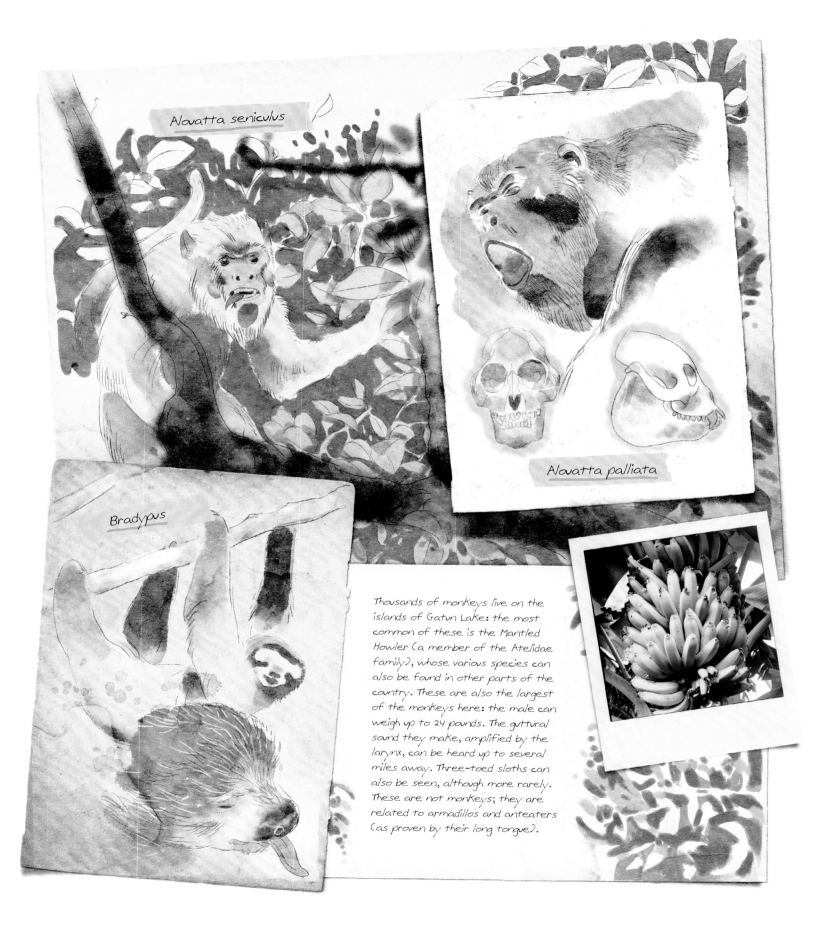

Alouatta seniculus

Alouatta palliata

Bradypus

Thousands of monkeys live on the islands of Gatun Lake: the most common of these is the Mantled Howler (a member of the Atelidae family), whose various species can also be found in other parts of the country. These are also the largest of the monkeys here: the male can weigh up to 24 pounds. The guttural sound they make, amplified by the larynx, can be heard up to several miles away. Three-toed sloths can also be seen, although more rarely. These are not monkeys; they are related to armadillos and anteaters (as proven by their long tongue).

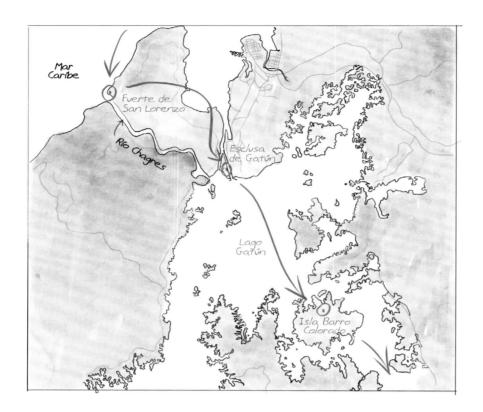

From the day it was formed, three million years ago, Panama has represented a biological bridge between North and South America. The result of this is a place that is unique in the world, with a concentration of living species that rivals that of the Amazon Rainforest.
Or the Garden of Eden. Eleven thousand plants, a thousand different bird species, hundreds of mammals, not to mention all the species that fill the two oceans: here, biodiversity is an institution. And the building of the Canal has made this corner of the planet even more unique: in the man-made lake that was created by the dam, the Gatun, the hills turn into islands on which hundreds of animal species find shelter and are thus concentrated. This has led to the rise of some absolute tropical shrines in the heart of the lake, like Barro Colorado, a miniature continent where we came across just about everything: monkeys everywhere, of course (like the very common "capuchin" shown to the side), birds, iguanas, crocodiles, insects...

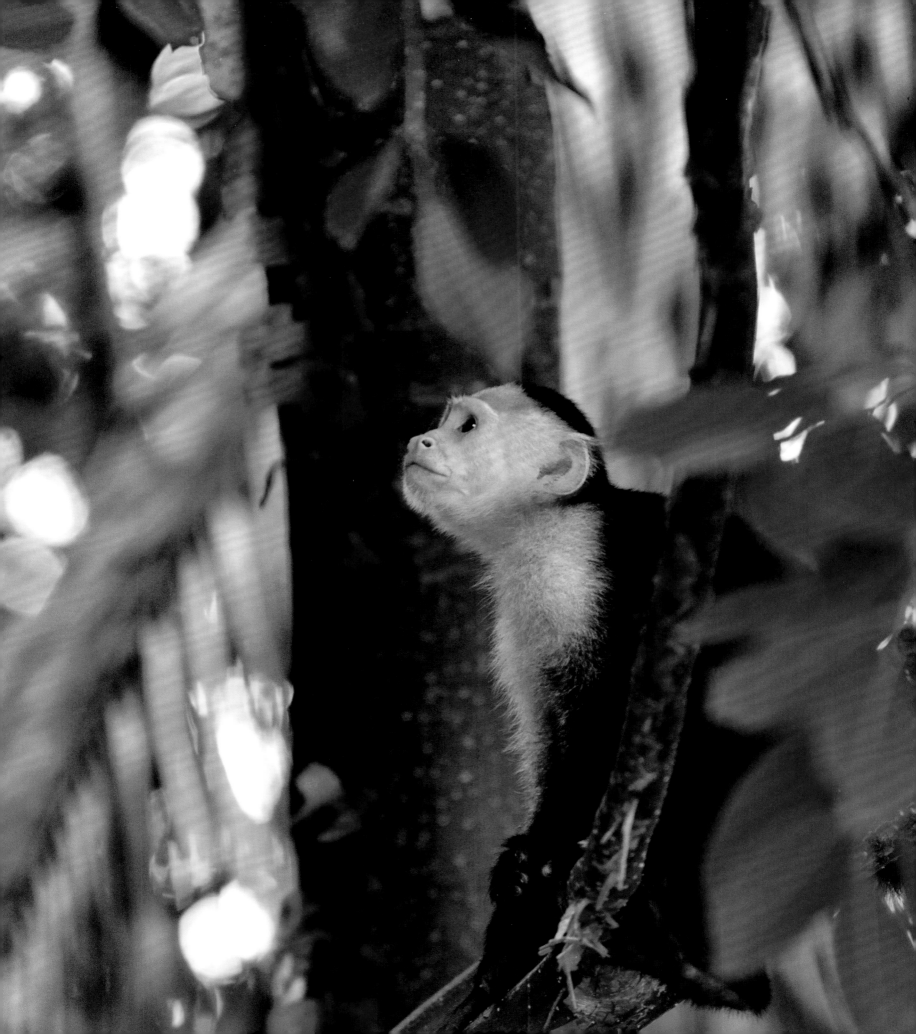

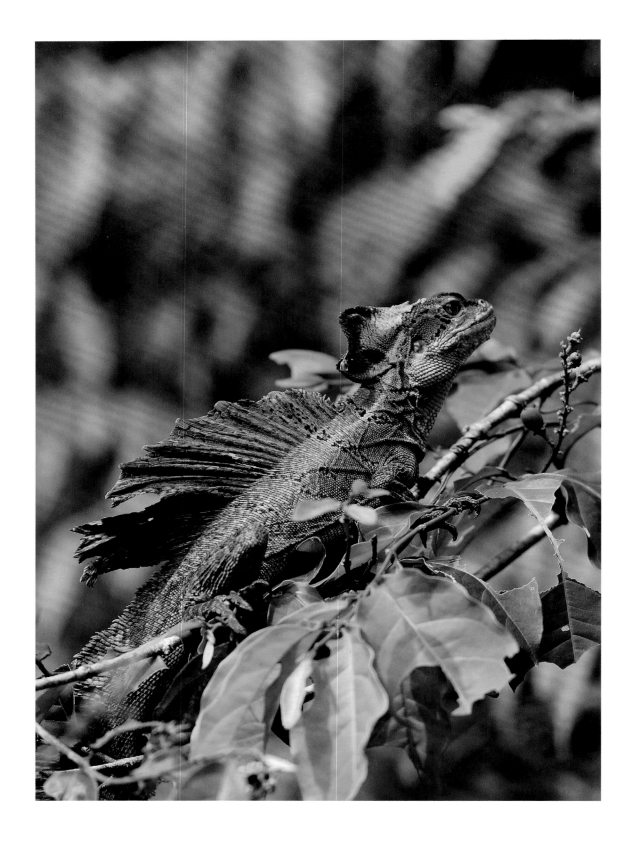

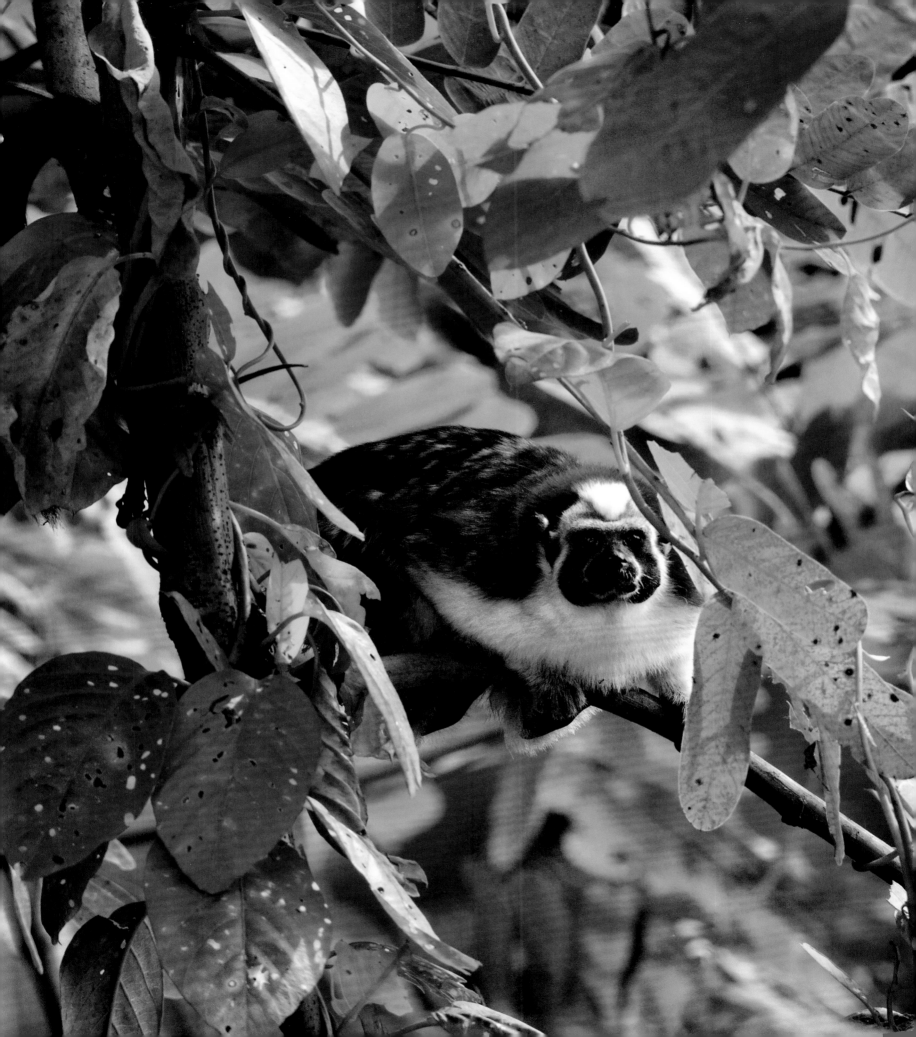

Among the approximately 1600 species of butterflies that populate this paradise called Panama, the Blue Morpho (Morpho peleides) is perhaps the most beautiful of all. When it spreads its wings (spanning up to 6 inches) its color brightens up the forest. It loves humid environments and mostly feeds on rotting fruit, sucking it through a long, protruding mouthpart (proboscis). Its larvae feed on leaves or... other larvae (yes indeed, these butterflies are cannibals).

"Labios" bloom all year round. With their bright colors, alluring flowers and fruit, they attract insects and birds, guaranteeing their reproduction.

Labios Ardientes, hot lips. The popular name of the Psychotria poeppigiana needs no explanation: someone might really think they're standing in front of the lips of Marilyn (or Mick Jagger, depending on whose you prefer). This shrub is a common species in the undergrowth.

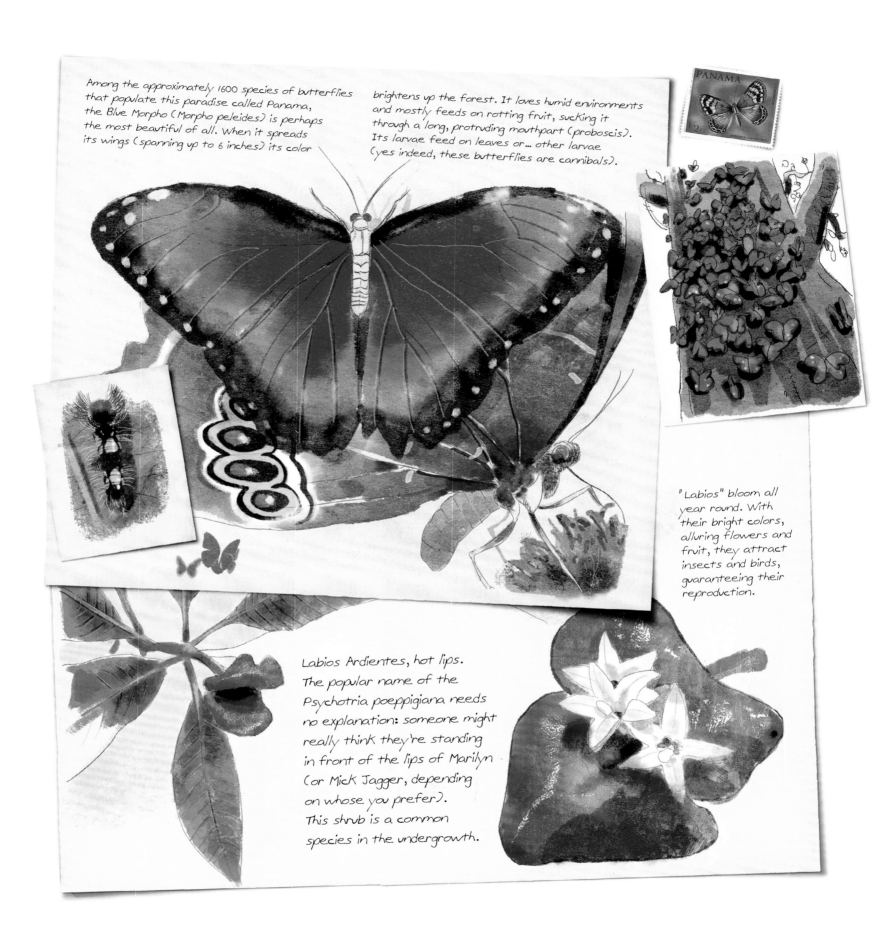

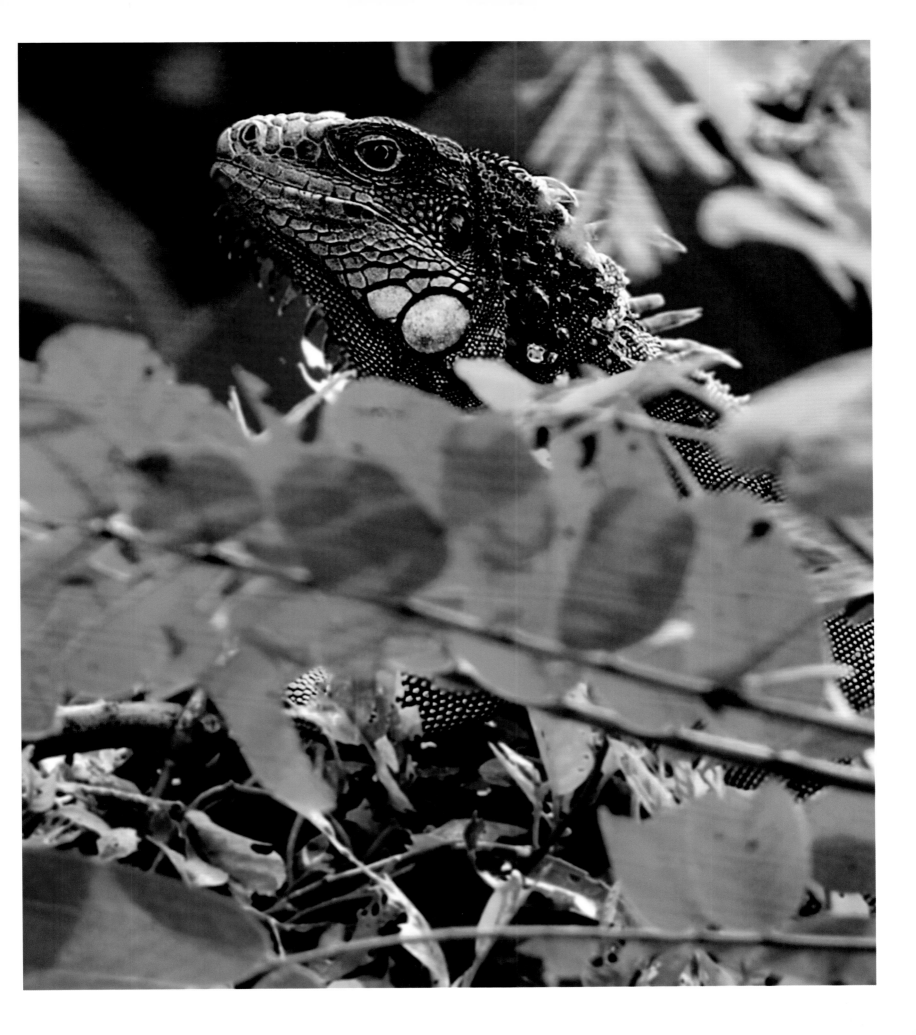

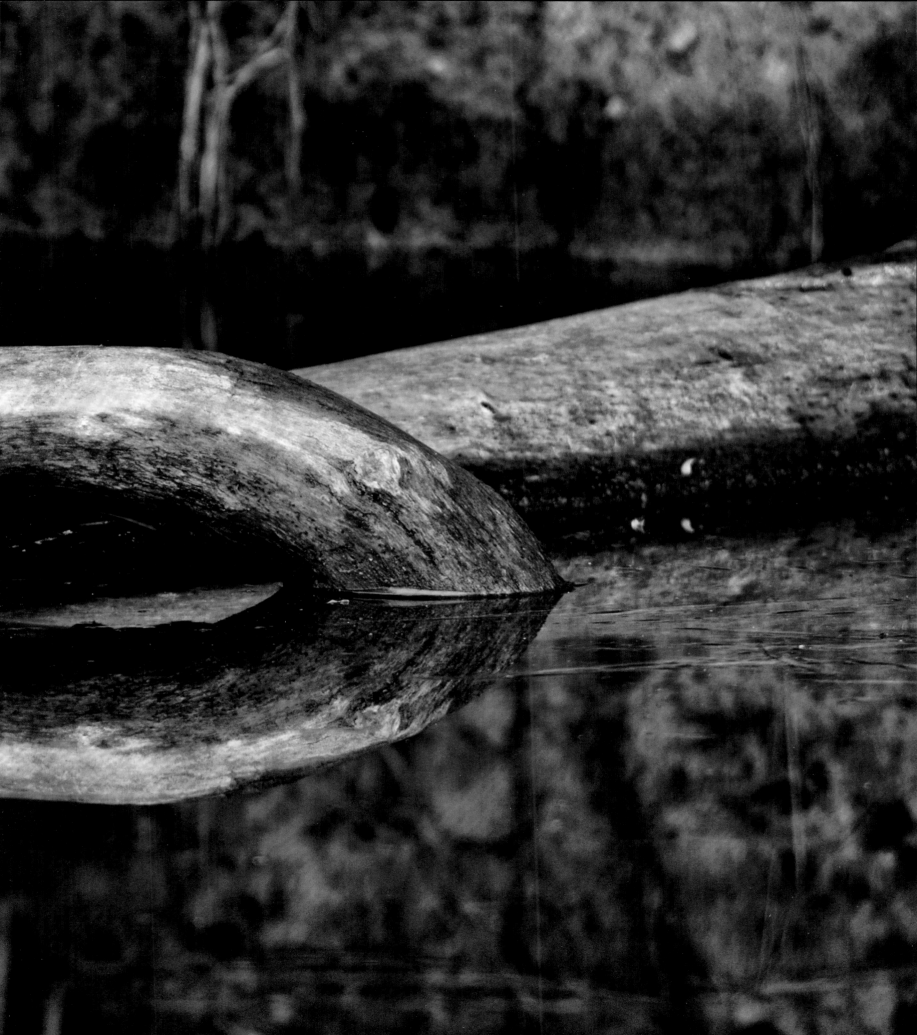

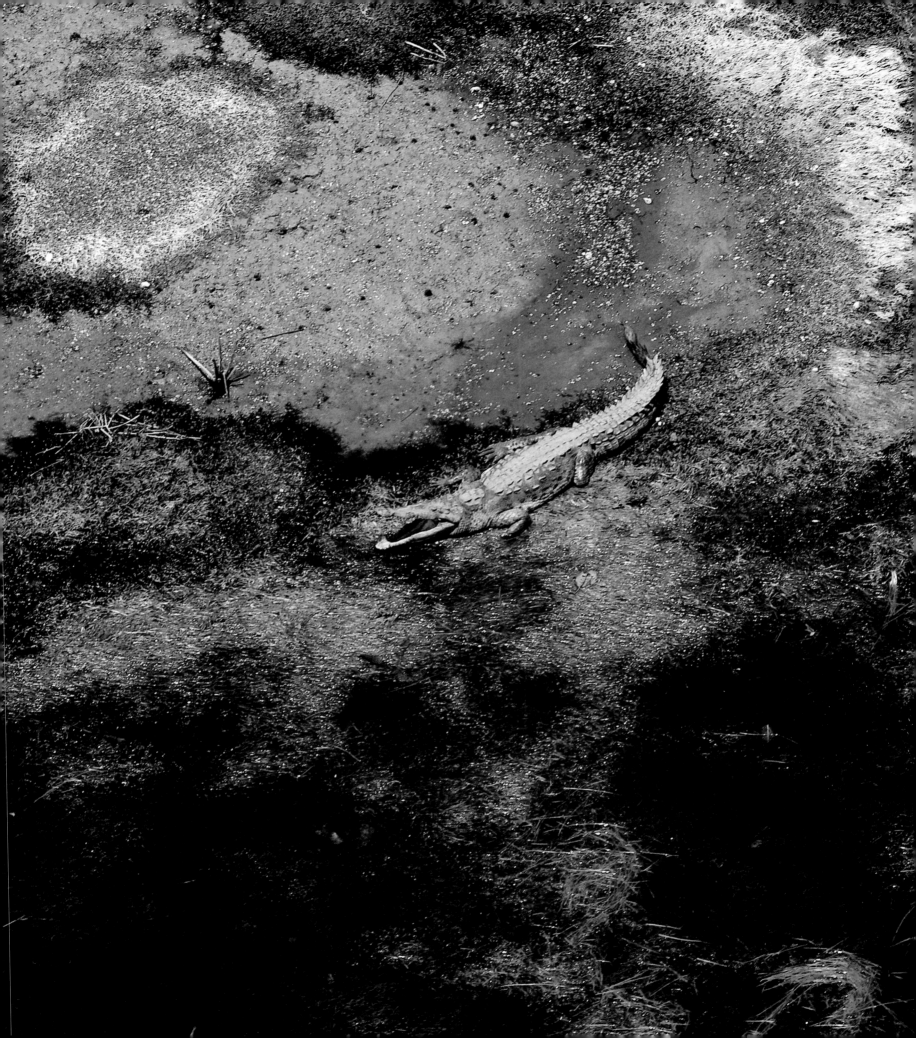

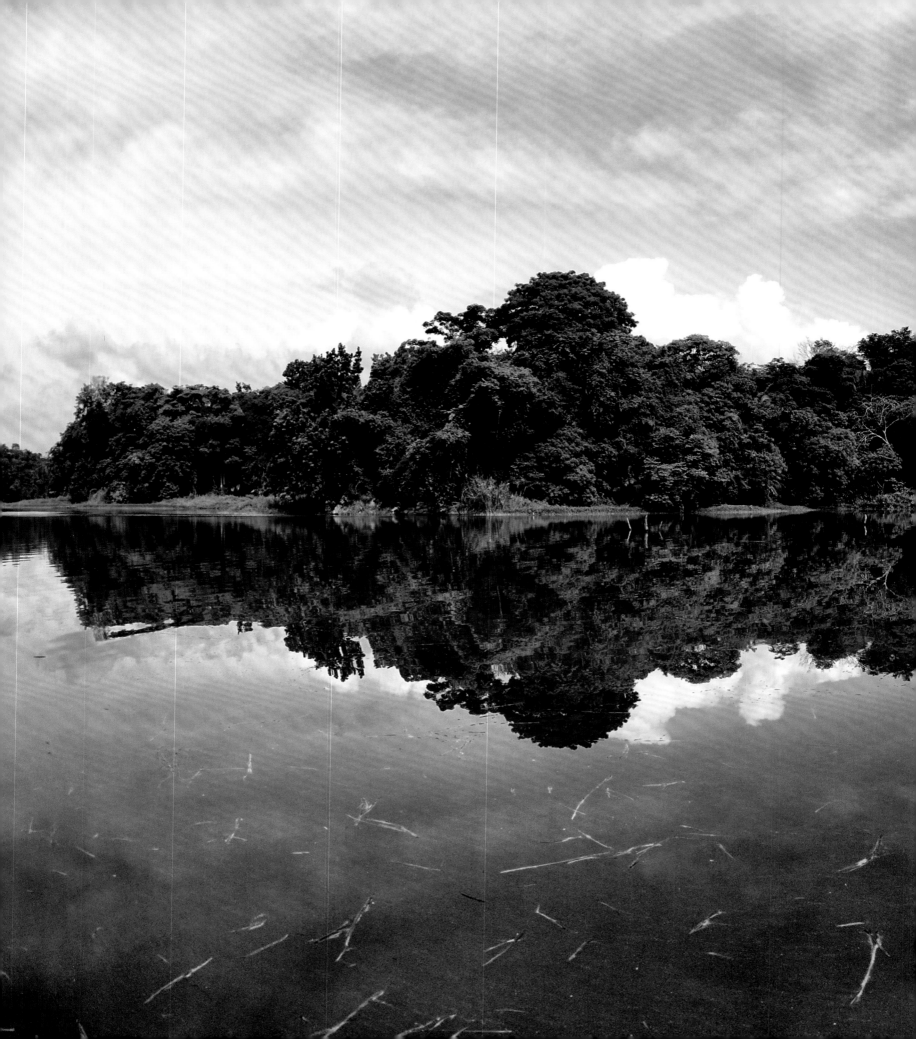

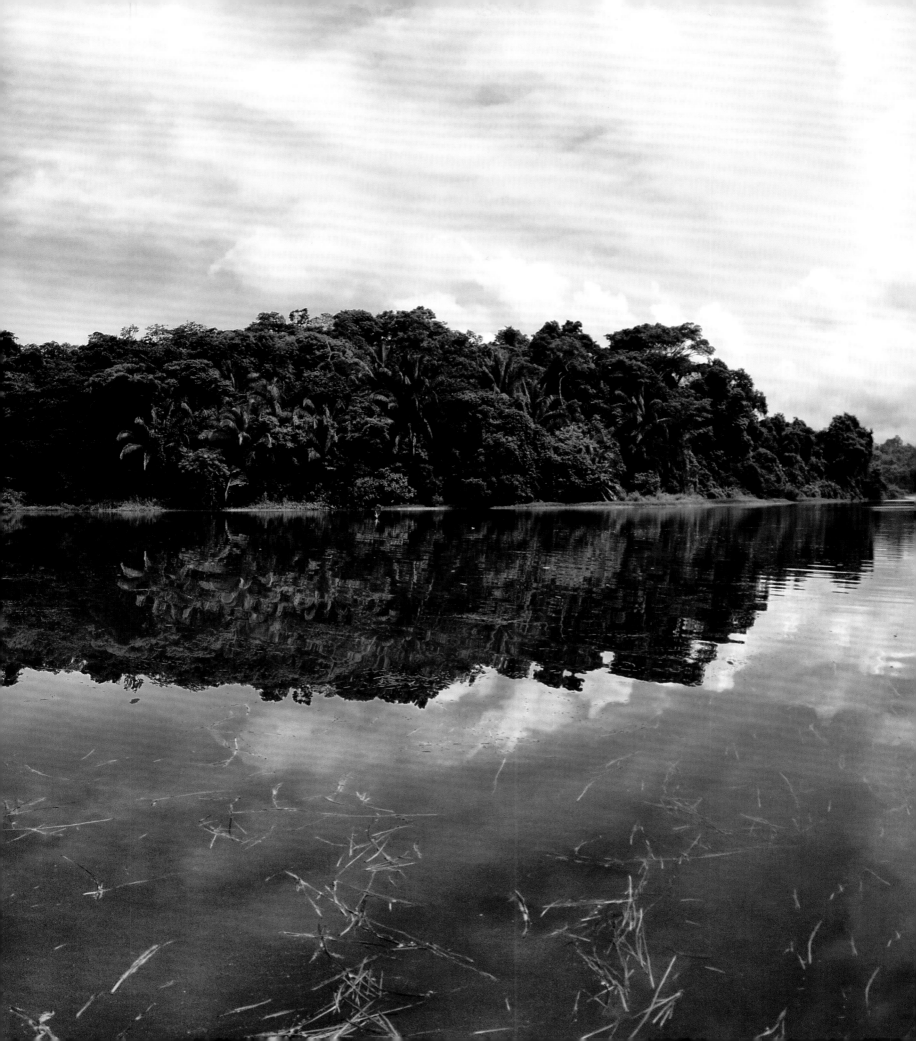

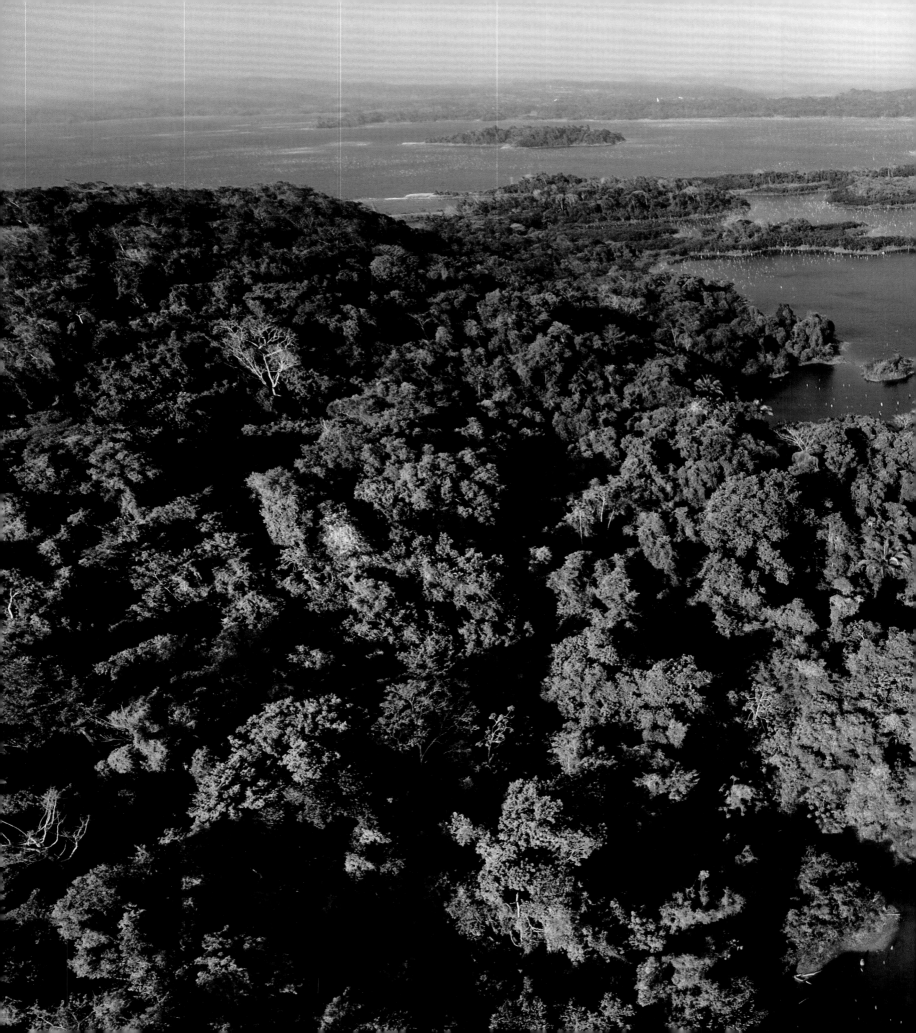

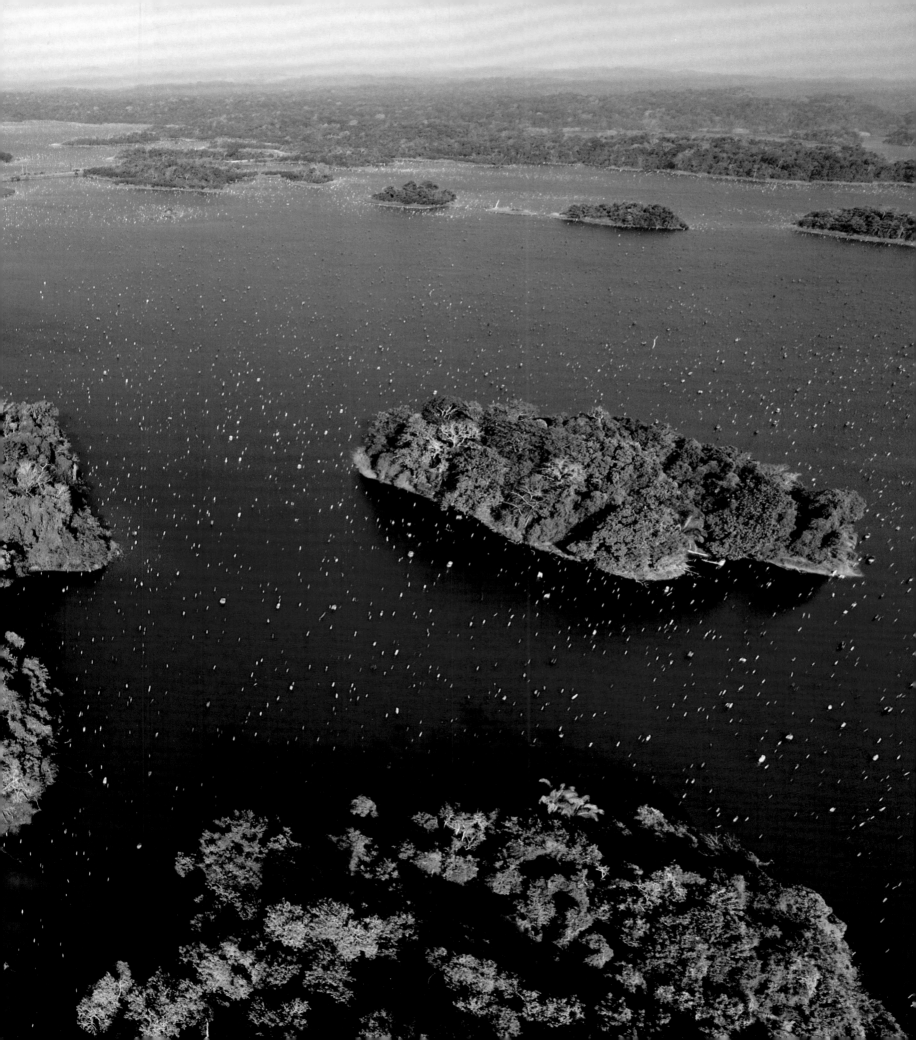

Those traveling along the Canal navigate on Gatun Lake for about 18 miles: almost half the entire route. The Gatun is to all effects a huge highway 85 feet above sea level, but it also represents the water reservoir that allows the locks to function. The lake is man-made: it was filled between 1907 and 1913, after the Chagres River was dammed just a few miles before it flowed into the Atlantic.

Actually, for many years it was the largest man-made lake in the world, before the advent of the great dams of the world shattered any record it may have held: it is still one of the most impressive of them all. These days about 15,000 ships, both freight and passenger ships, navigate Gatun Lake (and the Canal) every year. During cruise season, between October and April, over 230 large ships sail through carrying tourists across the blue heart of Panama.

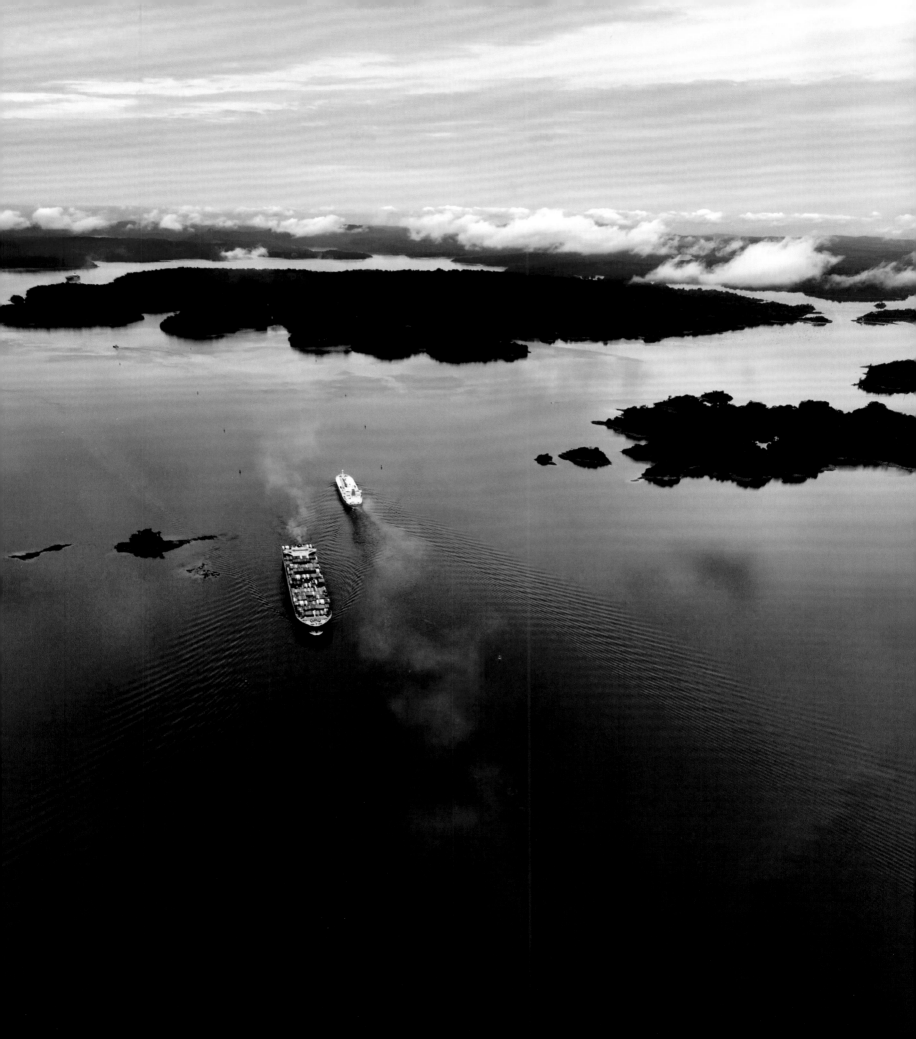

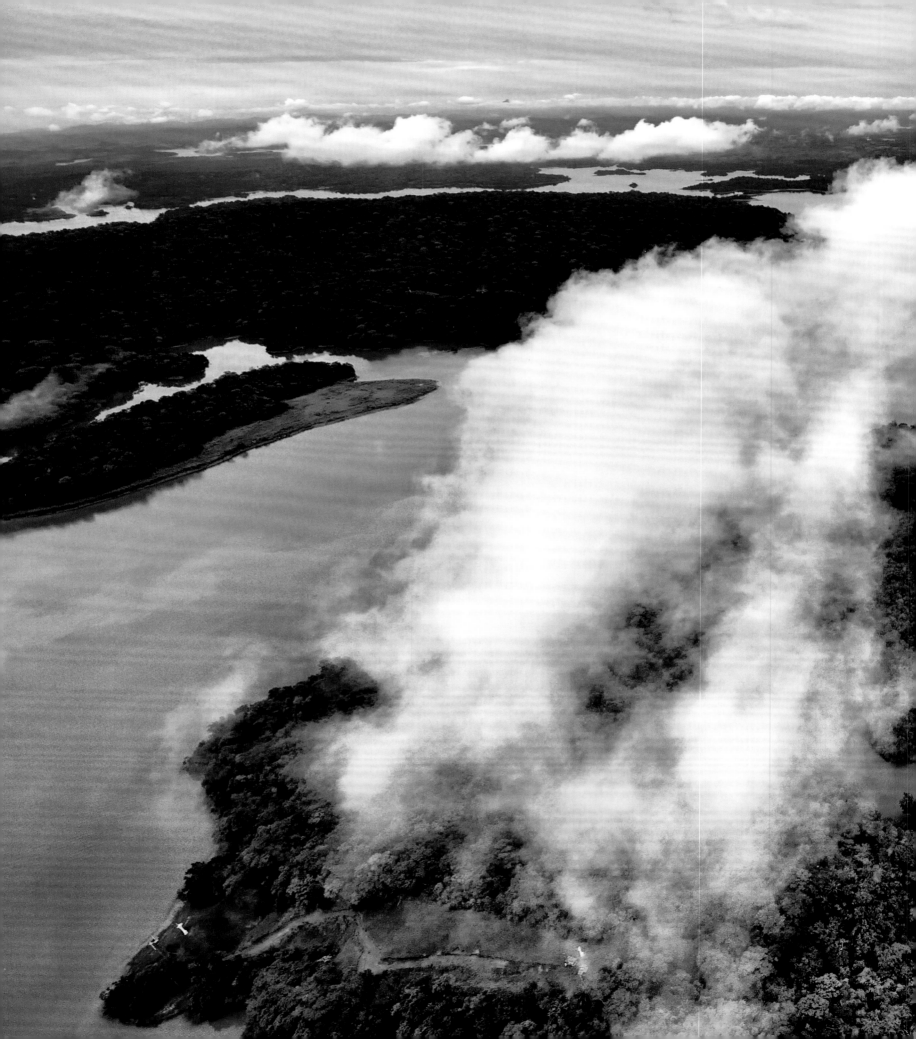

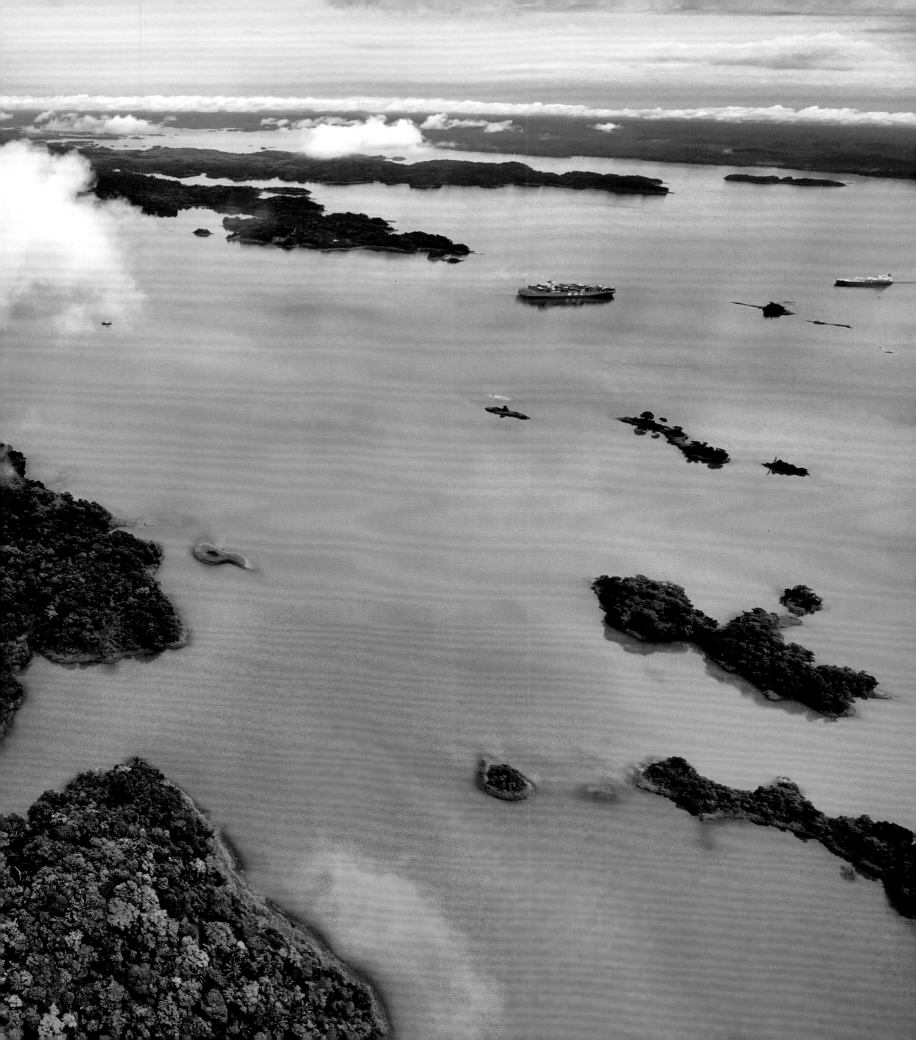

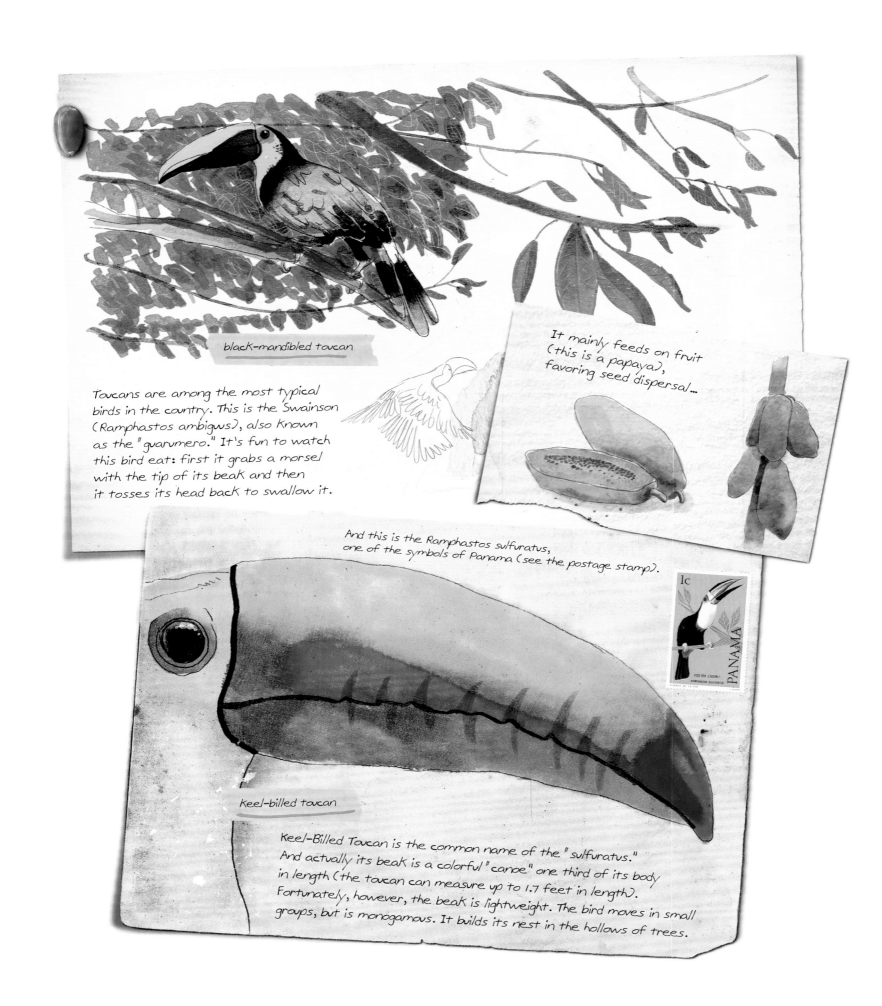

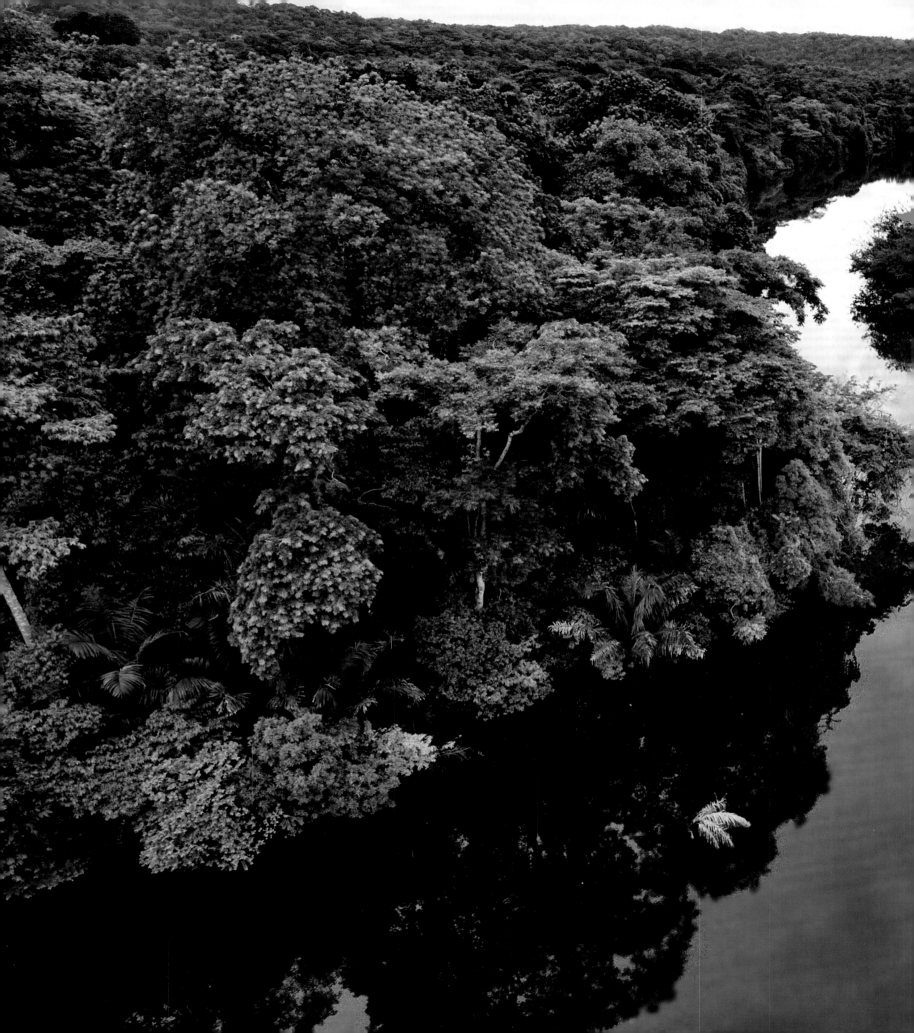

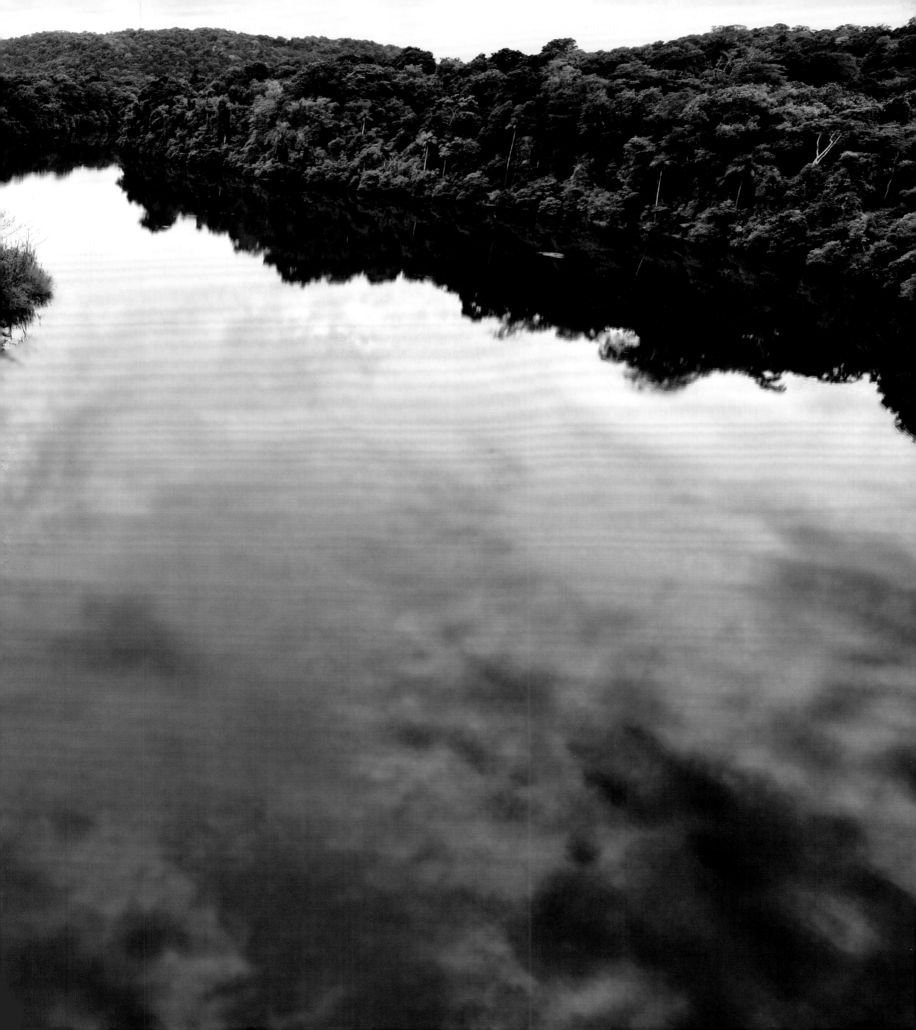

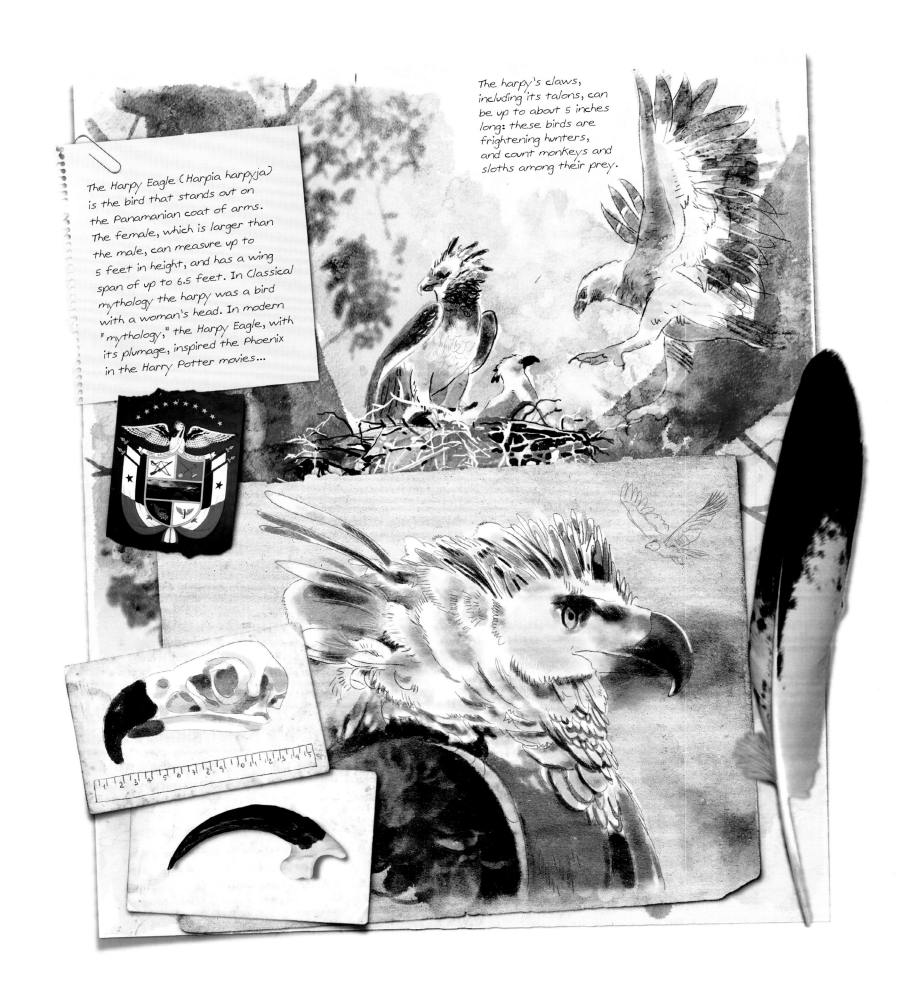

The Harpy Eagle (Harpia harpyja) is the bird that stands out on the Panamanian coat of arms. The female, which is larger than the male, can measure up to 5 feet in height, and has a wing span of up to 6.5 feet. In Classical mythology the harpy was a bird with a woman's head. In modern "mythology," the Harpy Eagle, with its plumage, inspired the Phoenix in the Harry Potter movies...

The harpy's claws, including its talons, can be up to about 5 inches long: these birds are frightening hunters, and count monkeys and sloths among their prey.

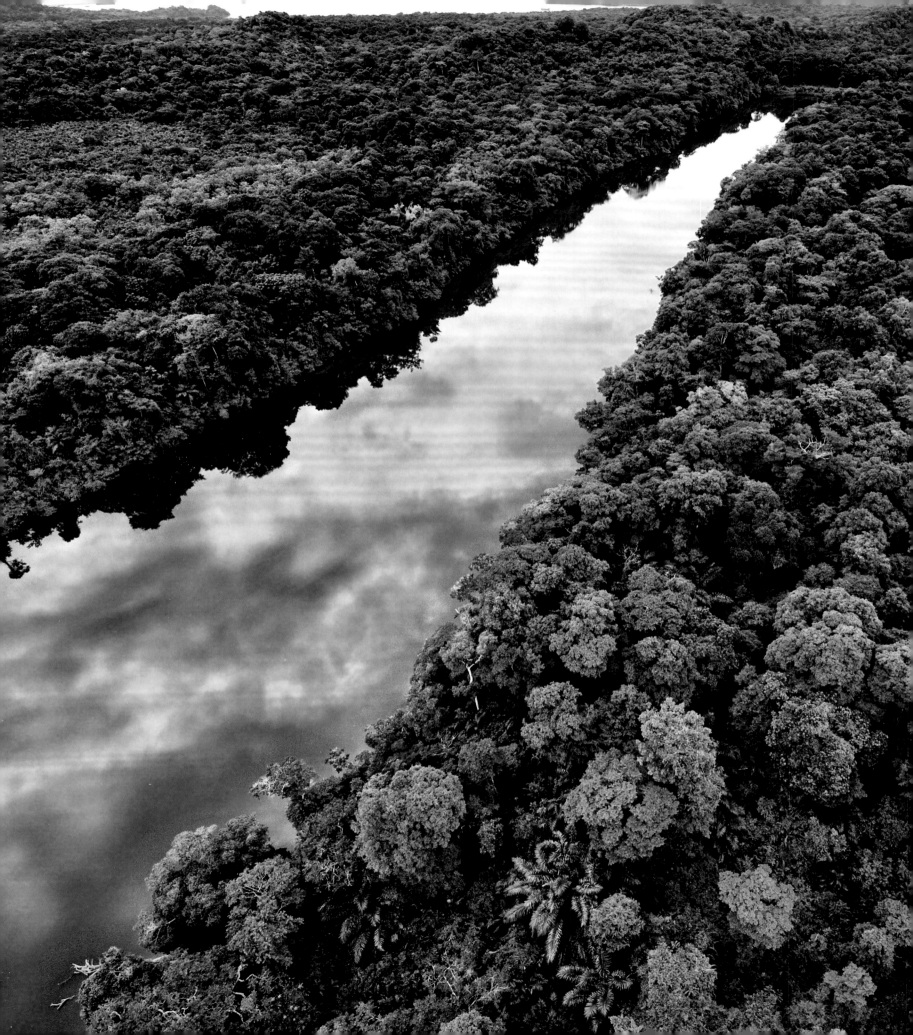

Bombacaceae seem to be everywhere (and they're gigantic too) in the forest, like the "pseudobombax septenatum," which the locals call "barrigón" (big belly) because its trunk is swollen at the base.

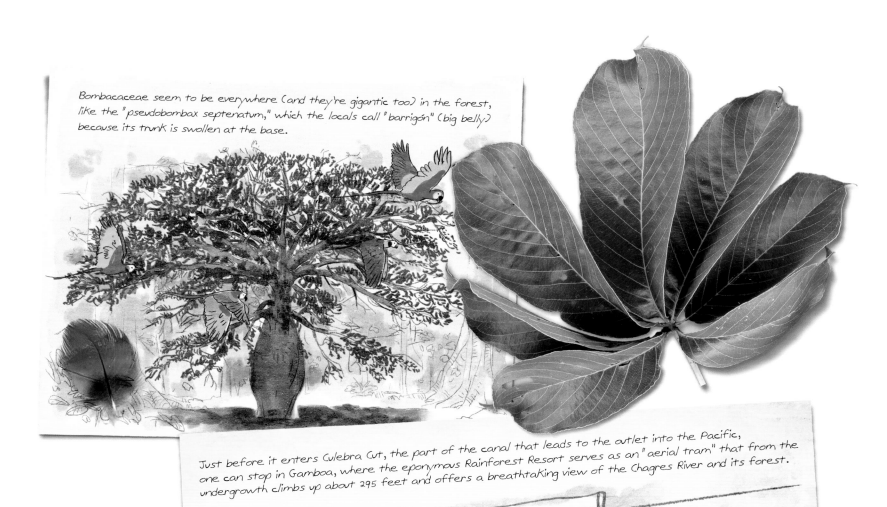

Just before it enters Culebra Cut, the part of the canal that leads to the outlet into the Pacific, one can stop in Gamboa, where the eponymous Rainforest Resort serves as an "aerial tram" that from the undergrowth climbs up about 295 feet and offers a breathtaking view of the Chagres River and its forest.

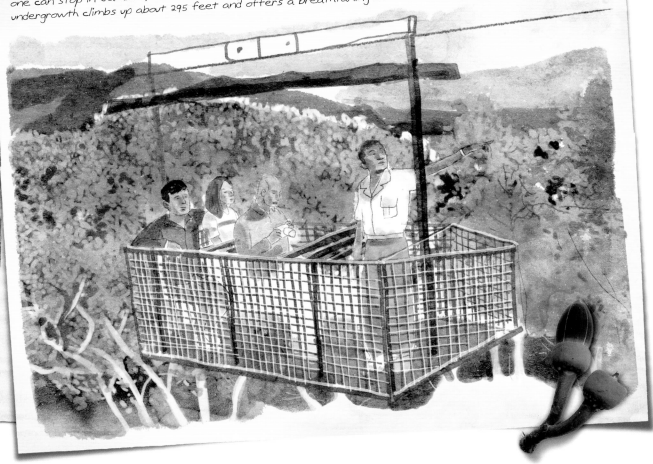

Needless to say, the forest hosts an amazing number of insects: this 3-inch long "giant metallic" scarab beetle is simply gorgeous.

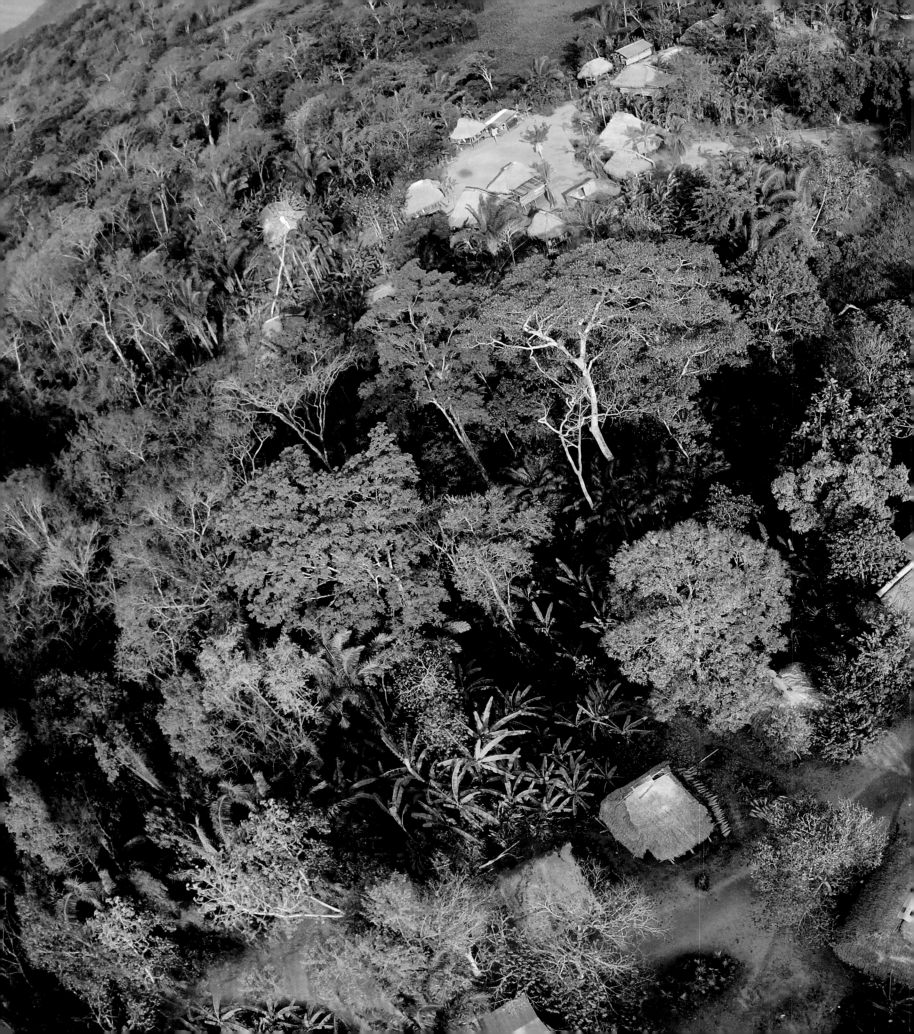

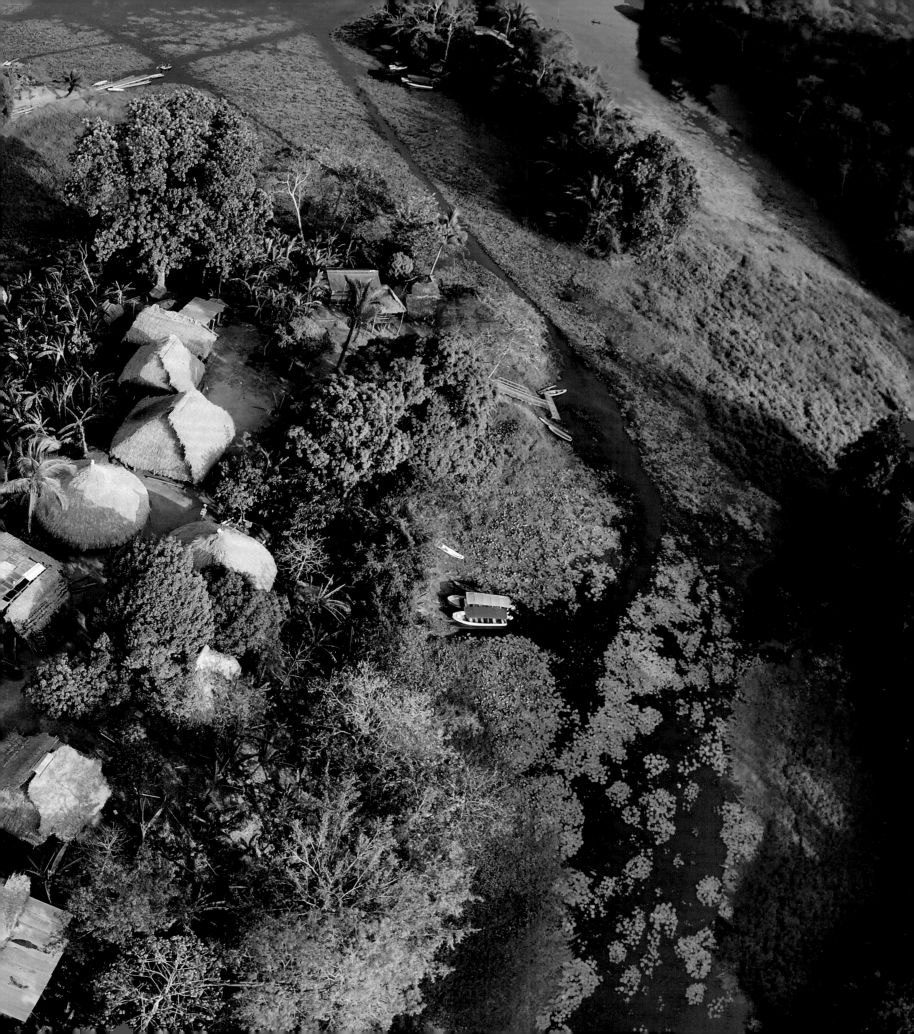

The Emberá are a small group of indigenous people of Panama and Colombia (the country dedicated a celebratory banknote to them for the 500th anniversary of the discovery of America).

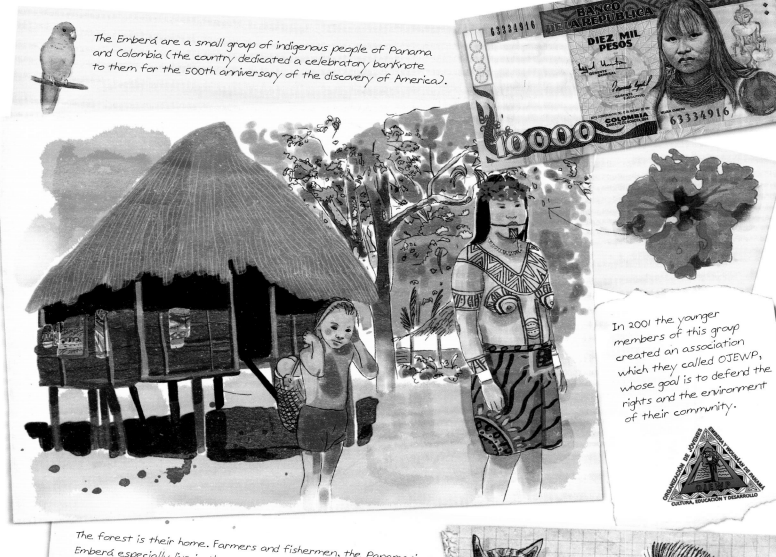

In 2001 the younger members of this group created an association which they called OJEWP, whose goal is to defend the rights and the environment of their community.

The forest is their home. Farmers and fishermen, the Panamanian Emberá especially live in the national park of Chagres, in villages that rose up along the banks of the river, where they welcome visitors with their hospitality, and sell them their artefacts. The women wear skirts woven and decorated with geometric motifs, multicolored beads, and bright red hibiscus crowns on their heads.

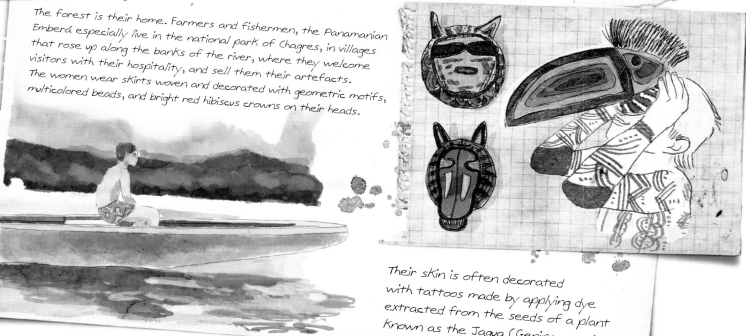

Their skin is often decorated with tattoos made by applying dye extracted from the seeds of a plant known as the Jagua (Genipa americana).

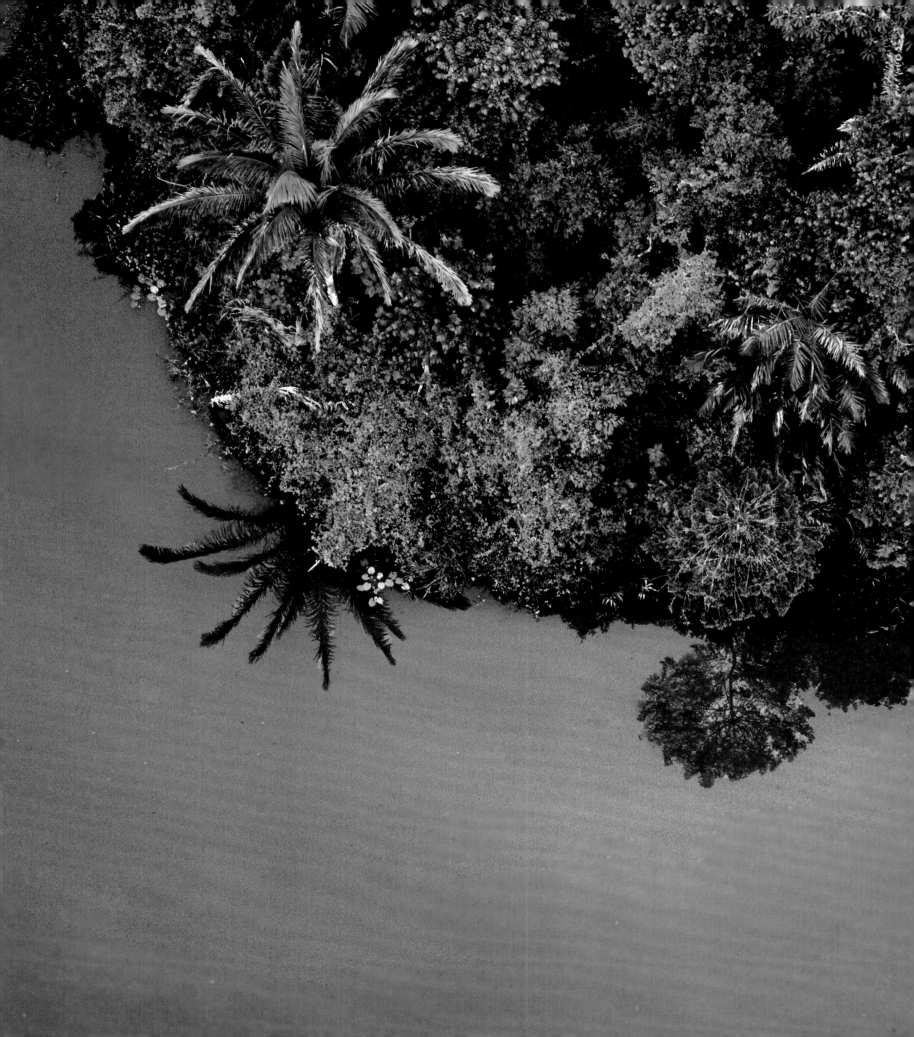

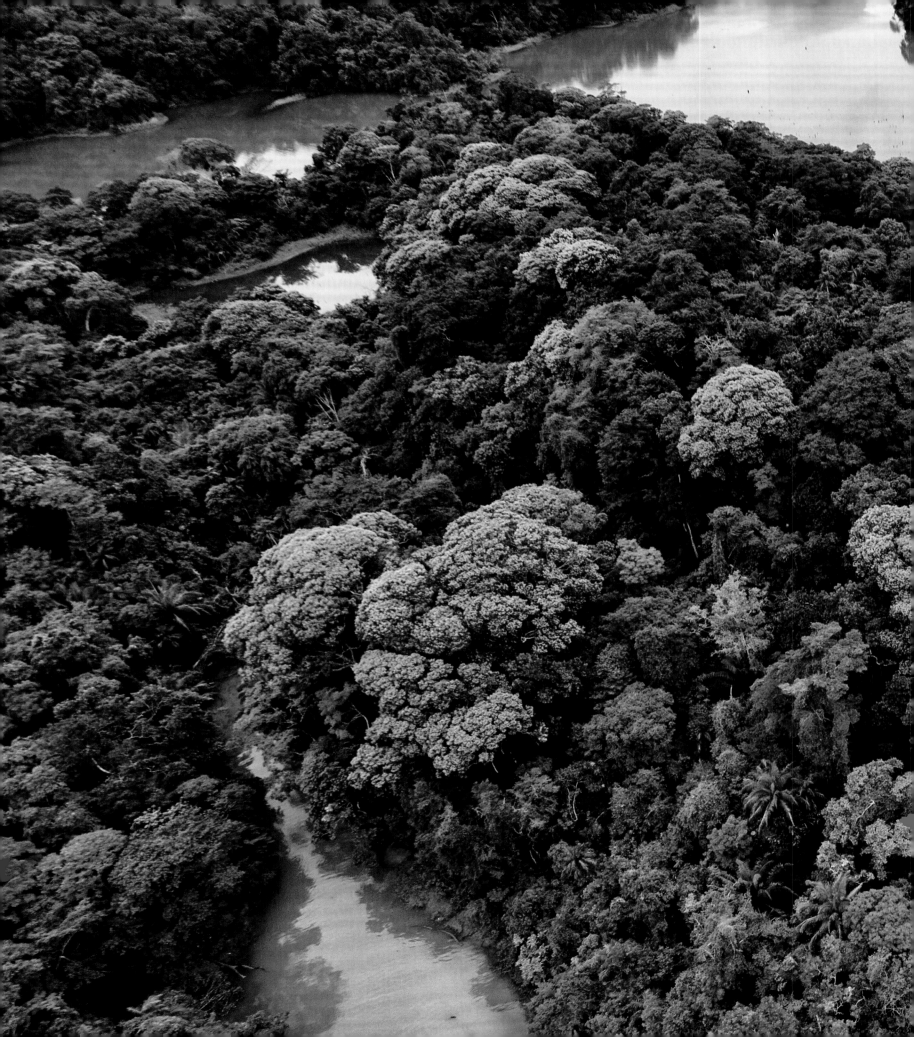

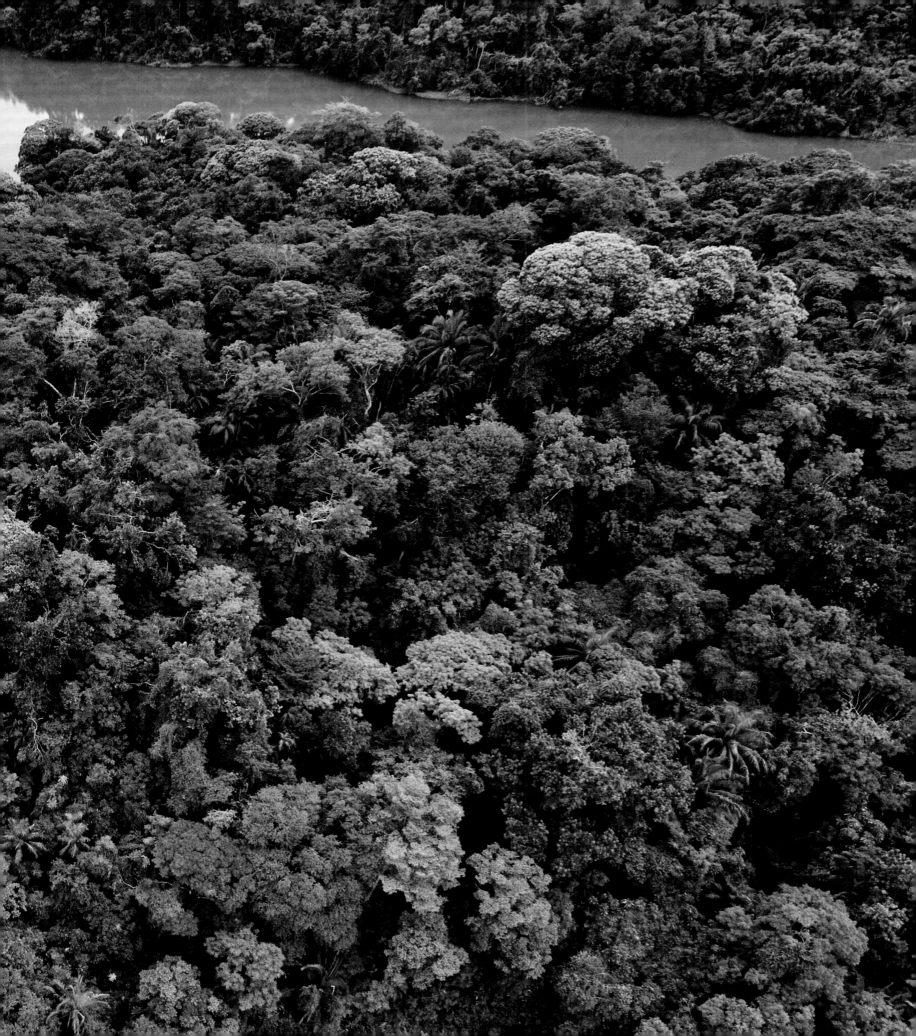

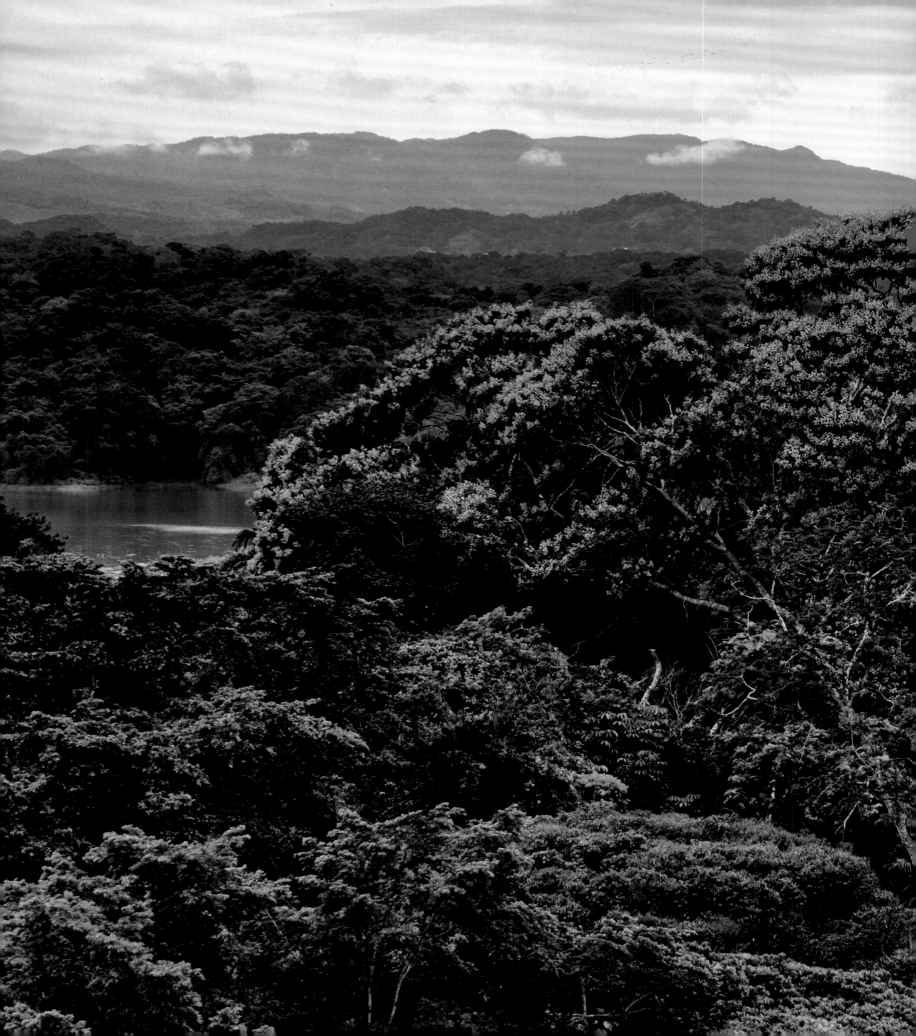

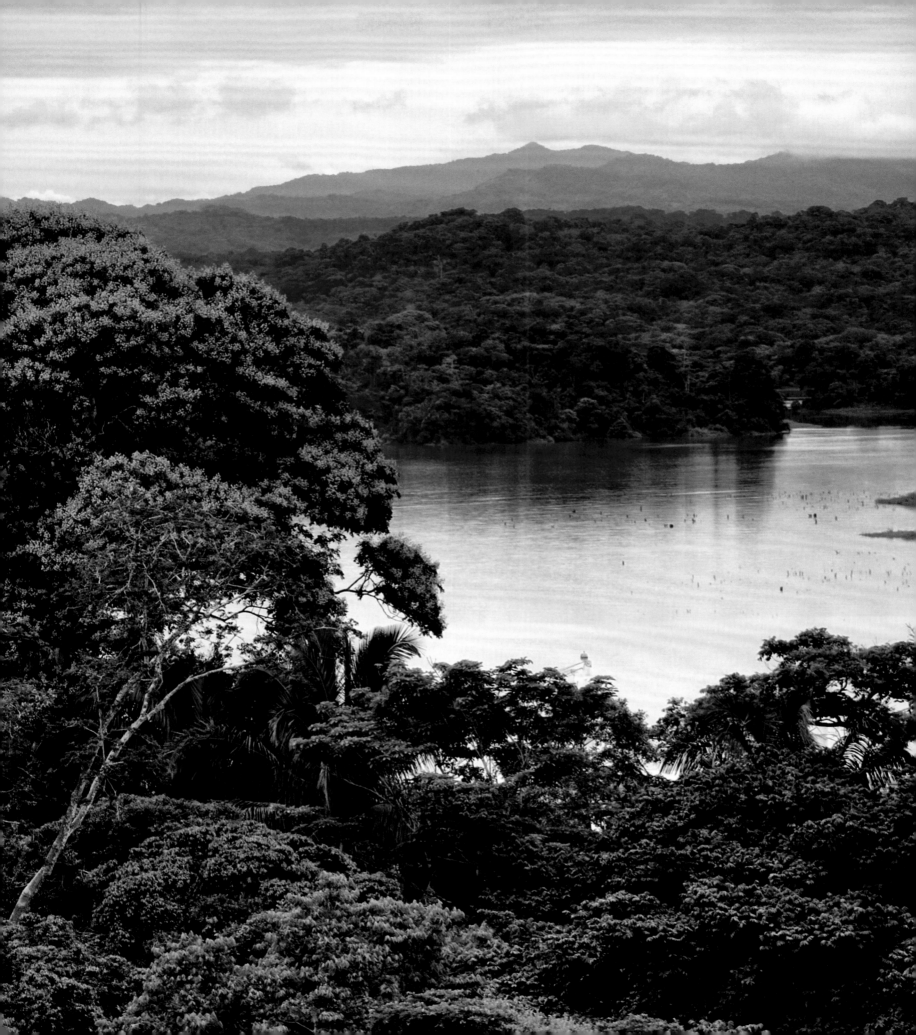

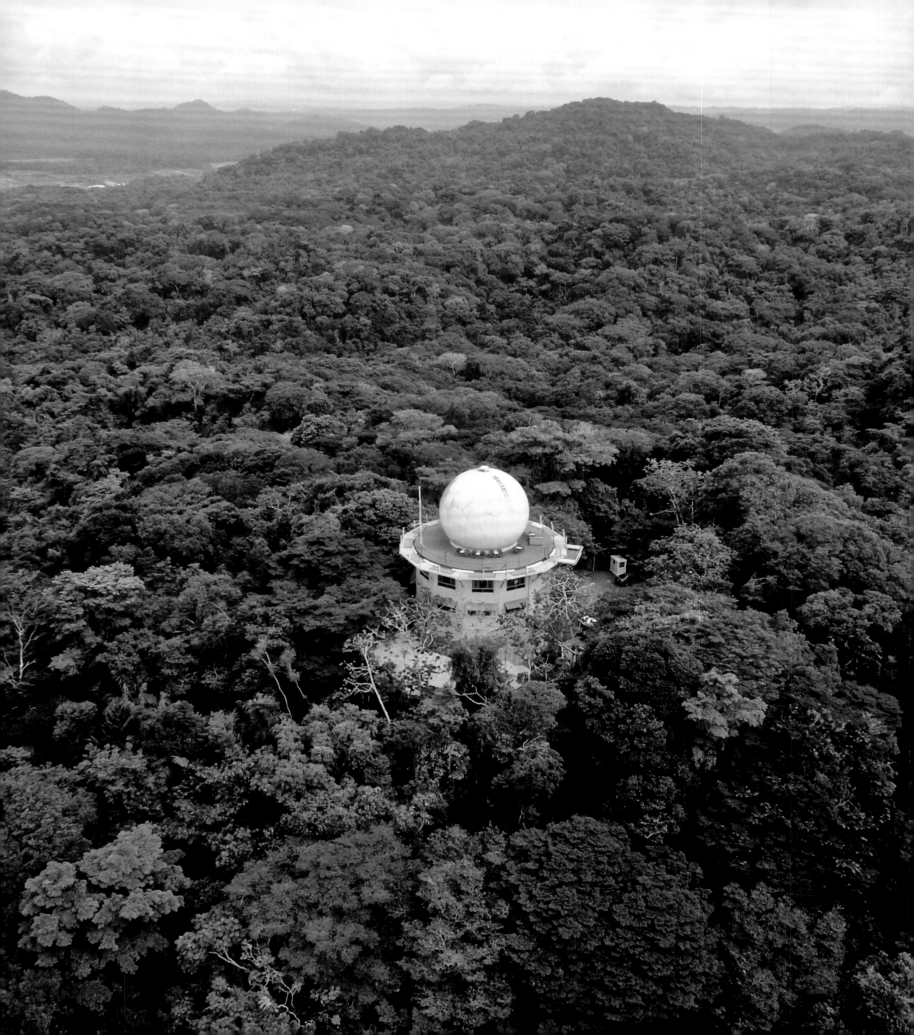

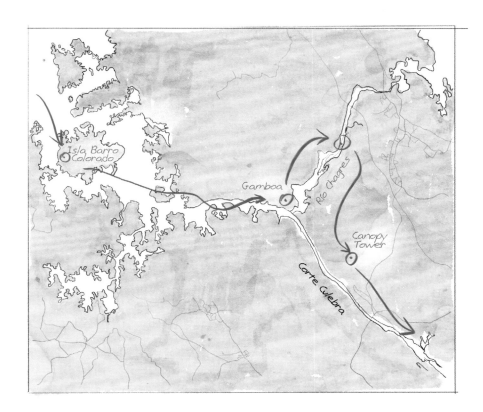

The Canopy Tower is a lighthouse used by bird-watching enthusiasts. Resembling a boa in the lush green of the rainforest, it is an observatory-lodge that attracts bird-watchers from every corner of the world. Here, immersed in Soberanía (meaning "sovereignty") National Park, you can live and sleep at the same high level as your feathered friends.
And when the autumn season brings hundreds of thousands of birds of prey from North to South America, the bottleneck represented by the isthmus forces them to fly together in just a few miles of sky: that's when the canopy truly becomes an enchanted island, and we become awe-struck sailors armed with our binoculars.

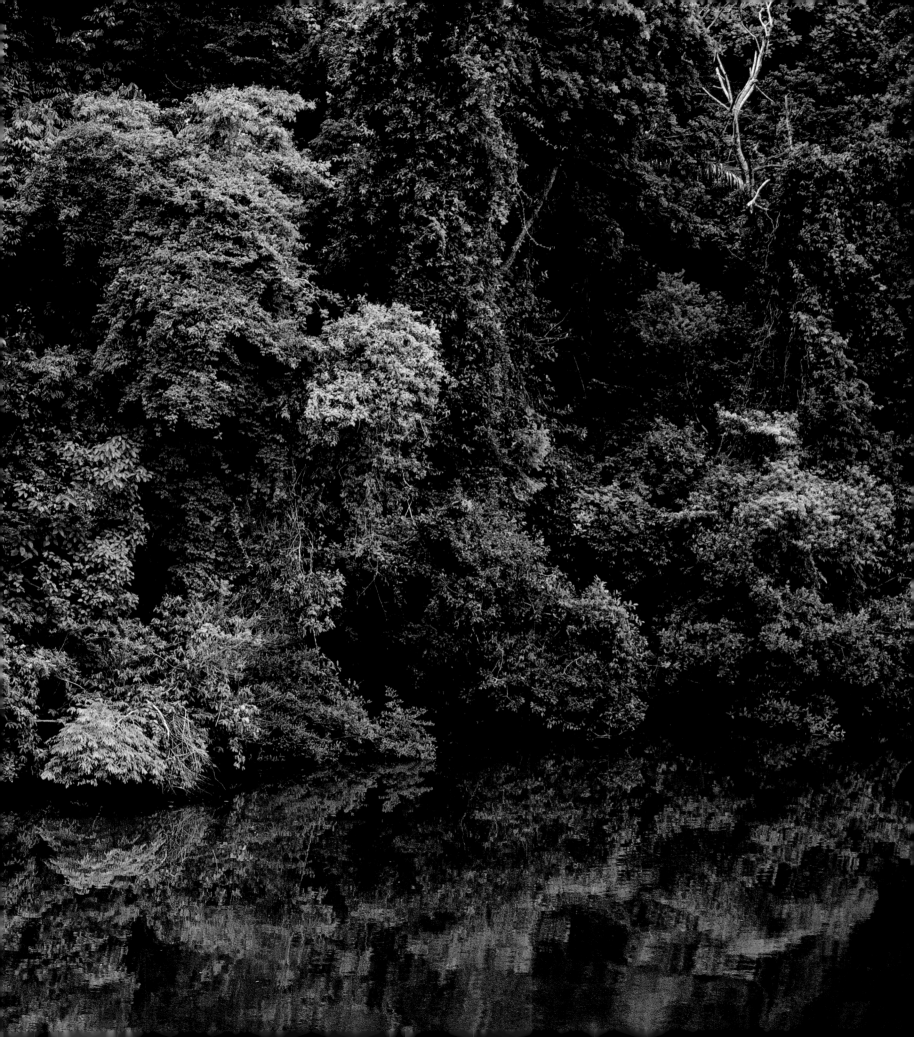

Culebra Cut symbolizes the strength of the pioneers who pursued the dream of the Canal. These 7.5 miles of man-made valley, which from the last arm of the Chagres River lead to the Pedro Miguel locks, toward the Pacific, were an engineering challenge worthy of the Pharaohs. Their excavation was begun by the French workers under diplomat and canal developer Ferdinand de Lesseps, who considered building the canal directly at sea level.
After the loss of countless lives his plan eventually failed, but it did pave the road for the intervention of the United States, which "accepted" the idea of digging a canal that was less deep (but wider). One cannot travel this part of the Canal without shivering at the thought of all those who sacrificed their lives in the attempt to change the face of our planet.

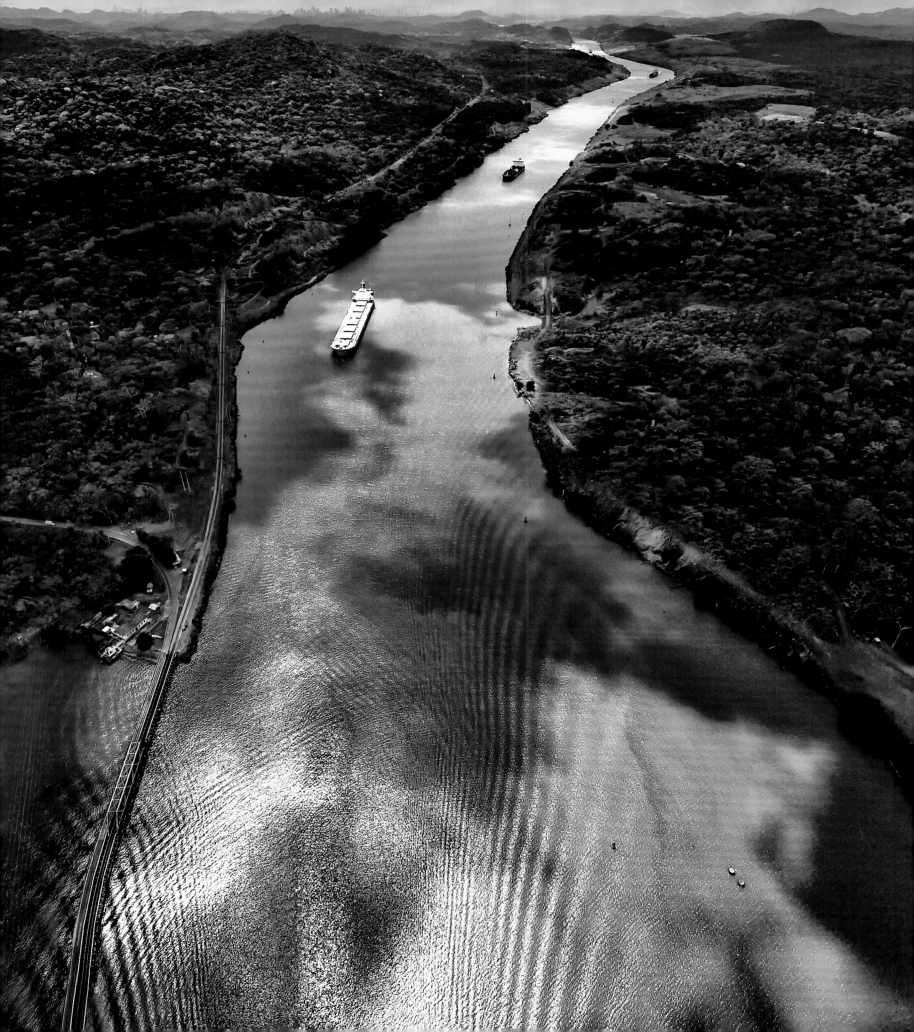

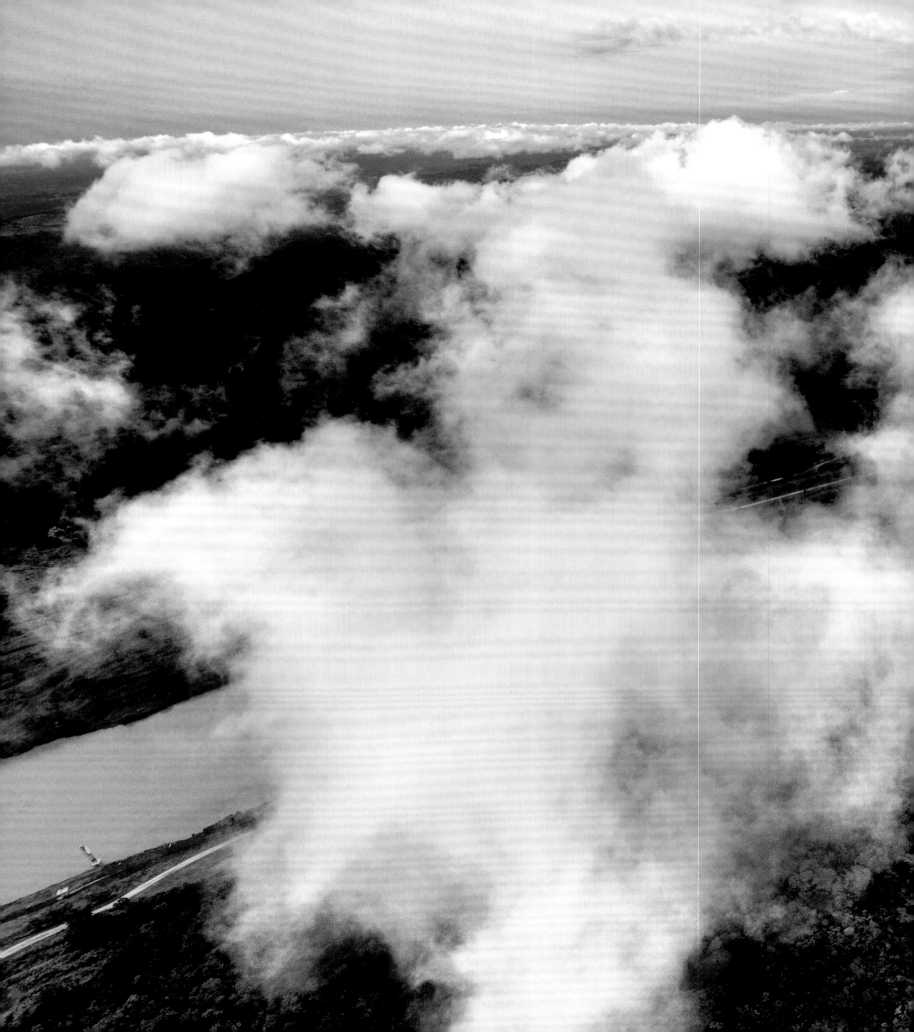

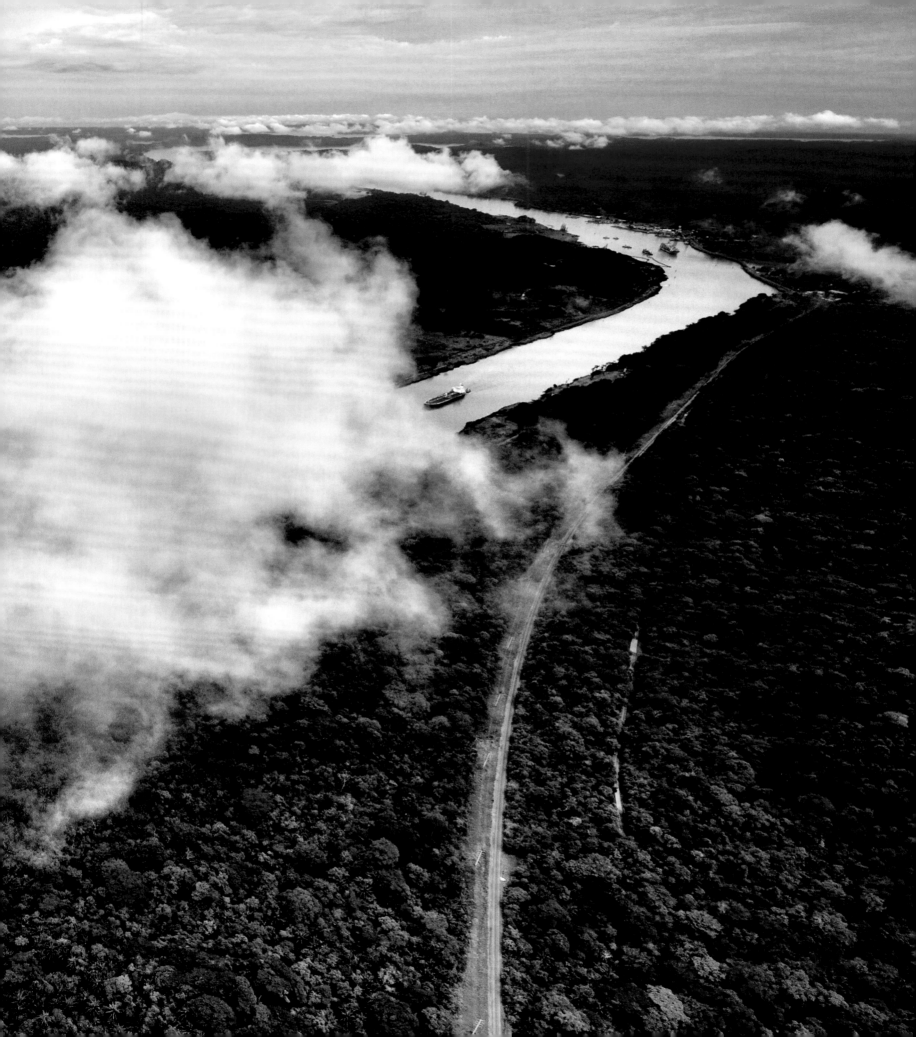

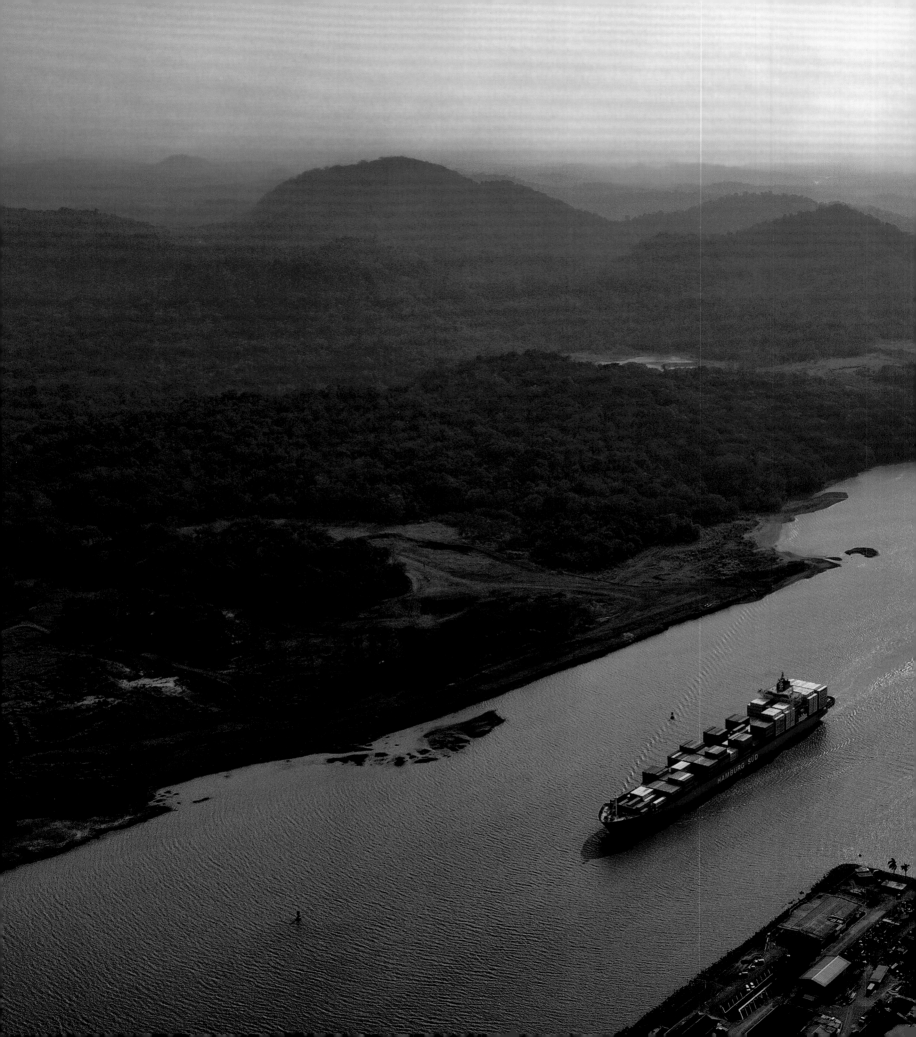

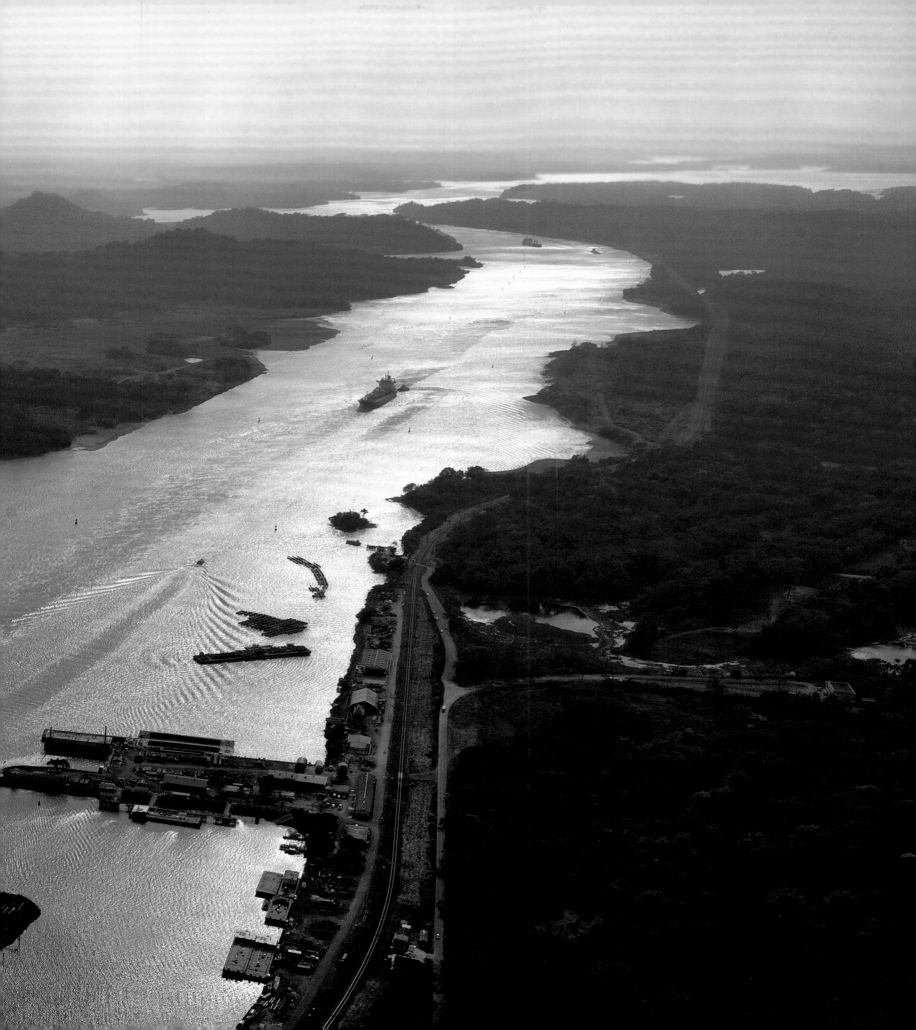

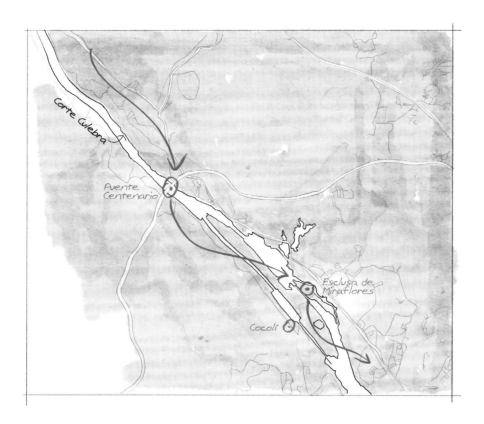

"Puente Centenario" (Centennial Bridge), which opened in 2004, was built here, close to the village of Paraíso, to lessen the traffic that weighed upon the Bridge of the Americas in Panama City. The bridge was called "Centenario" because it was inaugurated a century after the birth of the Republic of Panama. Sleek, simple, elegant, and functional, it lies completely outside the Canal (on two towers each almost 650 feet tall), and its clearance is 262 feet above water so as not to interfere with the ships passing below. Simply breathtaking.

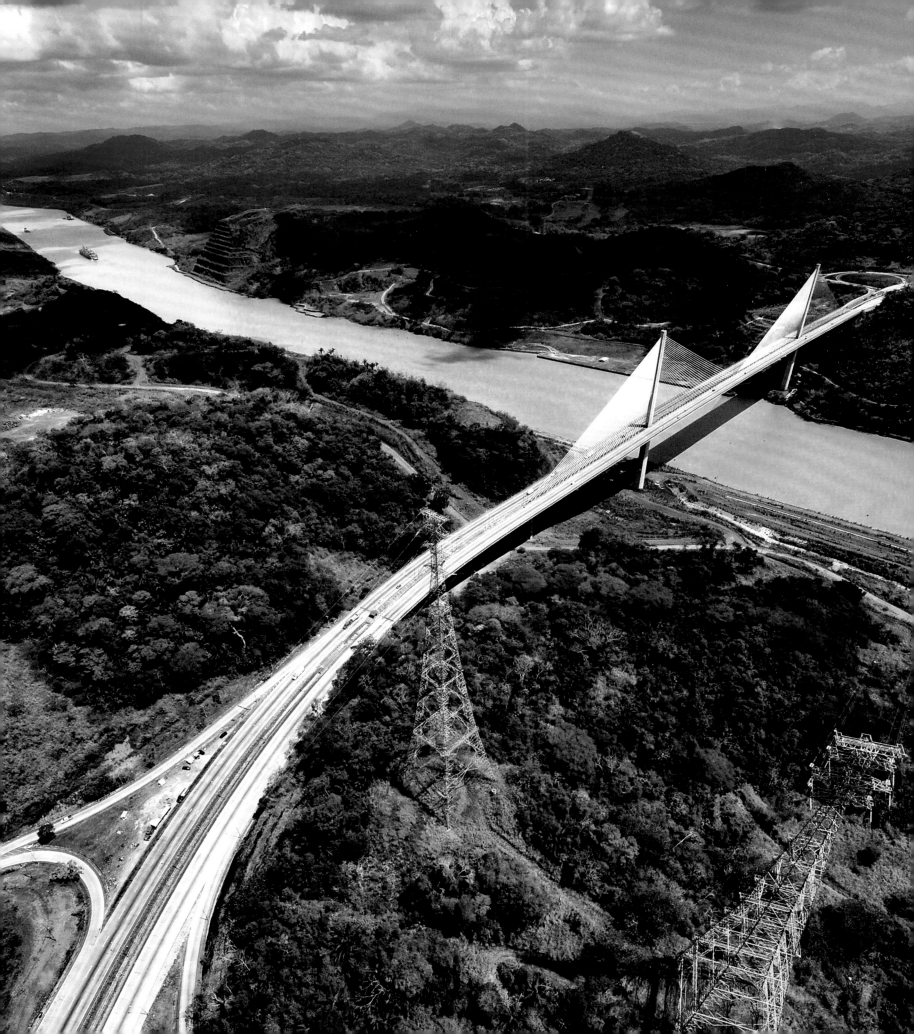

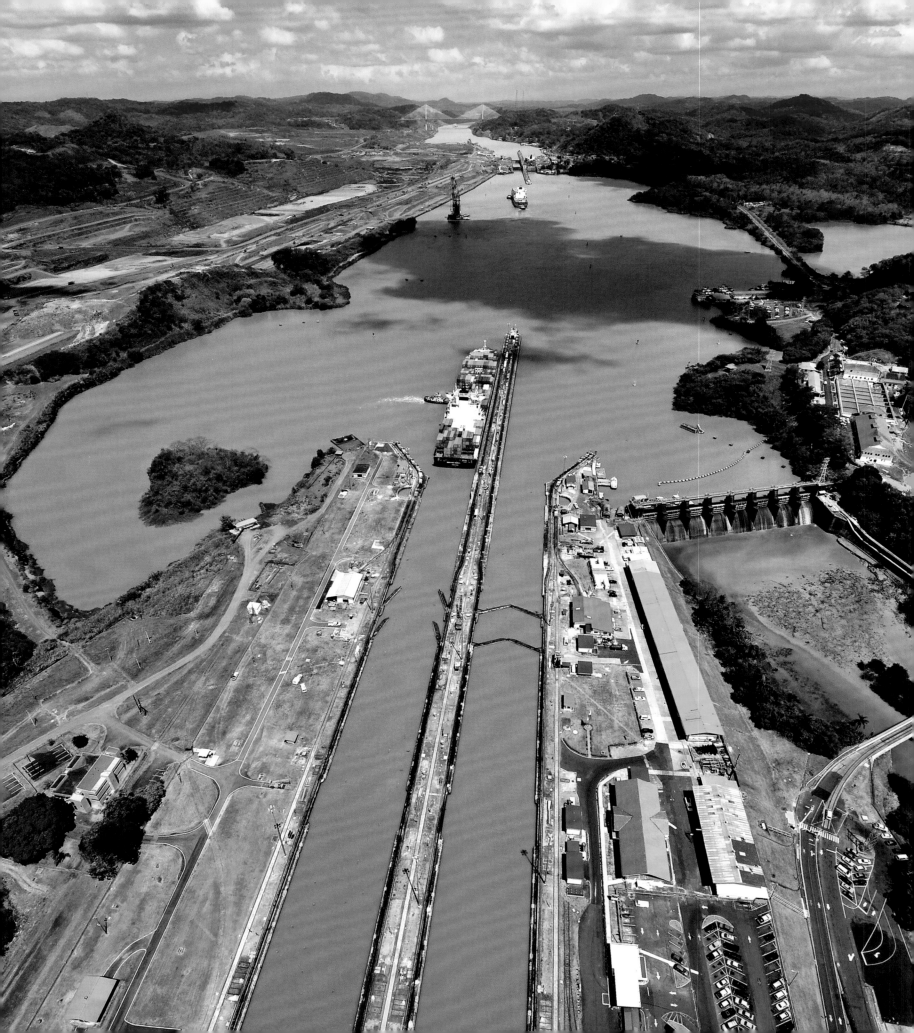

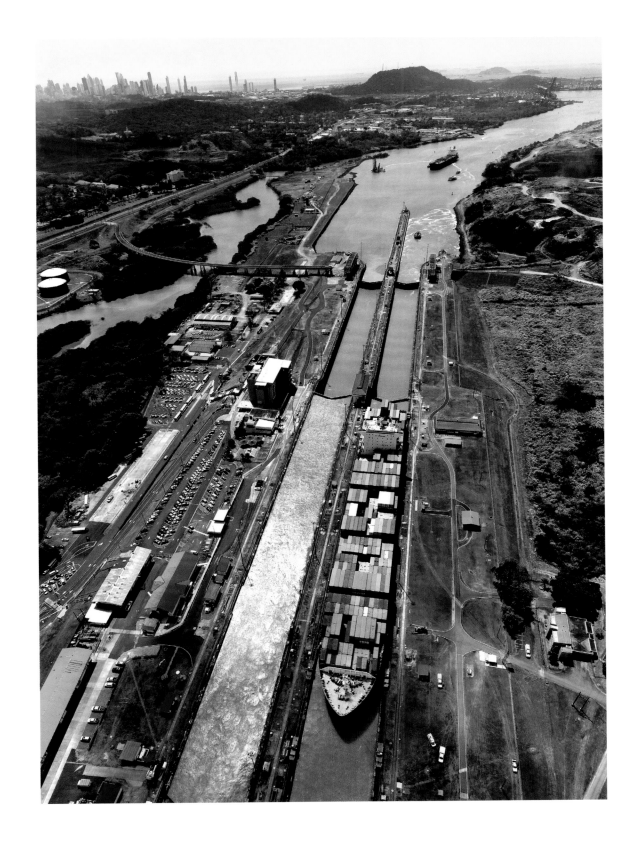

In recent years, tourism in Panama has grown by 10% annually (especially people from North and South America, confirming the country's vocation as a crossroads between the Latin culture and that of the United States).

The Miraflores locks are one of the most popular tourist sites on the Canal because they are the ones located closest to Panama City.

From the visitors' center we too have admired the "old" system of the basins and the transit of ships hooked up to the "mules" (*mulas*), the electric locomotives escorting them down the narrow passages. Not too far away are the new Cocolí locks, and although they may be less "vintage," they are equally fascinating.

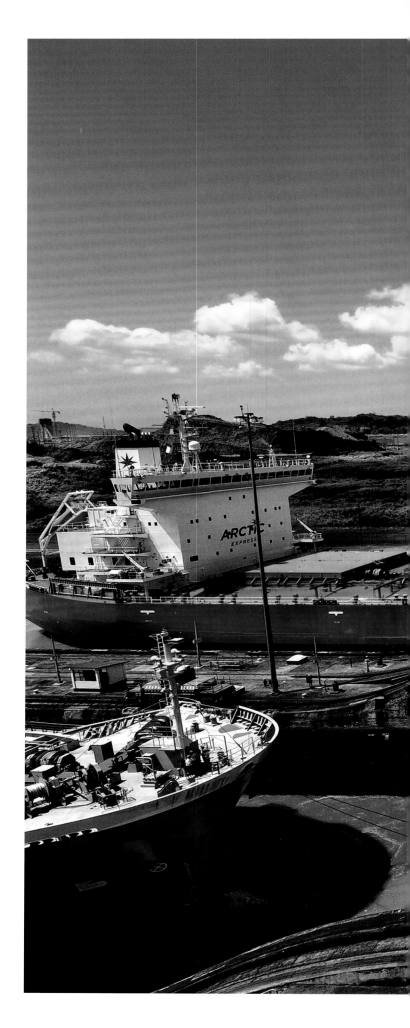

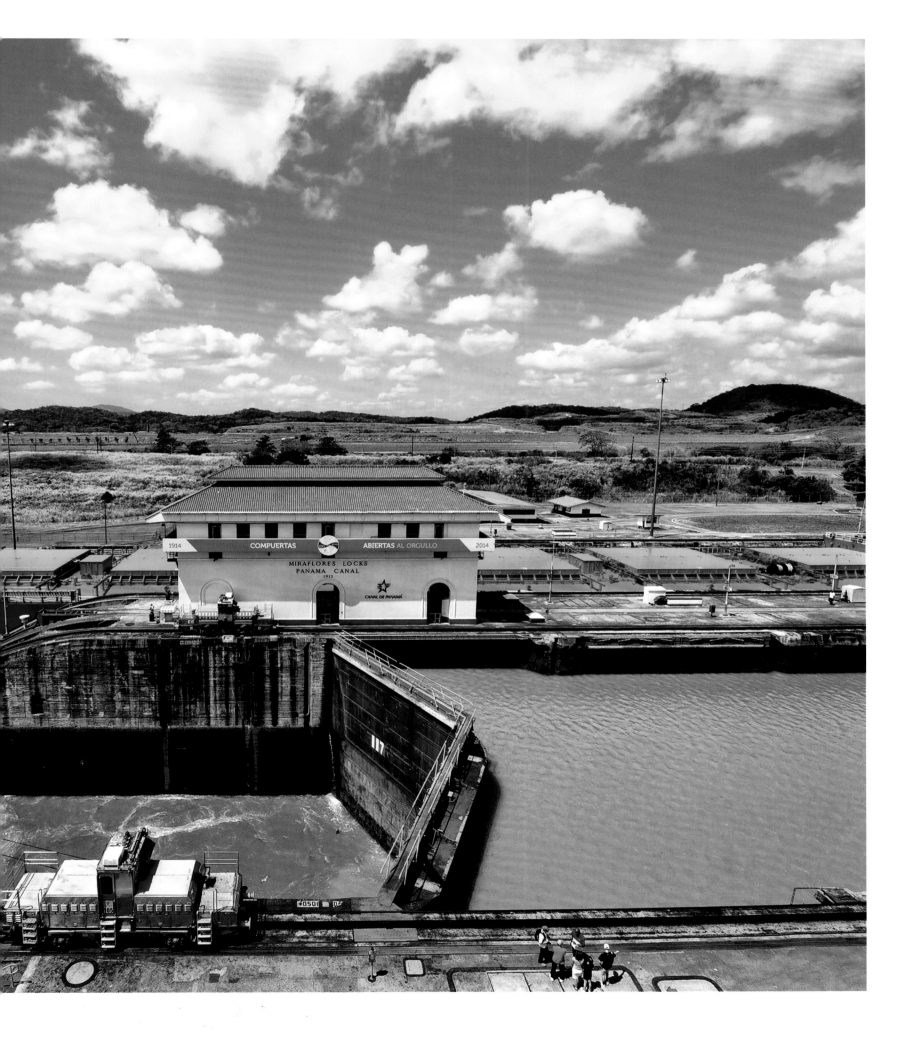

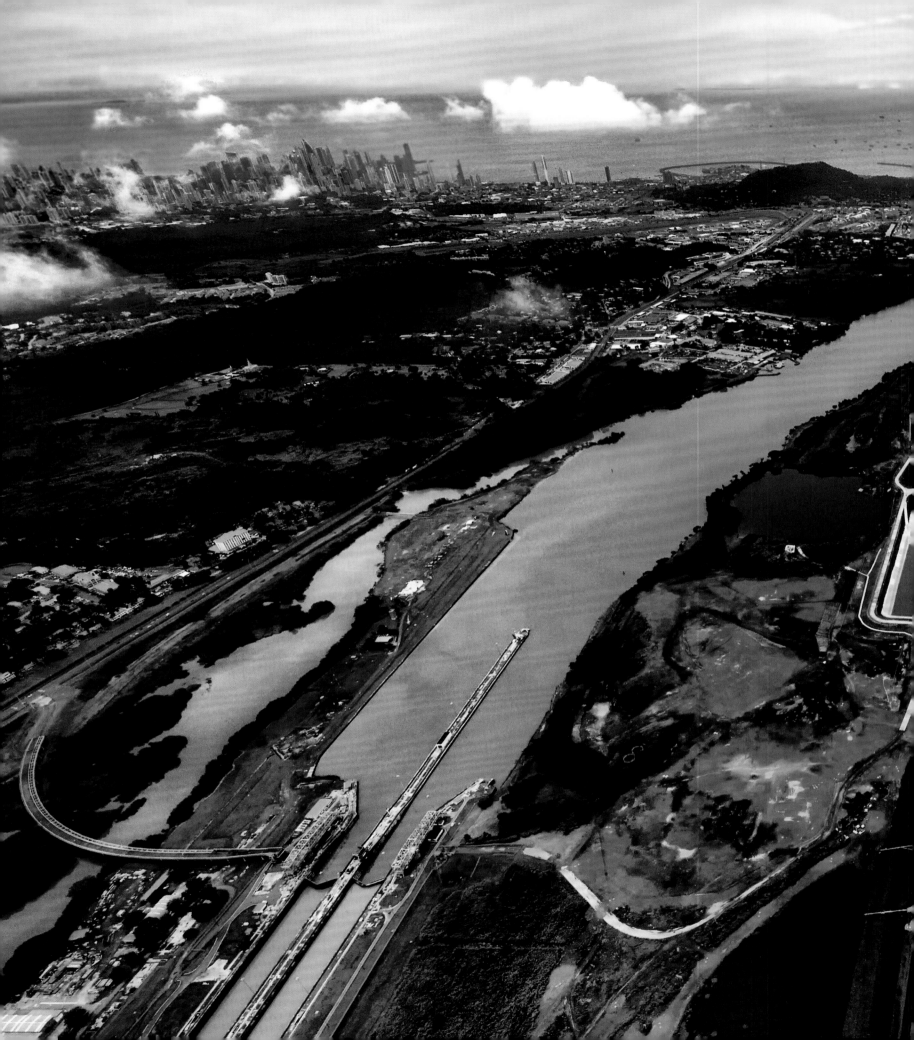

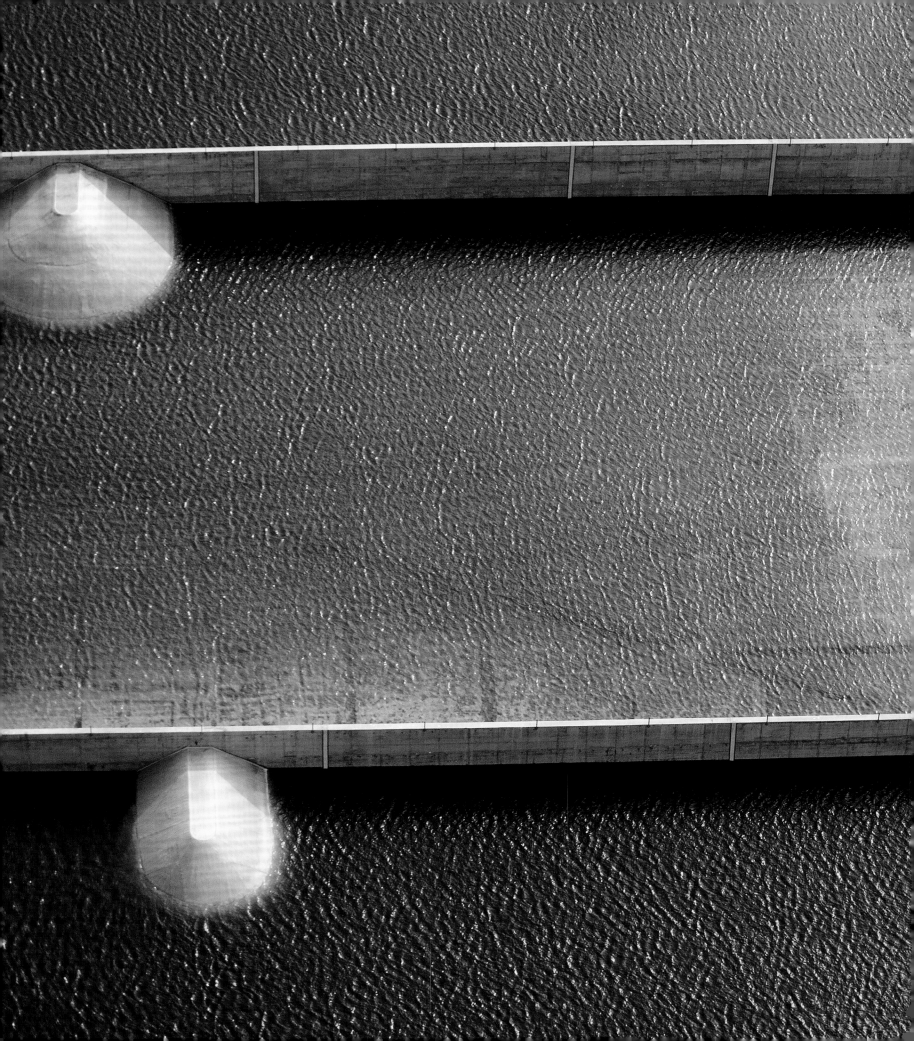

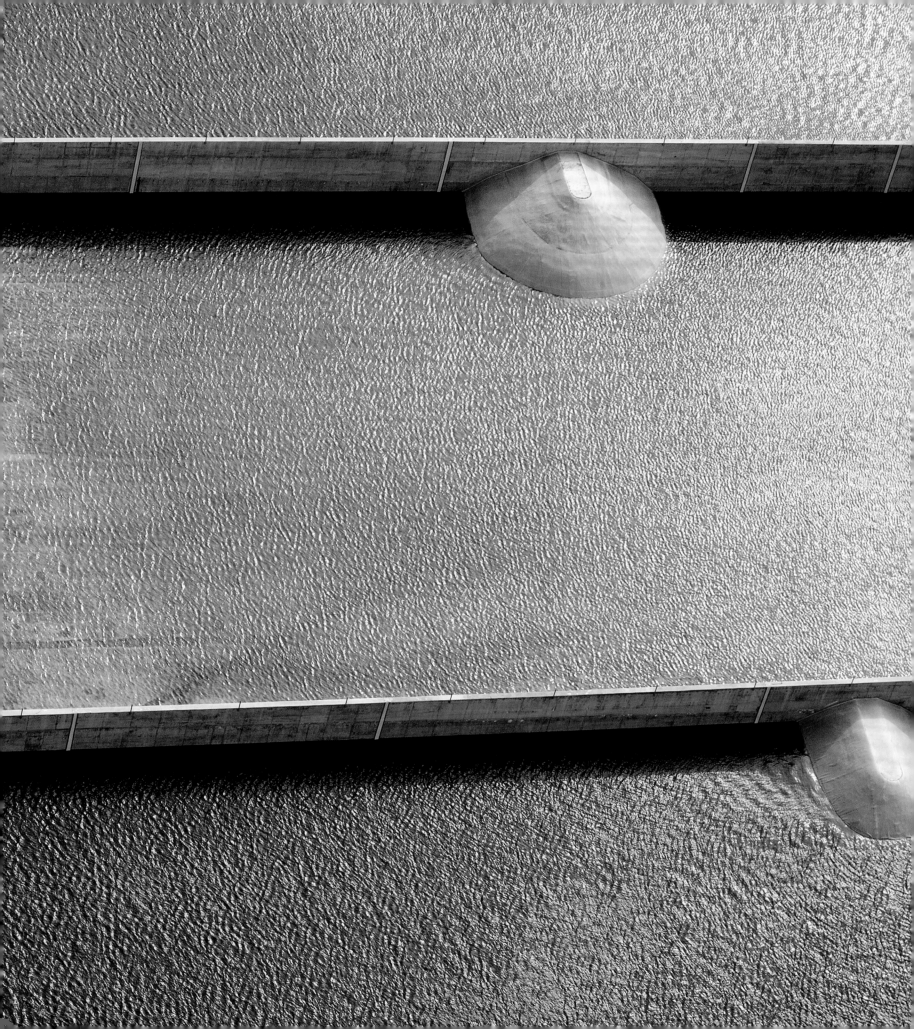

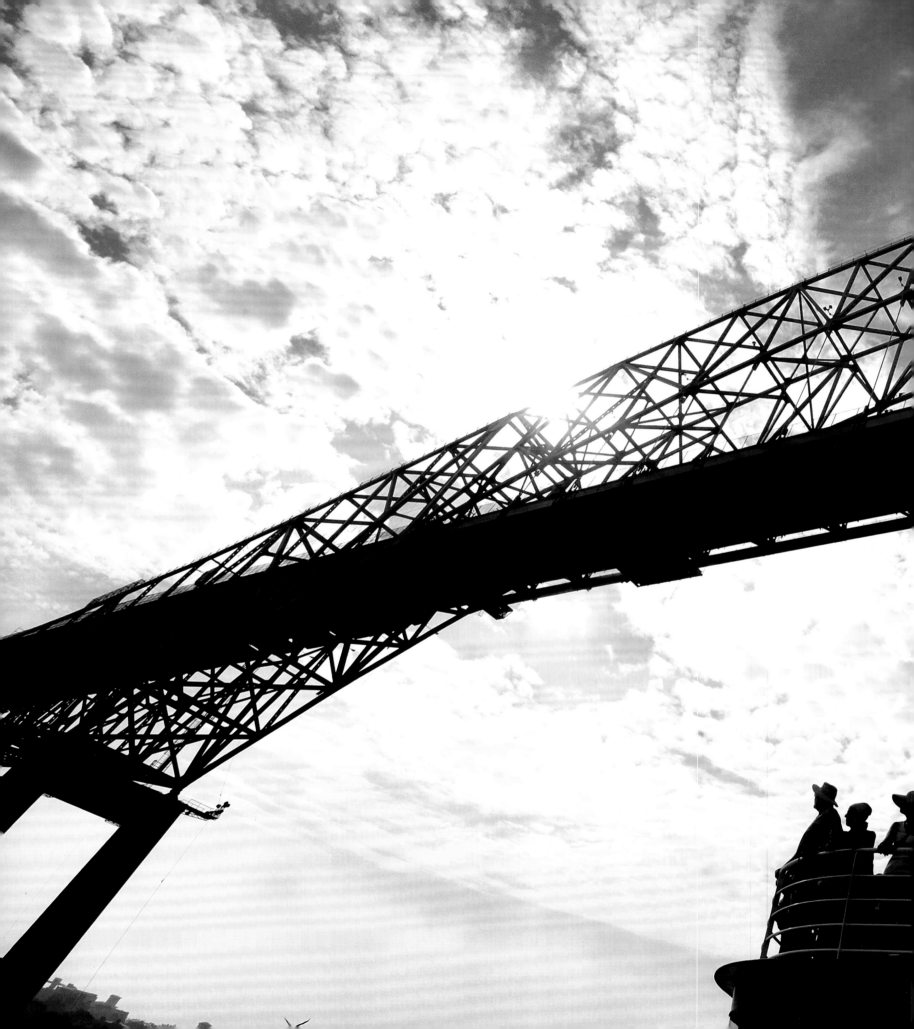

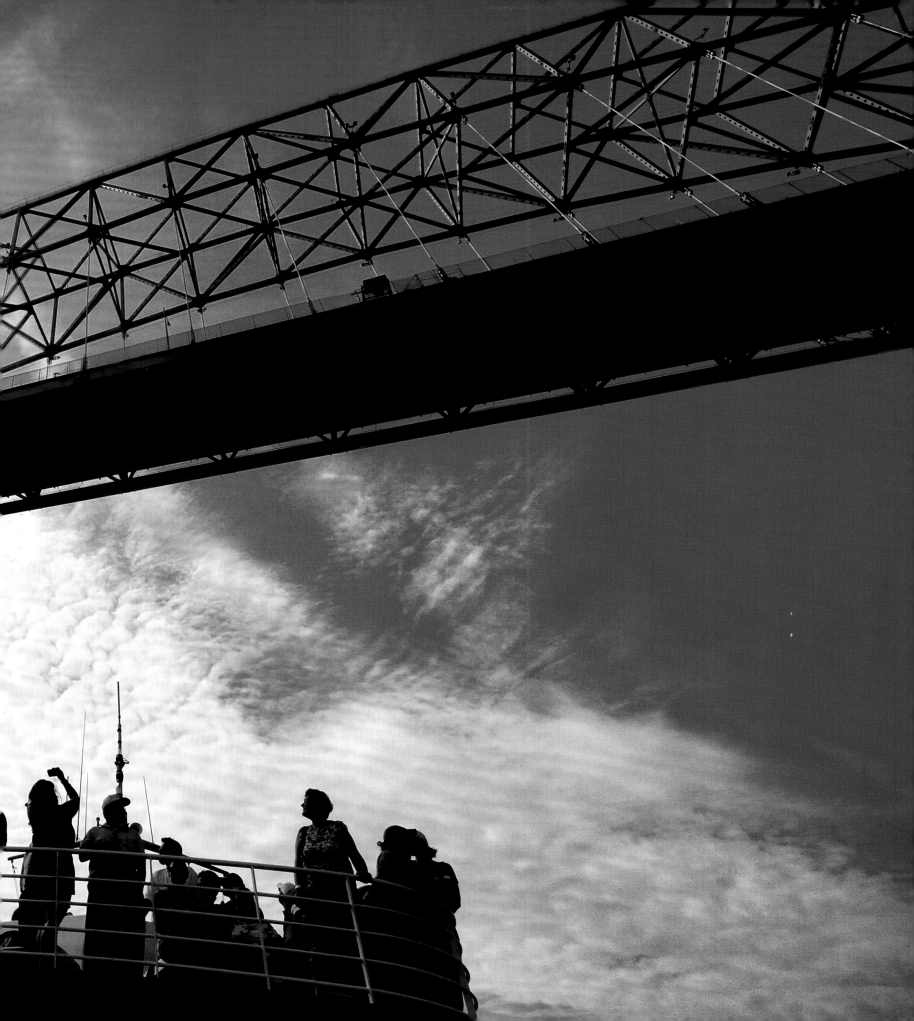

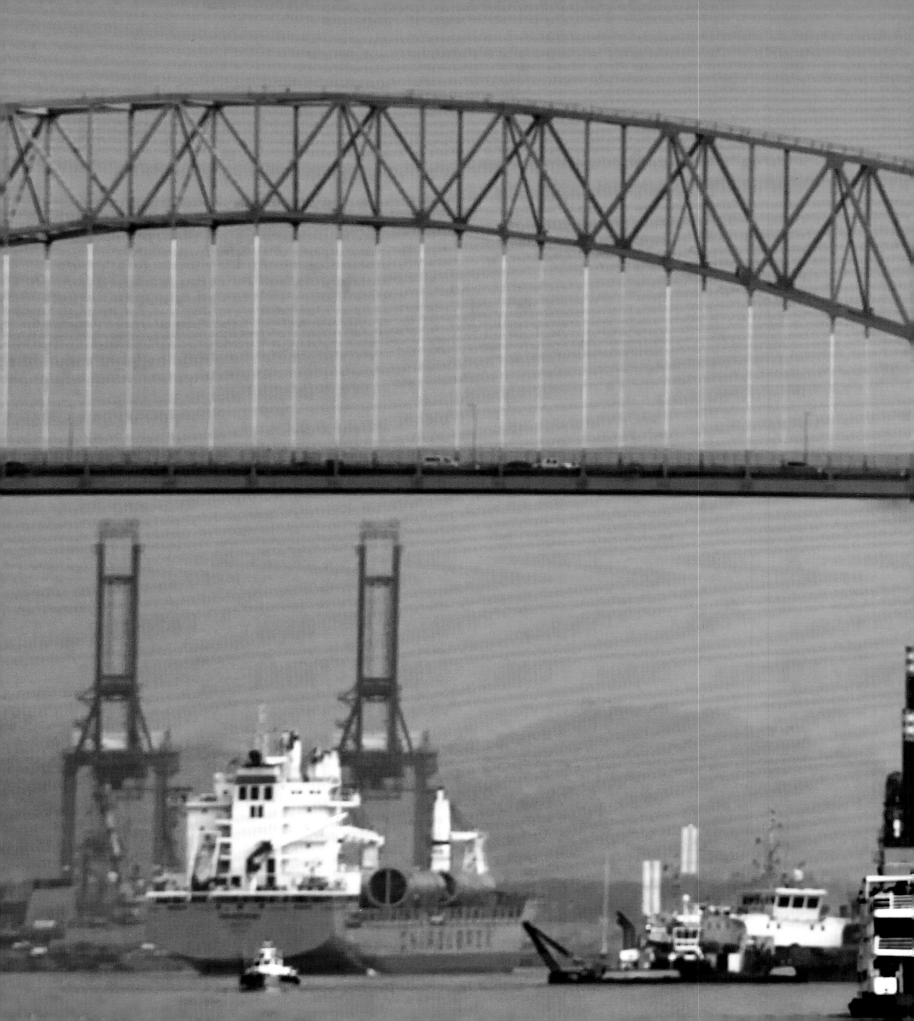

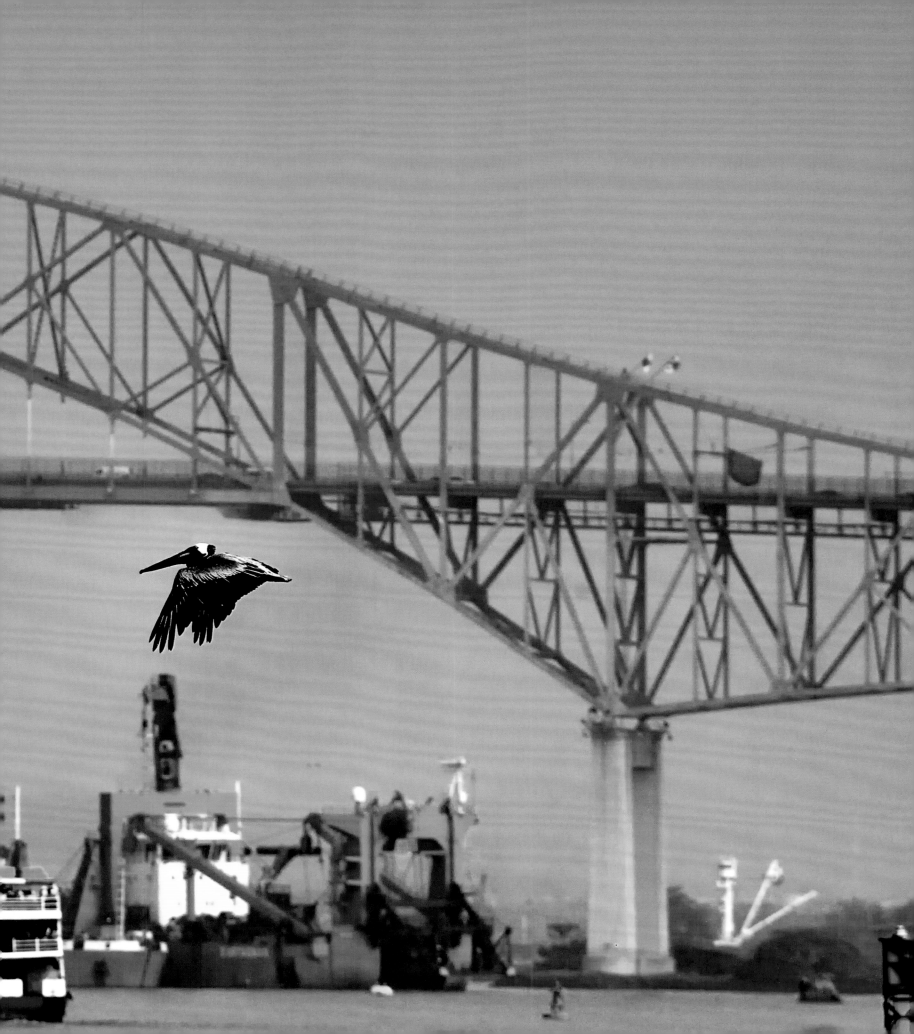

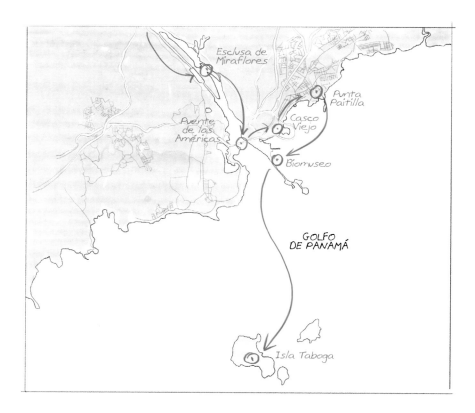

Finally, we cross the last "gate," the one that gives us a view of the Pacific Ocean and will take us to Panama: the Bridge of the Americas. For forty-two years, this stunning metal arch was the only fixed passage between North and South America, the only asphalt strip that soared over the Panama Canal to connect the two continents.

From the time of the Canal's inauguration, in fact, the country had been divided in two, its two shores connected only by a boat system first and by ferries later. During the Second World War a mobile bridge was created, and, finally, in 1955 the United States began building the arch, which was inaugurated in 1962. The problem seemed to have been solved... that is, until the congested traffic made circulation impossible once more, forcing the authorities to build a second passage: the Centennial Bridge that we left behind us further toward the north.

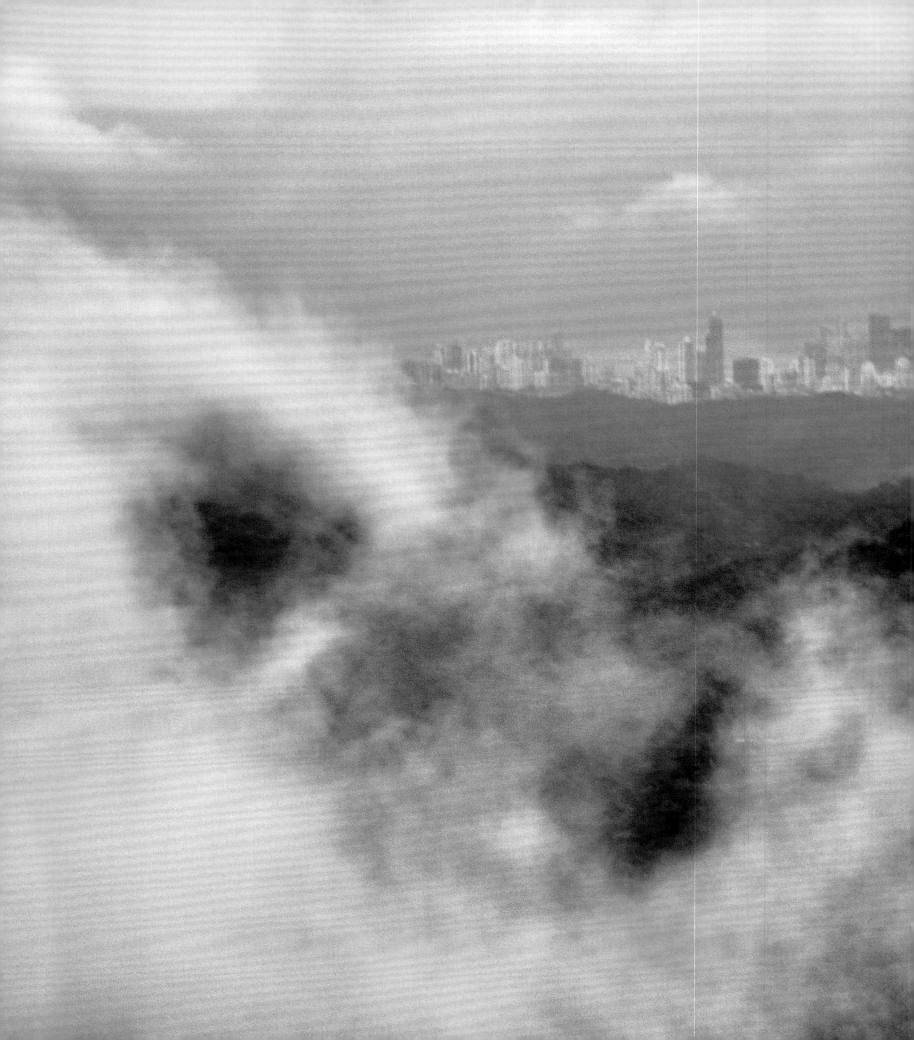

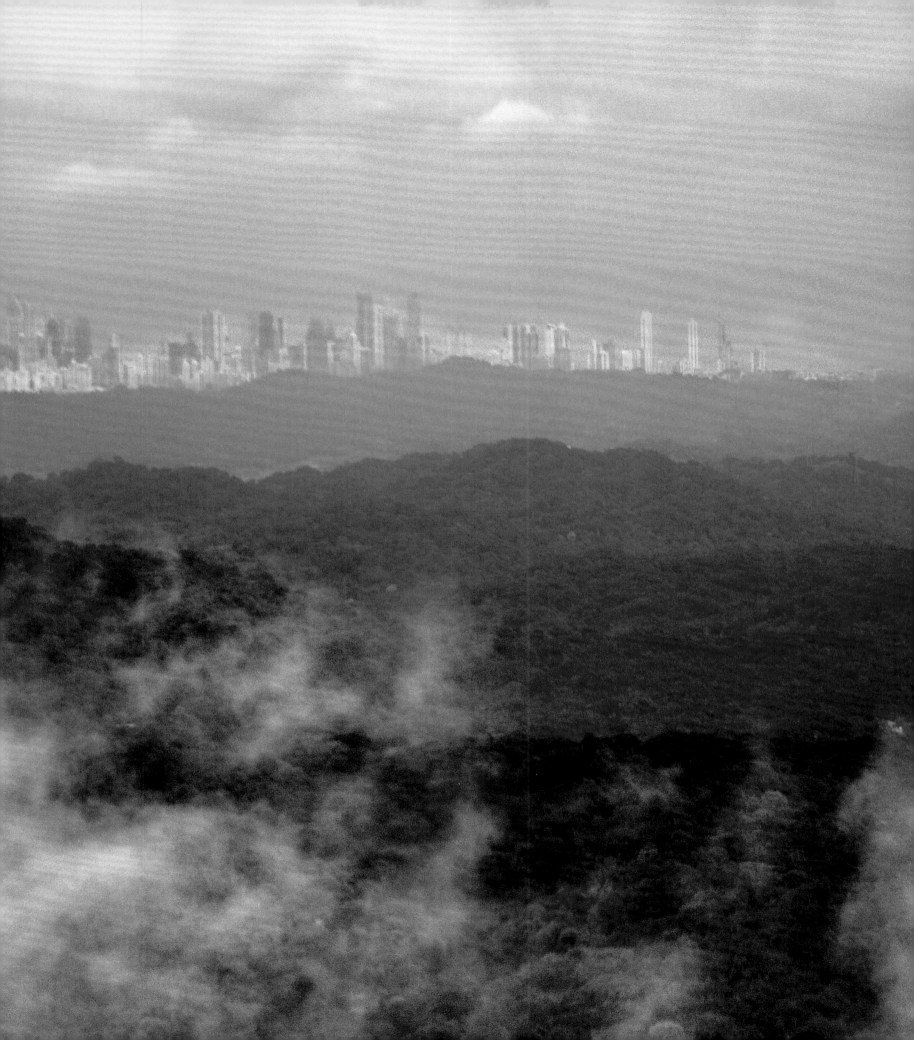

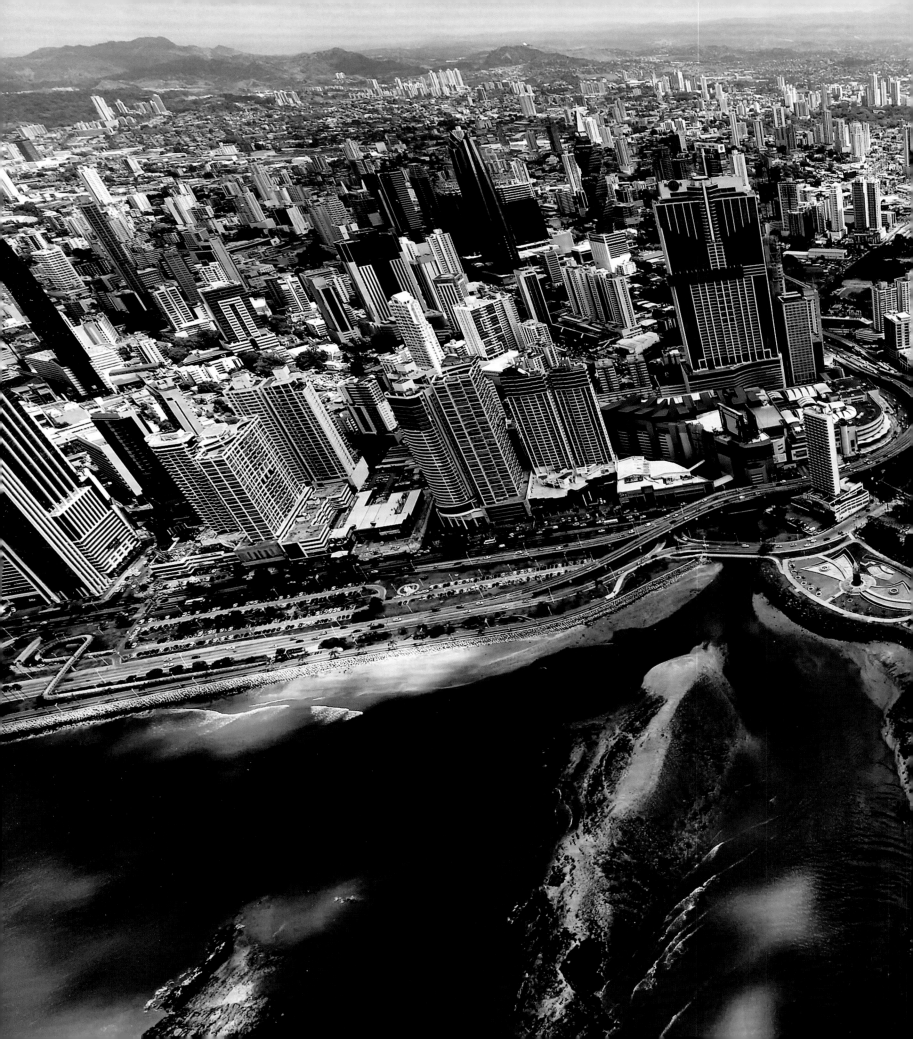

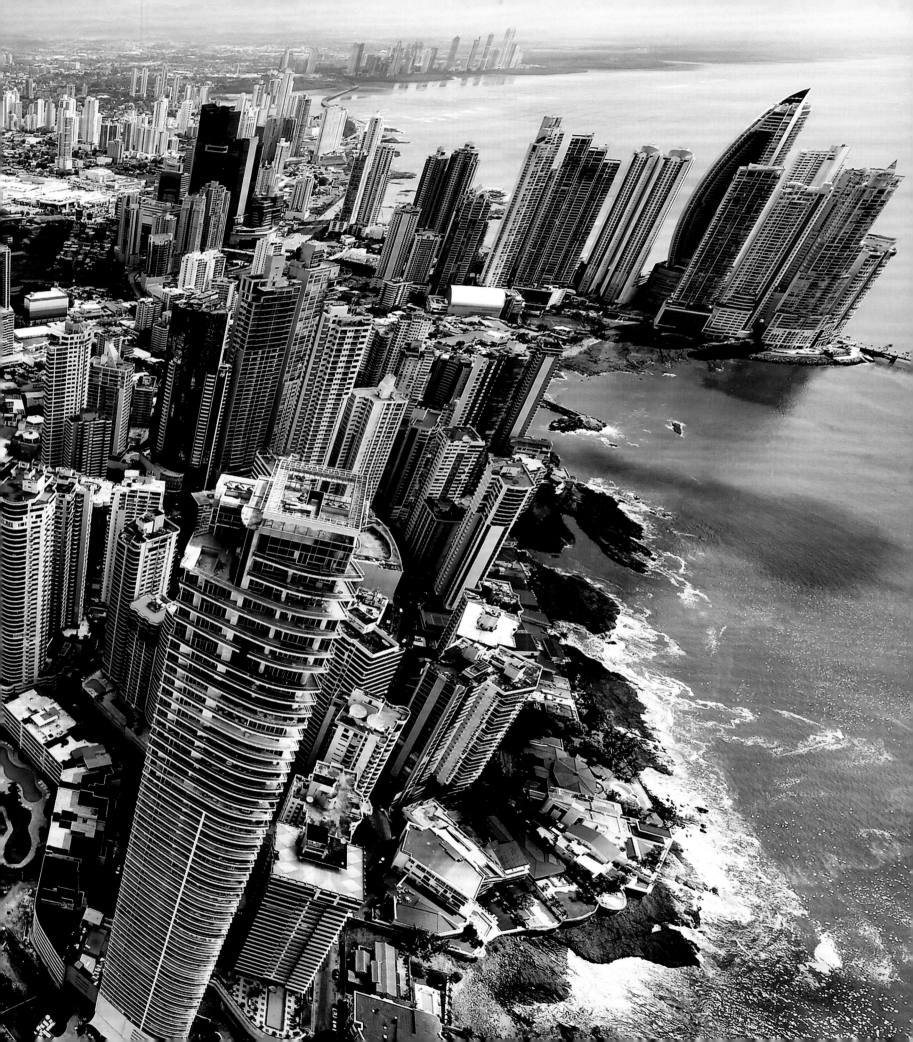

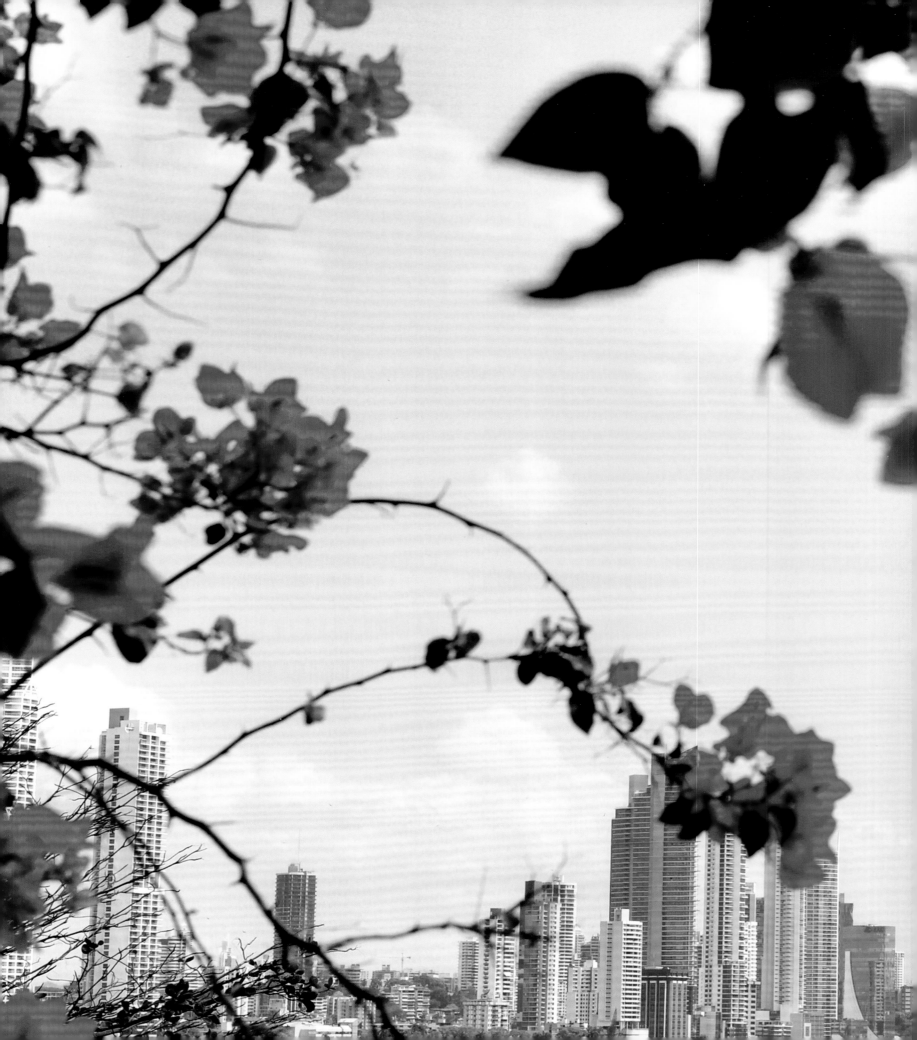

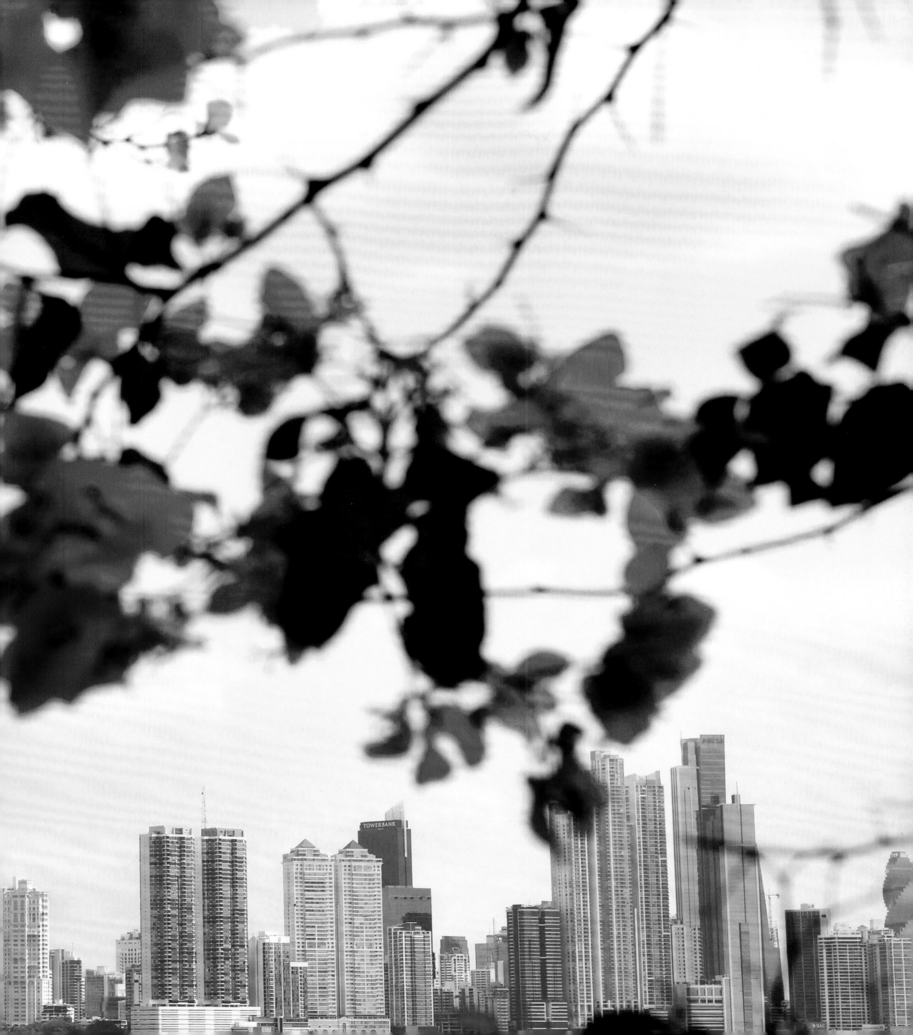

Panama City: Old Spain, New America, with a hint of Dubai and the Far East. Skyscrapers, colonial houses, and nightlife so exciting dawn arrives without your even realizing.
Land of transit and migration, Panama has welcomed into its capital a combination of races and cultures that have made it unique, and the finest music, the preeminent cosmopolitan and universal language, has added sound to all the color. In the streets and shops, in the eateries and on the buses, folk or jazz: music is everywhere, music is everyone.

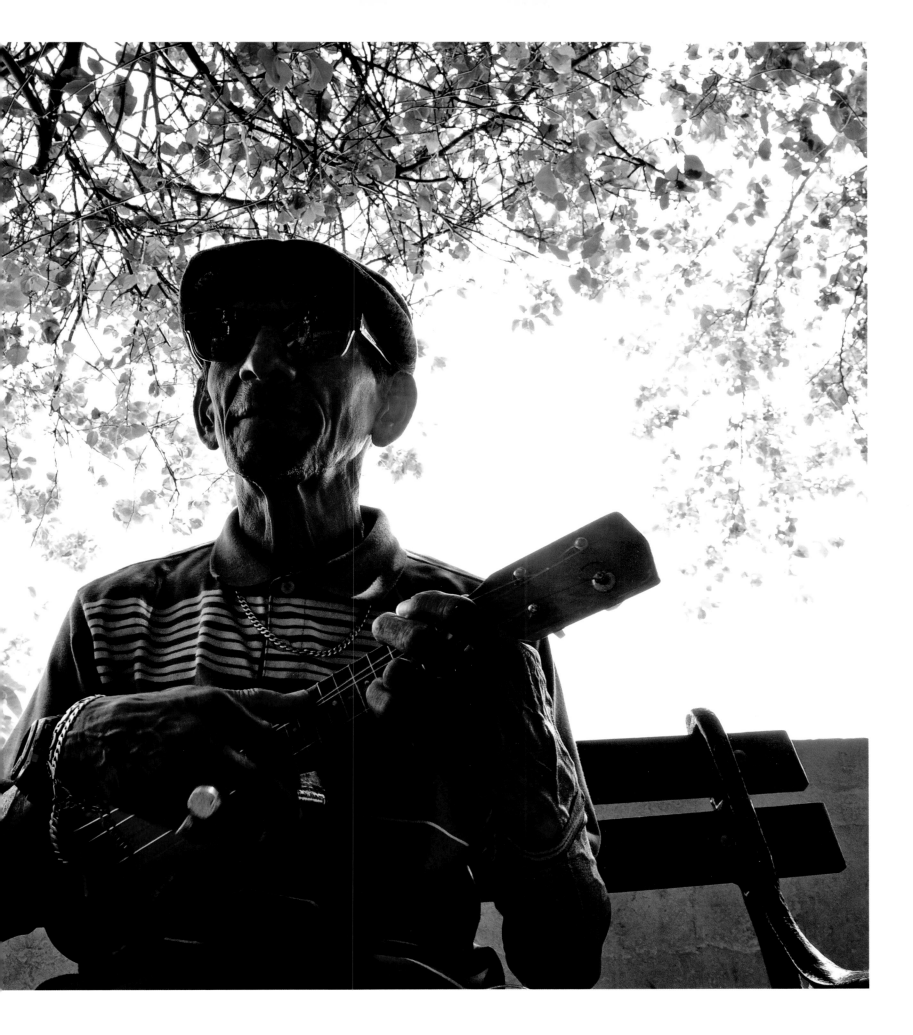

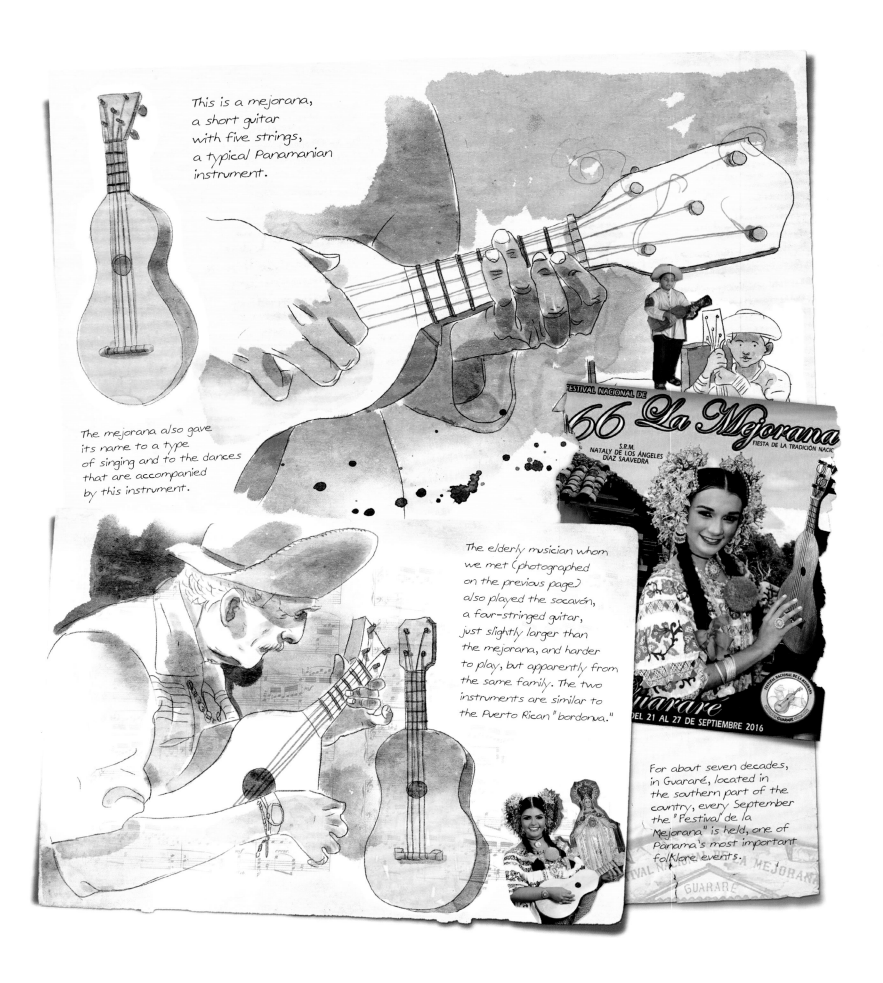

This is a mejorana, a short guitar with five strings, a typical Panamanian instrument.

The mejorana also gave its name to a type of singing and to the dances that are accompanied by this instrument.

The elderly musician whom we met (photographed on the previous page) also played the socavón, a four-stringed guitar, just slightly larger than the mejorana, and harder to play, but apparently from the same family. The two instruments are similar to the Puerto Rican "bordonua."

For about seven decades, in Guararé, located in the southern part of the country, every September the "Festival de la Mejorana" is held, one of Panama's most important folklore events.

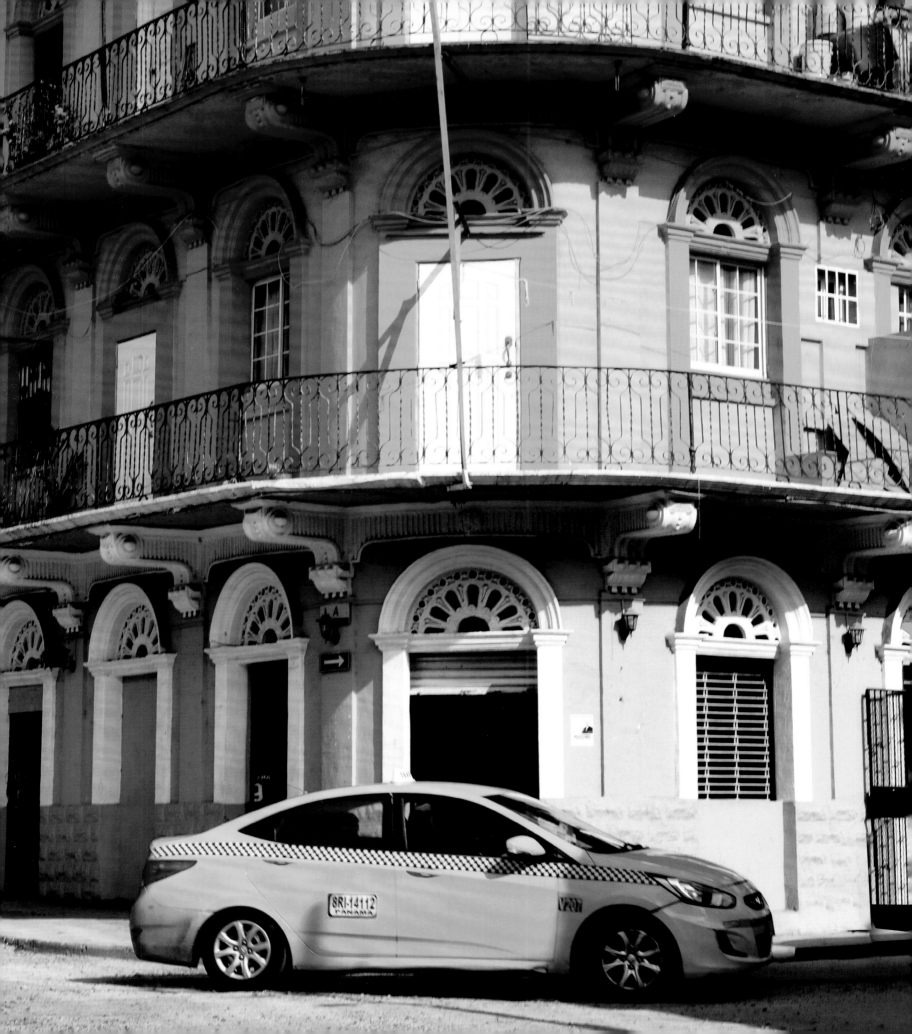

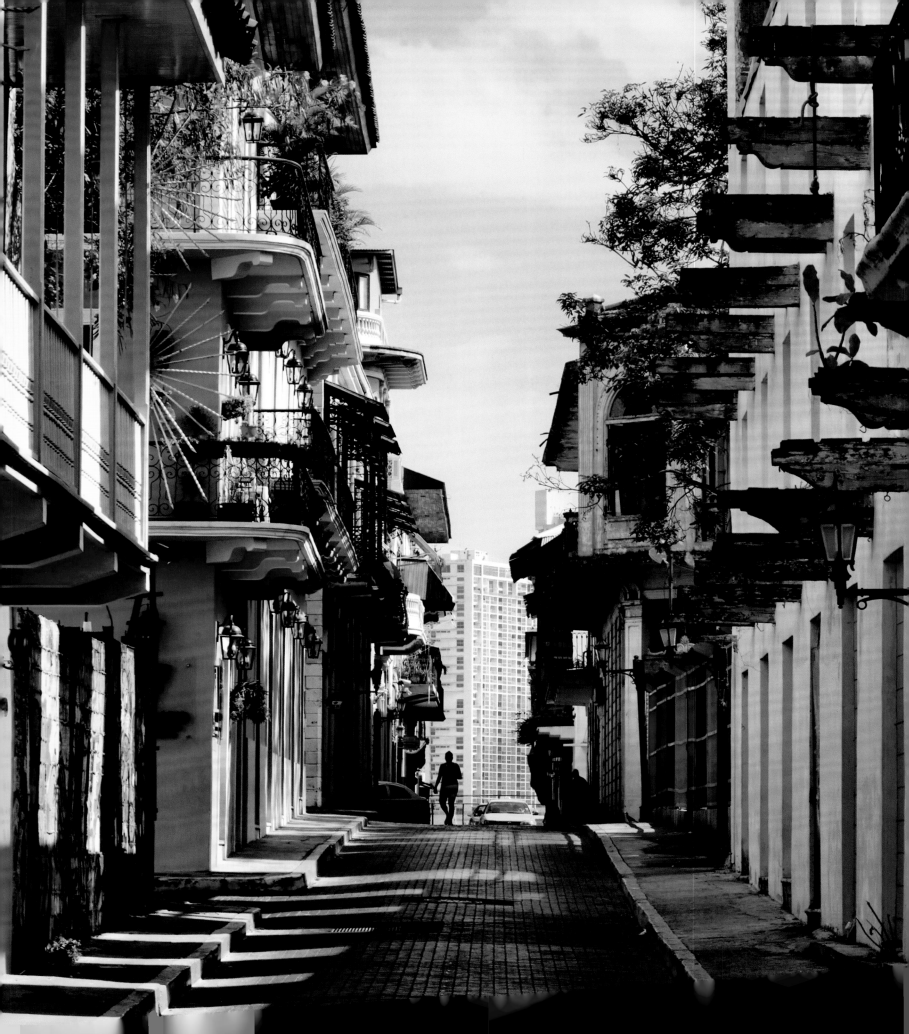

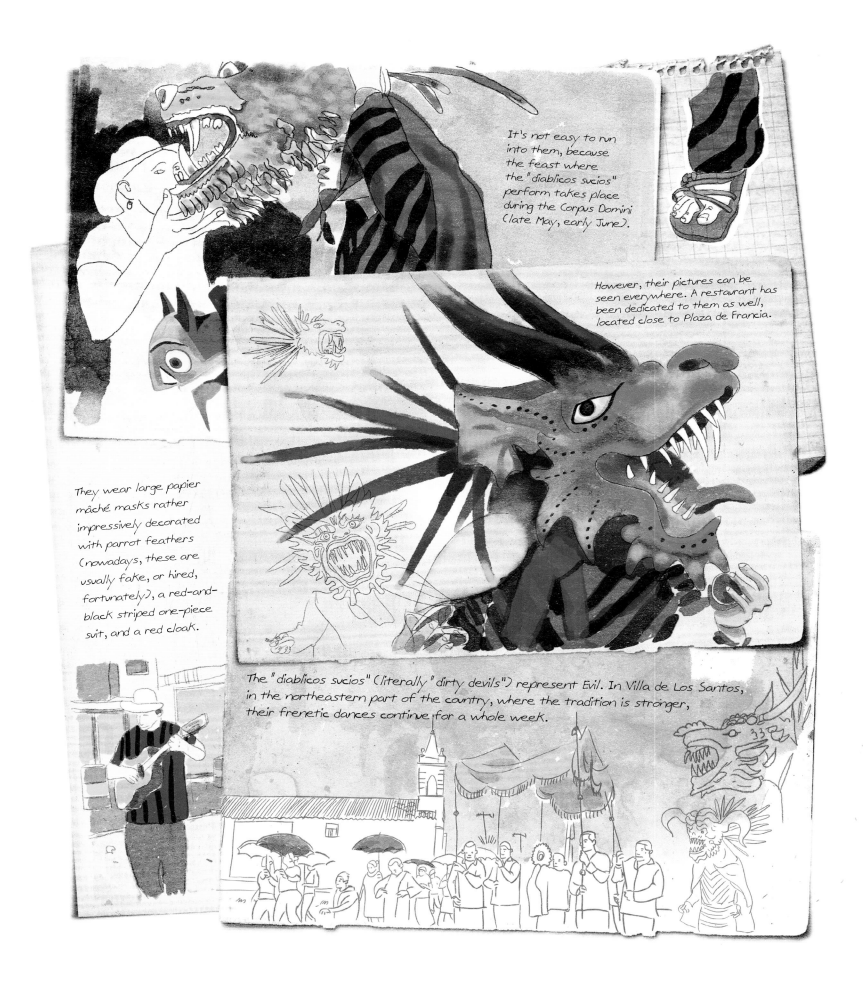

It's not easy to run into them, because the feast where the "diablicos sucios" perform takes place during the Corpus Domini (late May, early June).

However, their pictures can be seen everywhere. A restaurant has been dedicated to them as well, located close to Plaza de Francia.

They wear large papier mâché masks rather impressively decorated with parrot feathers (nowadays, these are usually fake, or hired, fortunately), a red-and-black striped one-piece suit, and a red cloak.

The "diablicos sucios" (literally "dirty devils") represent Evil. In Villa de Los Santos, in the northeastern part of the country, where the tradition is stronger, their frenetic dances continue for a whole week.

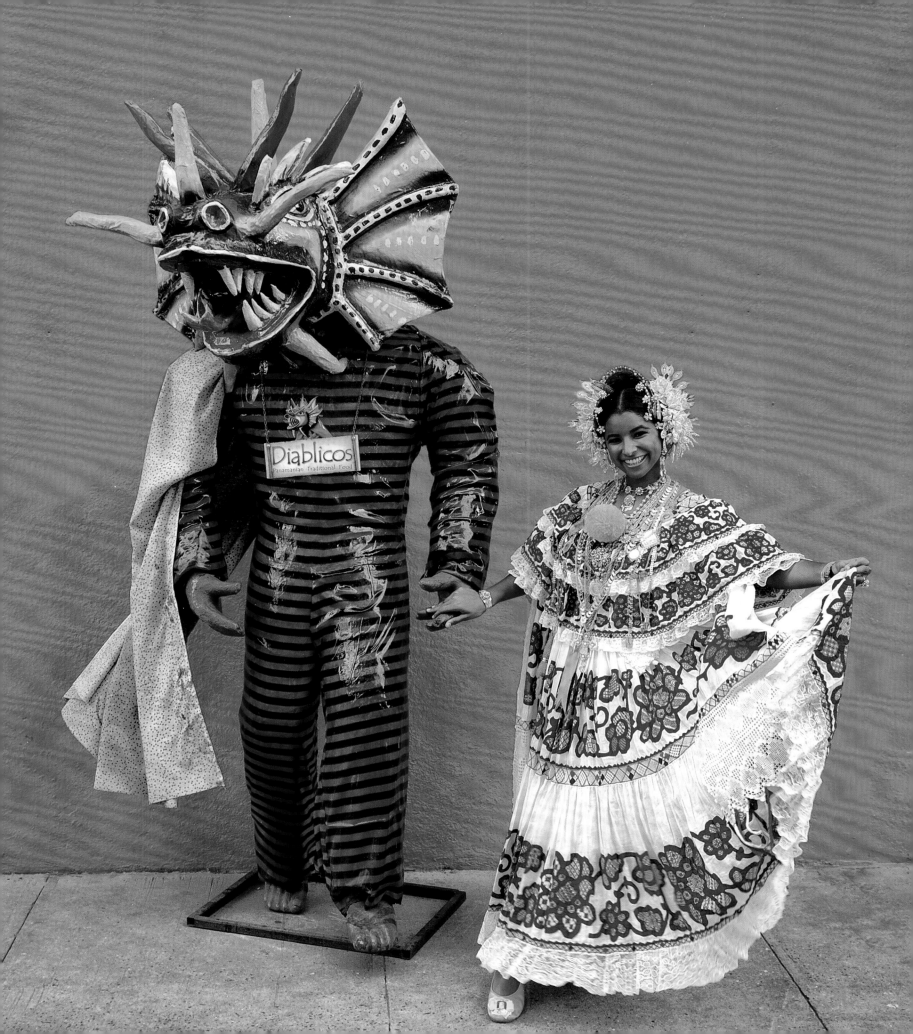

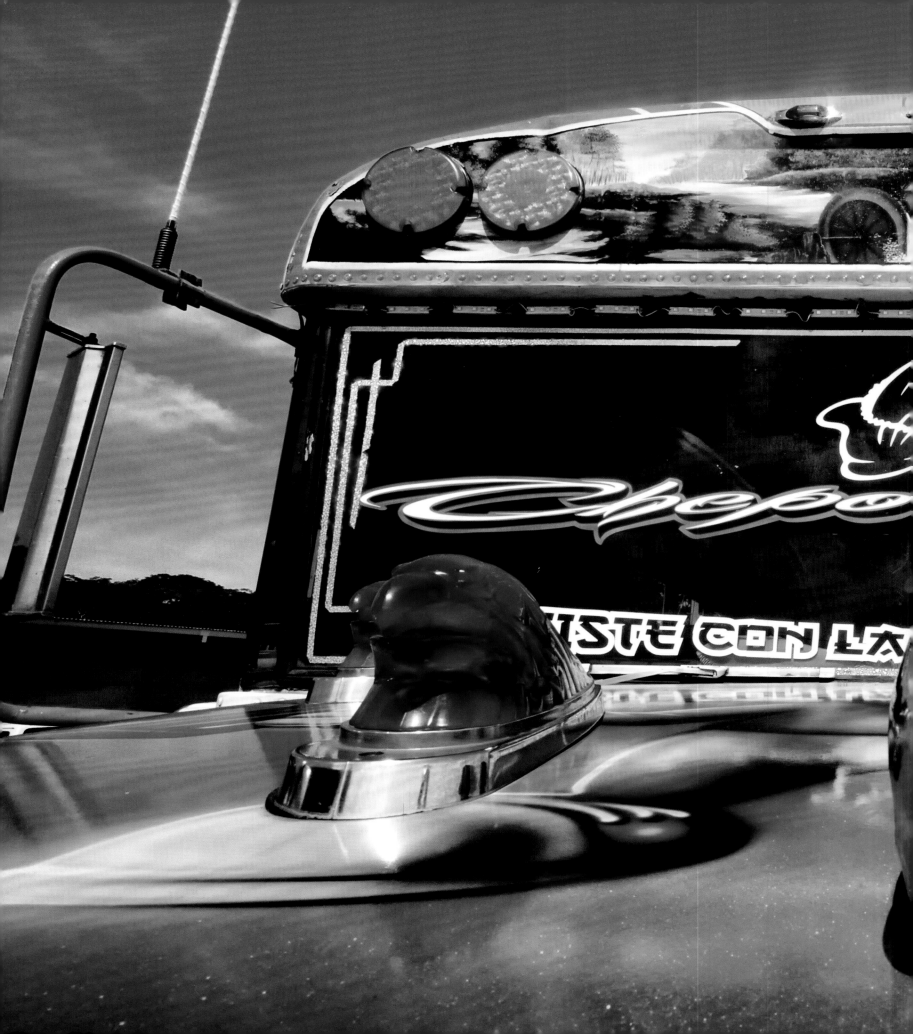

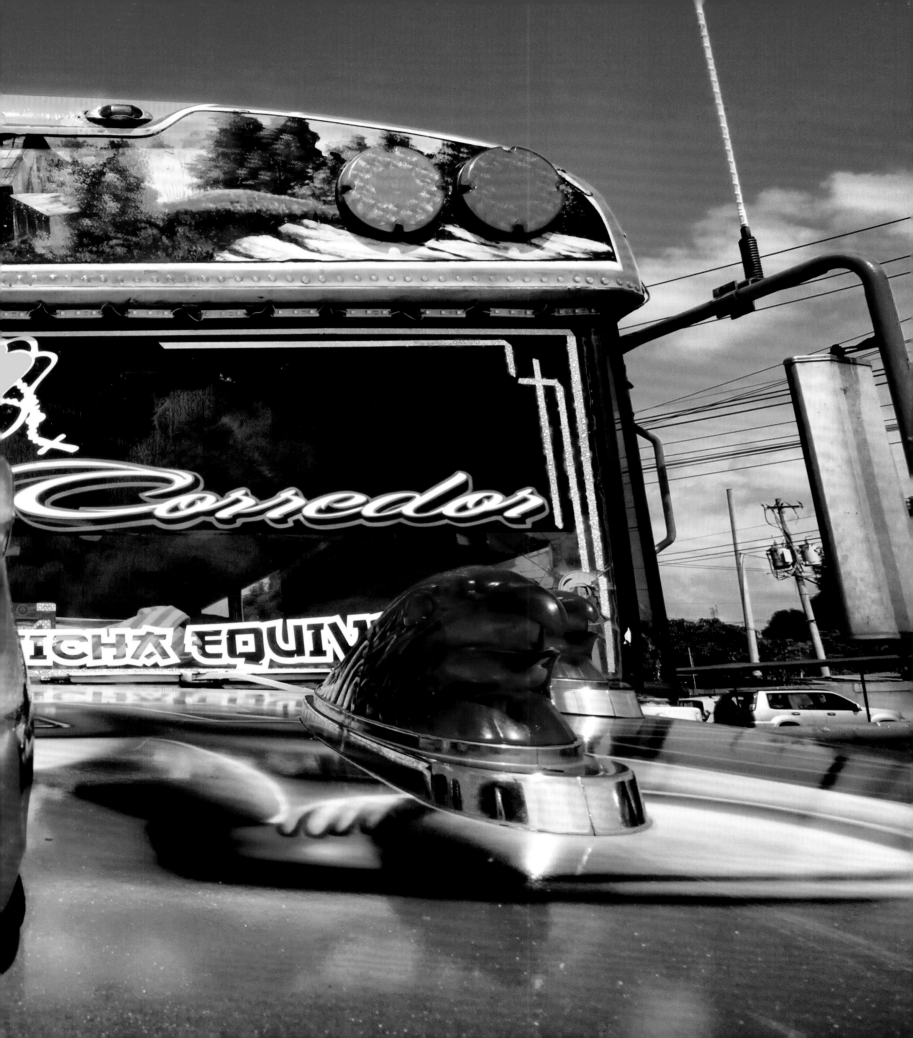

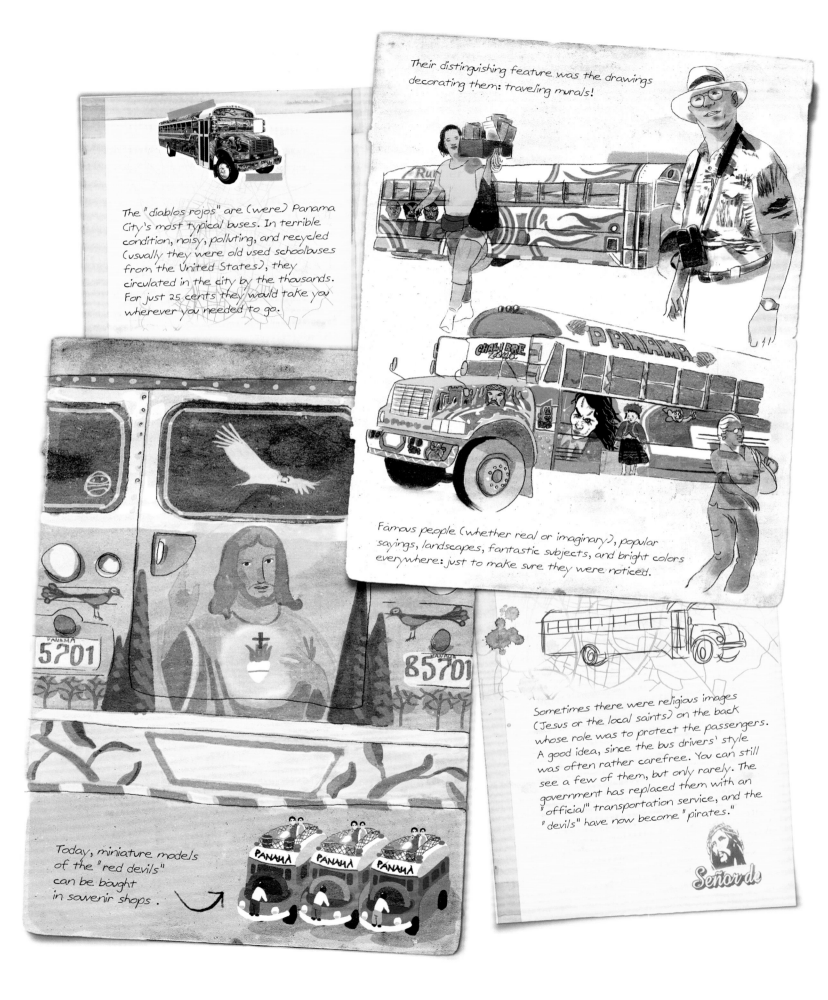

The "diablos rojos" are (were) Panama City's most typical buses. In terrible condition, noisy, polluting, and recycled (usually they were old used schoolbuses from the United States), they circulated in the city by the thousands. For just 25 cents they would take you wherever you needed to go.

Their distinguishing feature was the drawings decorating them: traveling murals!

Famous people (whether real or imaginary), popular sayings, landscapes, fantastic subjects, and bright colors everywhere: just to make sure they were noticed.

Sometimes there were religious images (Jesus or the local saints) on the back whose role was to protect the passengers. A good idea, since the bus drivers' style was often rather carefree. You can still see a few of them, but only rarely. The government has replaced them with an "official" transportation service, and the "devils" have now become "pirates."

Today, miniature models of the "red devils" can be bought in souvenir shops.

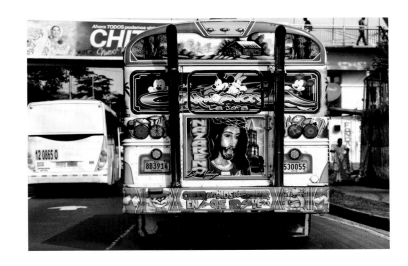

Like most major cities, Panama City must also solve its congestion problem, which is truly chaotic during rush hour: understandably, these are perhaps the only moments in the day when even the naturally calm Panamanians show some signs of aggressiveness...
The solutions: to cut the number of taxis (a huge number, and relatively economical), improve public transportation, ban the pirate buses. Unlike other major cities, instead, bicycles do not seem to be the vehicles of the future for Panama City. This is partly because of the climate (often either too hot and muggy for physical exercise, or too rainy), and partly because the streets are narrow and there isn't enough room to create bicycle paths. And we cannot overlook the number of reckless drivers, making these paths even more dangerous. On the other hand, especially on Sundays, the Cinta Costera and the Calzada de Amador offer bicyclists a breathtaking tour of the bay and of the Bridge of the Americas.

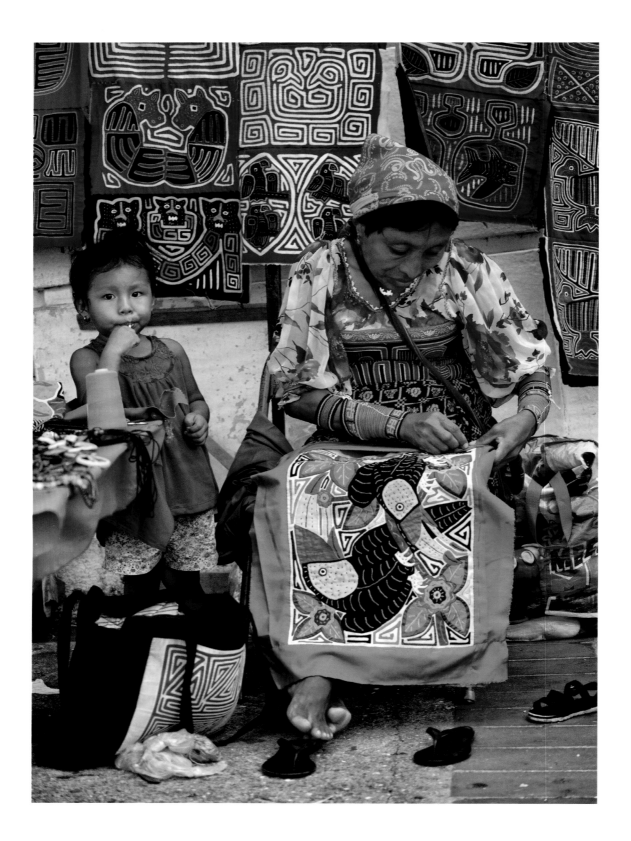

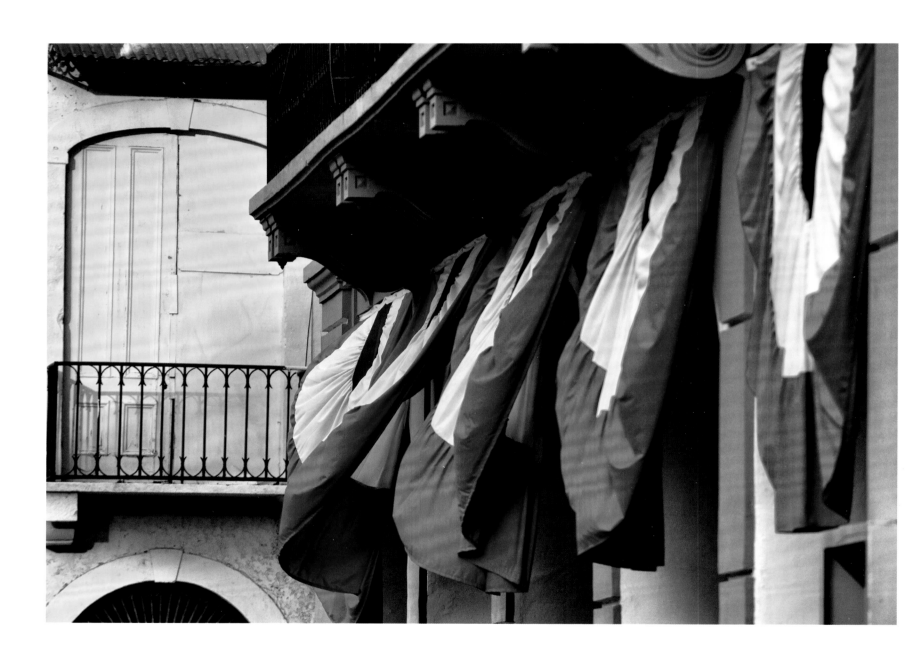

The church of San José, in Casco Viejo, is famous for its altar covered in gold leaf. Legend has it that the monks saved it from the plundering of Morgan's pirates by hiding it under a layer of black dust. Things probably didn't go exactly that way, but the beauty of the location, the sumptuous Baroque details, still make it one of the most intriguing works from the colonial period. We decided to visit it with one of our "local guides" dressed in a *pollera*, the traditional woman's dress. Folklore, and not just of the religious kind, is very important in Panama: in a country where many stories and cultures are combined, the proud loyalty to one's (different) roots involves everybody, from the indigenous groups to the heirs to the *conquistadores*.

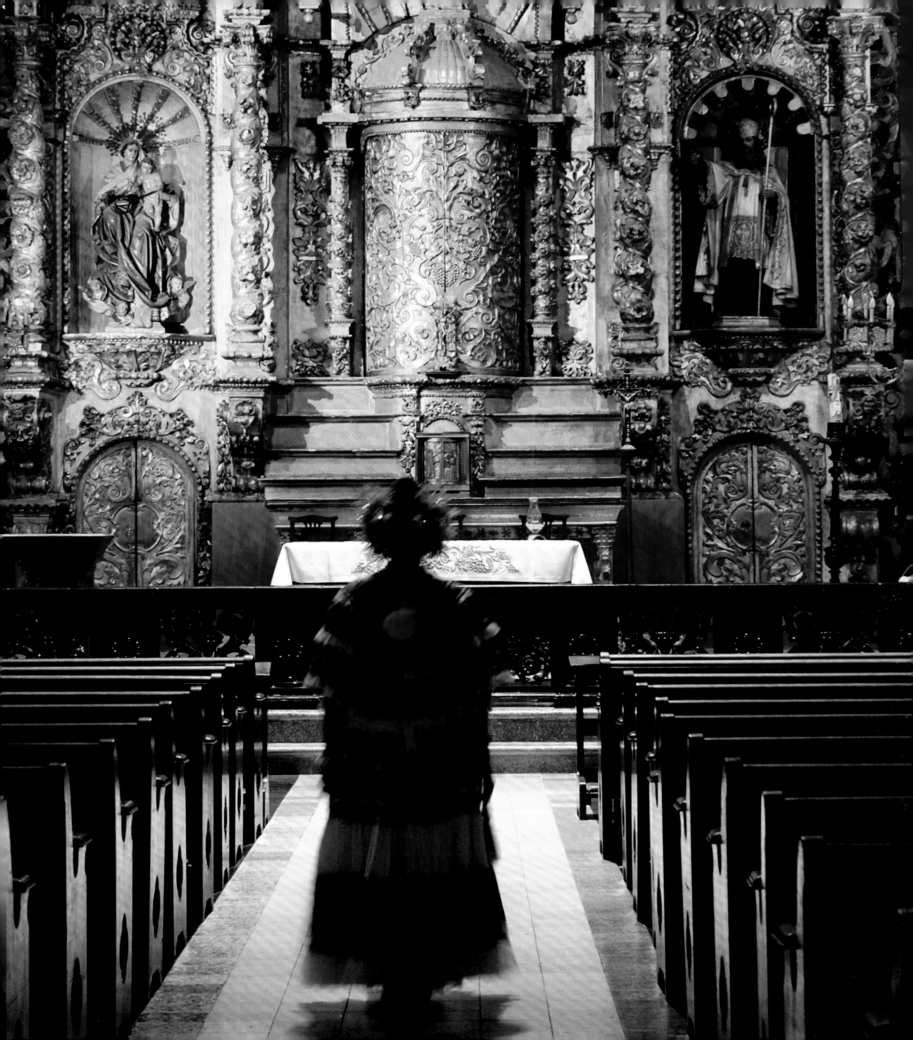

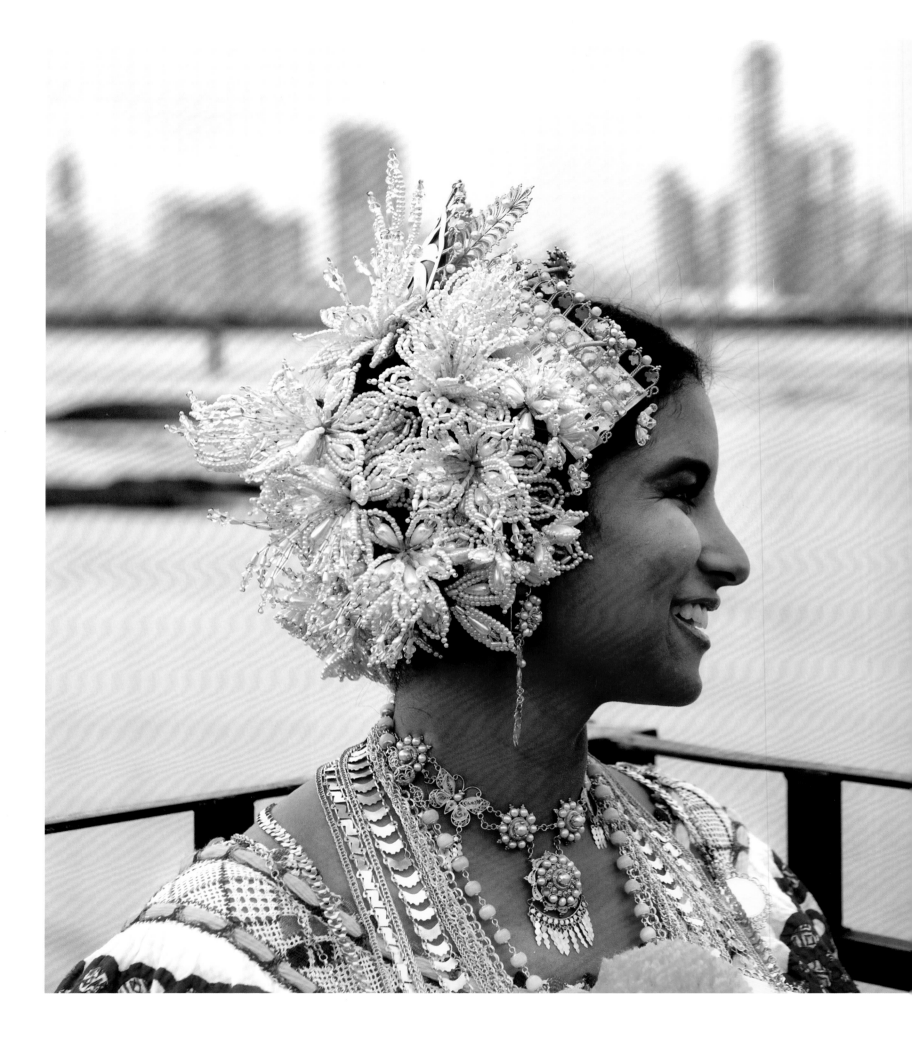

Mixing and overlapping in the capital are not just the races and traditions, but the architecture as well. Panama City is truly a city of remarkable contrasts. After strolling down the narrow streets of the colonial neighborhood of Casco Viejo, one of the most beautiful, most colorful locations in Latin America, it is enough for us to look out at the fisherman's wharf and further out at the opposite part of the bay, at Punta Paitilla, for the skyline of glass skyscrapers to transport us back to another time and another place, to a place poised between Manhattan, Miami, and Dubai.

Here, the Old World and the New World, the distance between them no more than the short flight of the pelican, are so close they can virtually look each other in the eye.

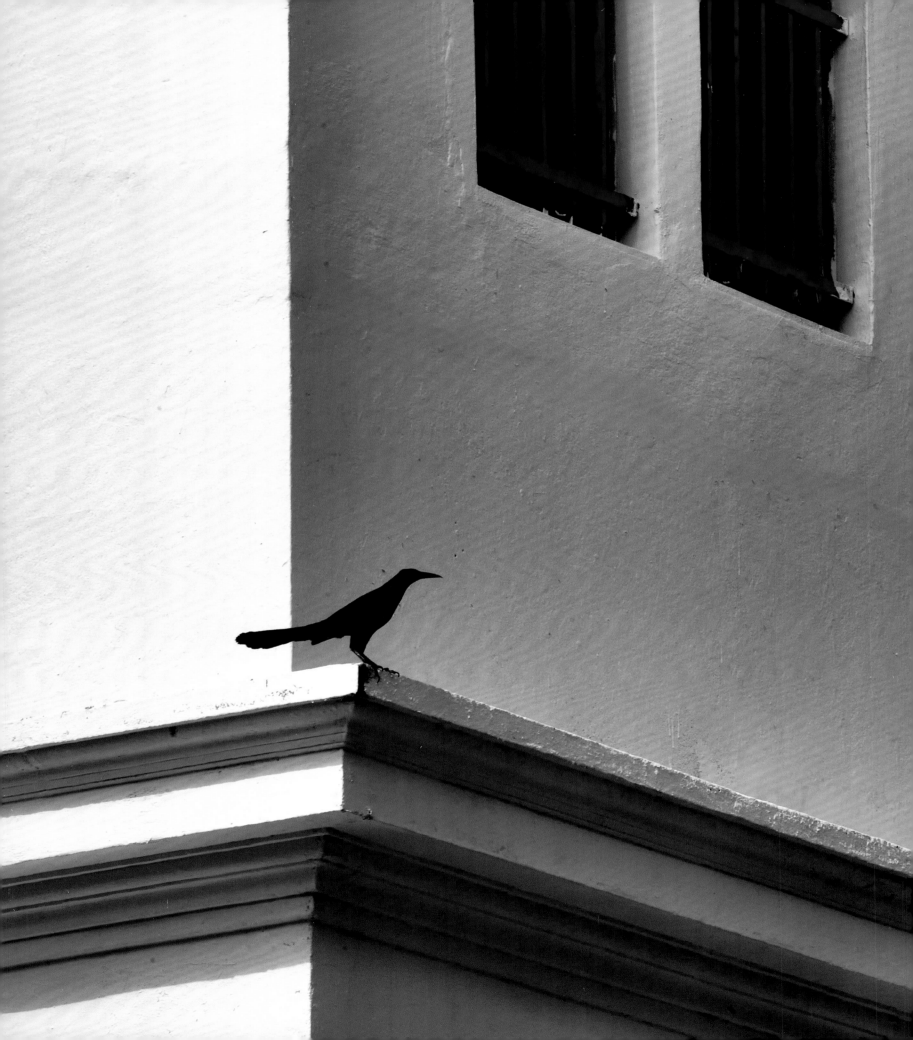

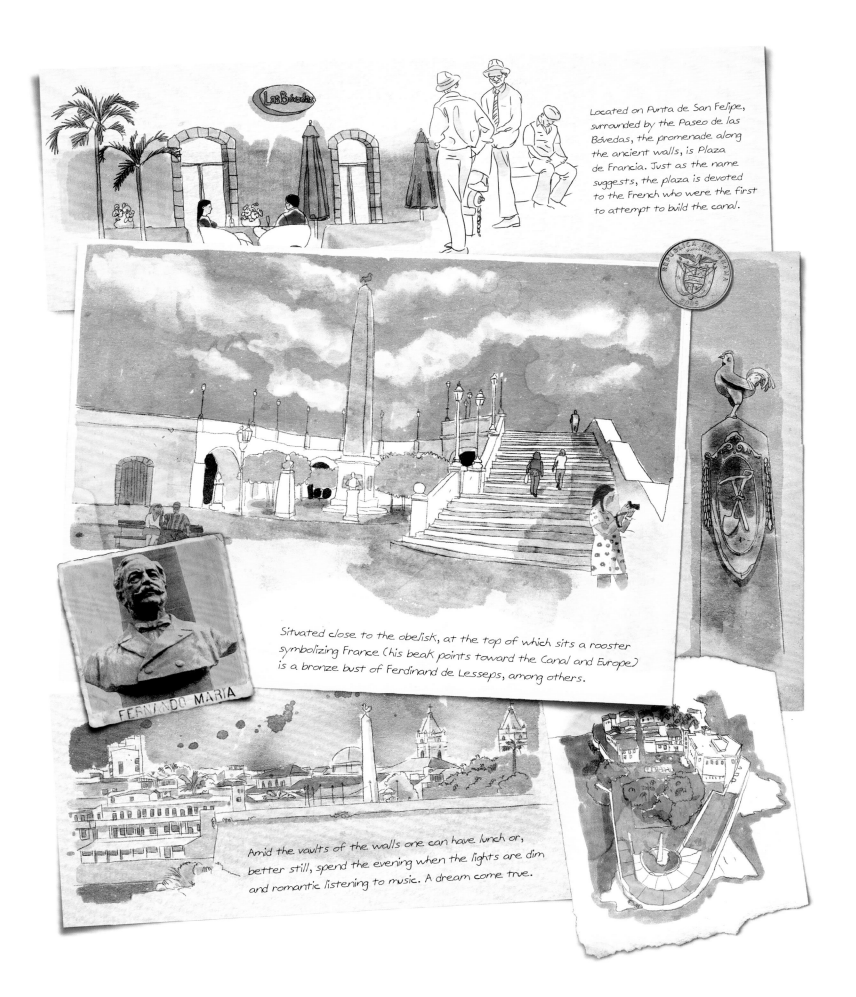

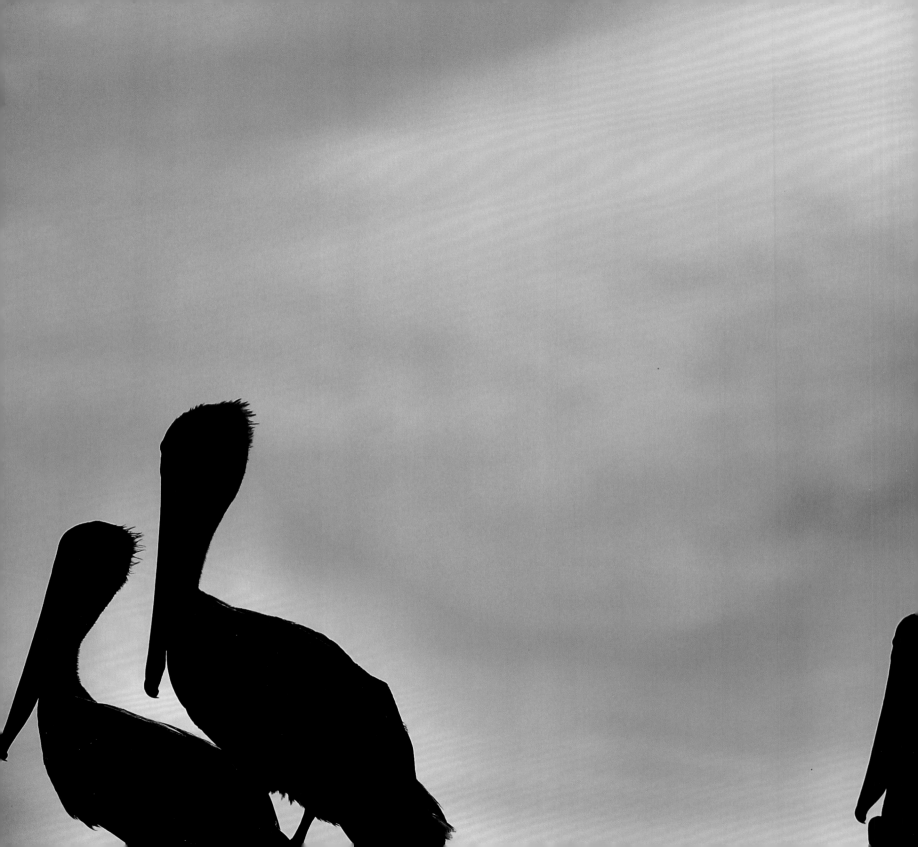

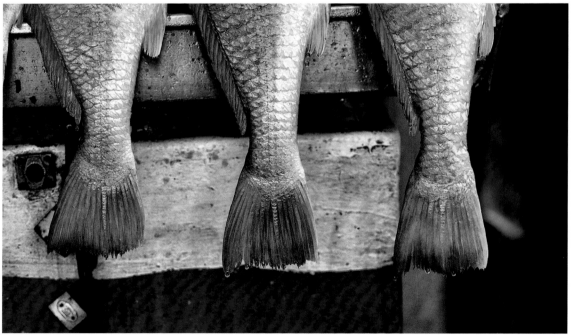

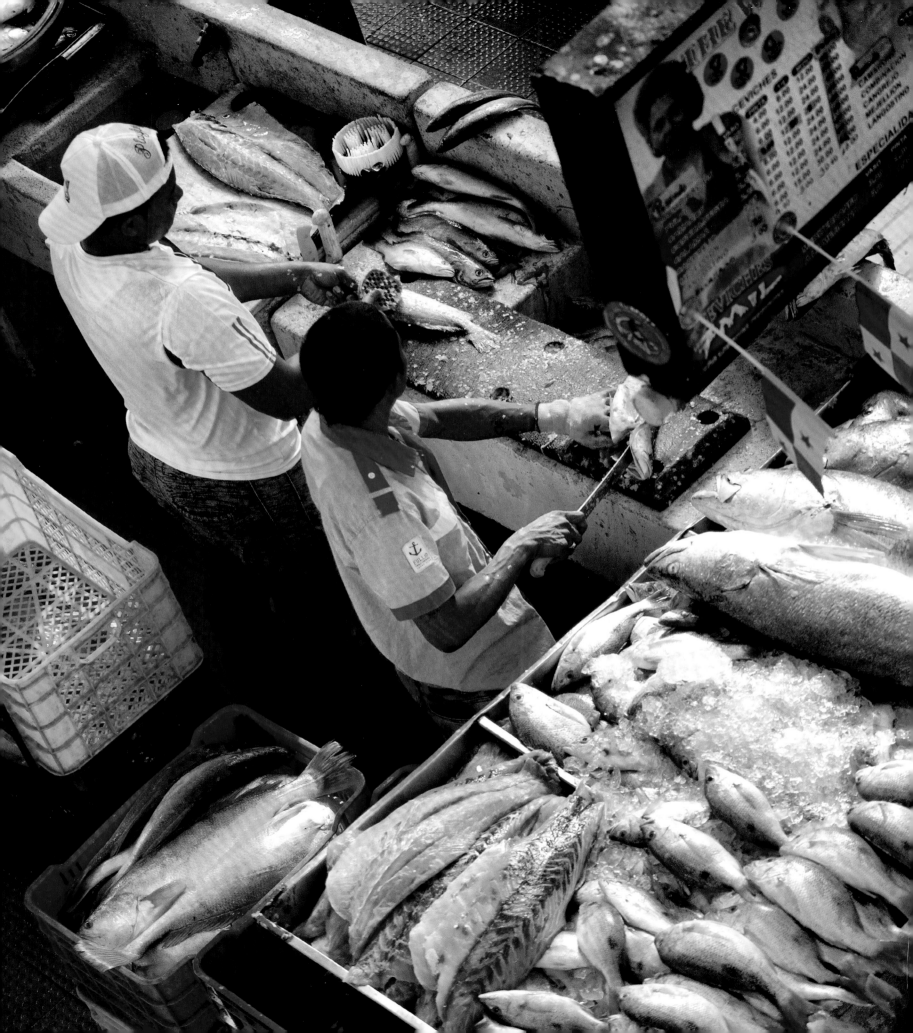

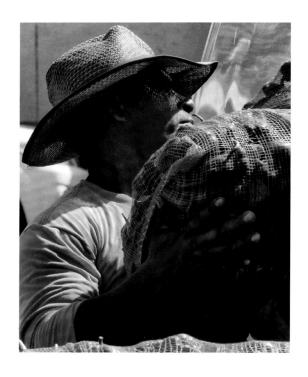

Before approaching Cinta Costera, however, we visit the fish market and nearby fruit and vegetable stands. All of our senses are overwhelmed by this immersion in the country's gastronomic palette. It is a triumph of fragrances, tastes, and colors, and the voices of fishermen and vendors complete the chaotic yet enjoyable confusion we experience surrounded by the stands.
We re-emerge with a fresh glass of "chicheme," a beverage made of corn (available everywhere here), milk, cinnamon, and vanilla, and whatever else it takes to create this magic potion that will energize you for the rest of the visit.

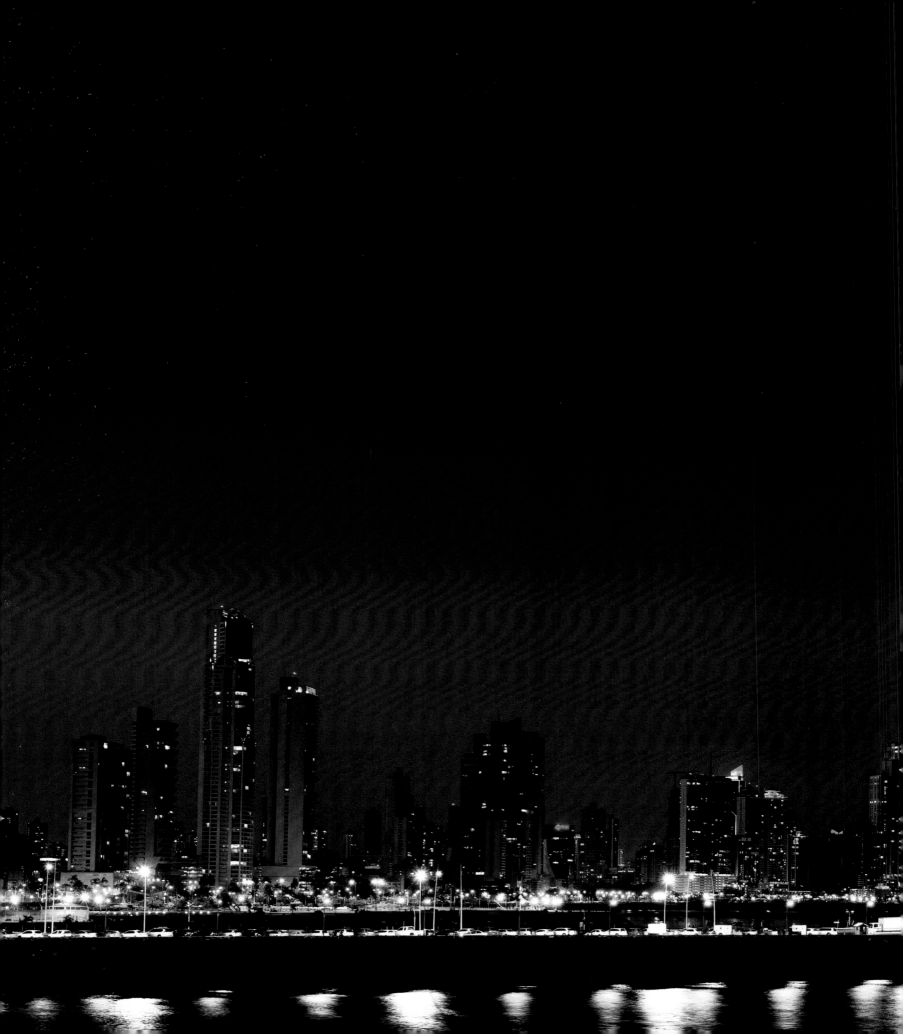

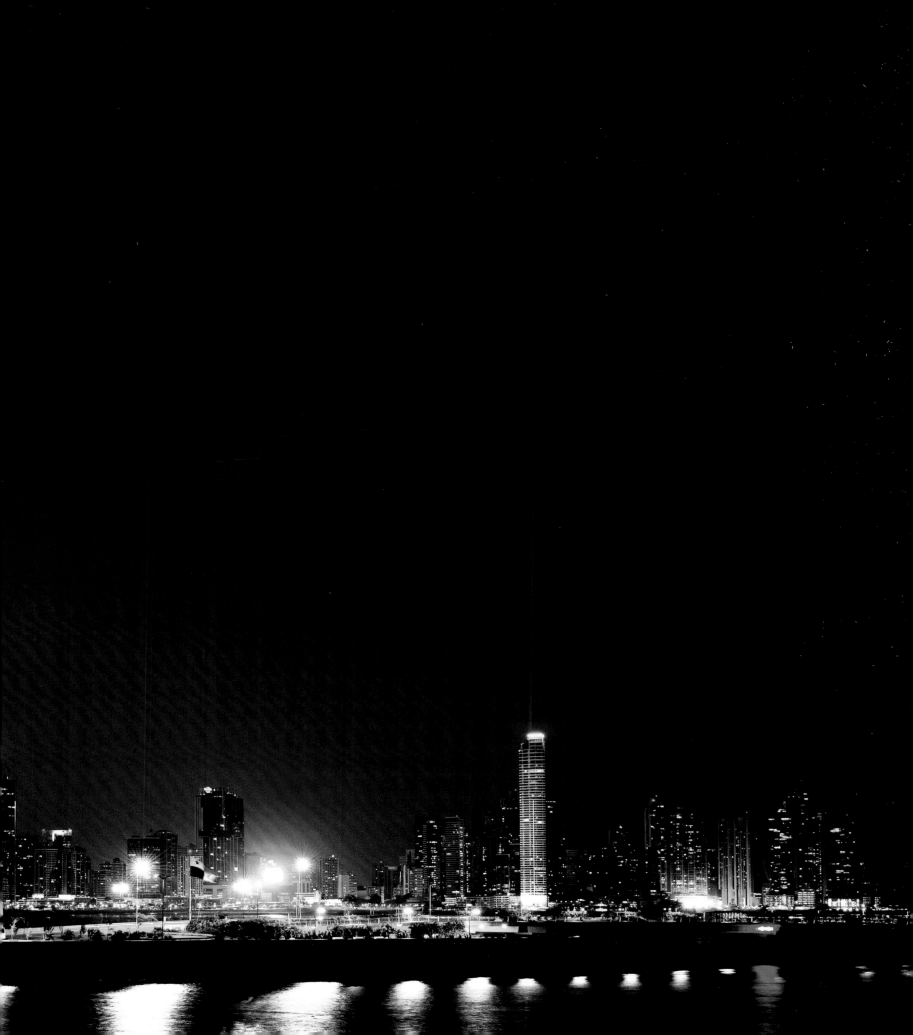

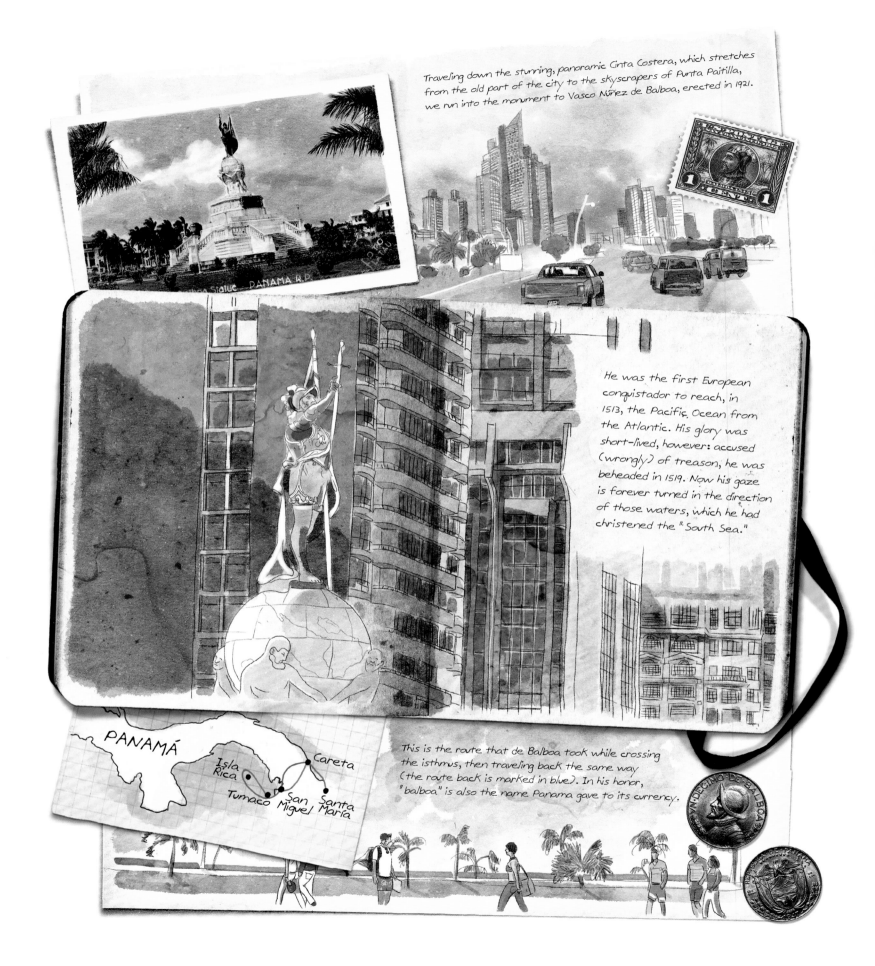

Traveling down the stunning, panoramic Cinta Costera, which stretches from the old part of the city to the skyscrapers of Punta Paitilla, we run into the monument to Vasco Núñez de Balboa, erected in 1921.

He was the first European conquistador to reach, in 1513, the Pacific Ocean from the Atlantic. His glory was short-lived, however: accused (wrongly) of treason, he was beheaded in 1519. Now his gaze is forever turned in the direction of those waters, which he had christened the "South Sea."

This is the route that de Balboa took while crossing the isthmus, then traveling back the same way (the route back is marked in blue). In his honor, "balboa" is also the name Panama gave to its currency.

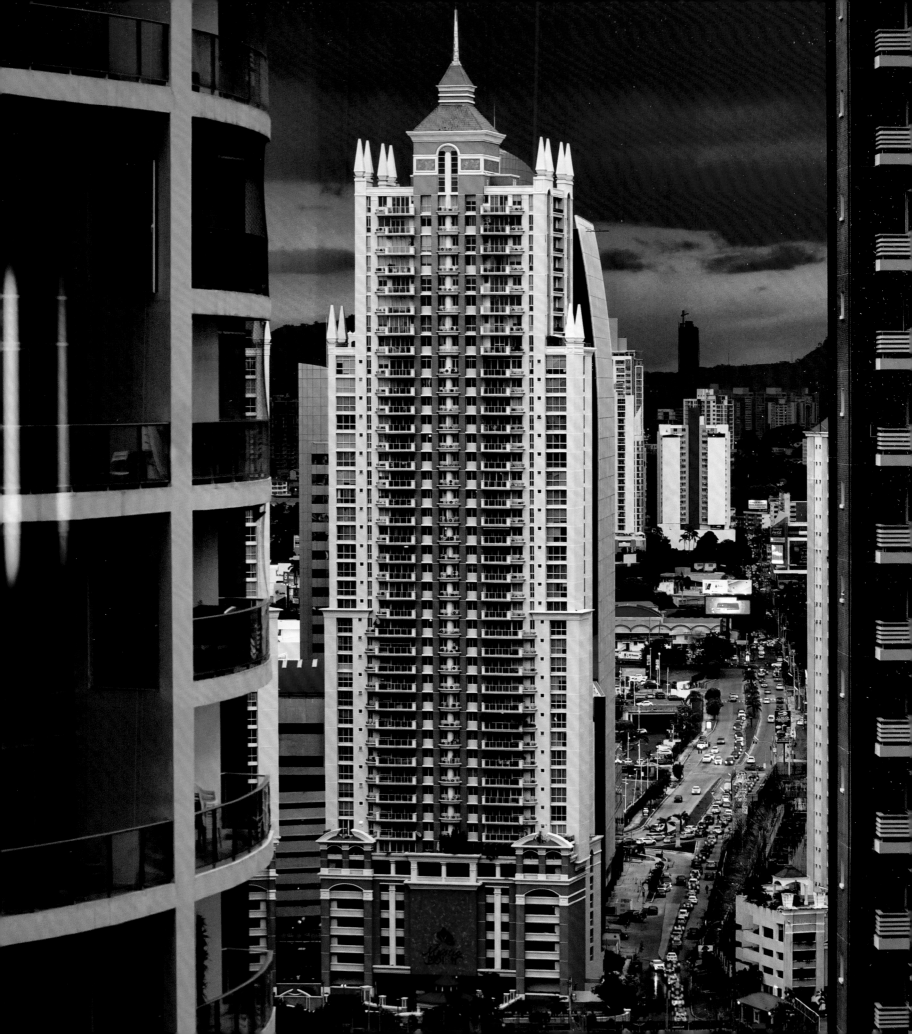

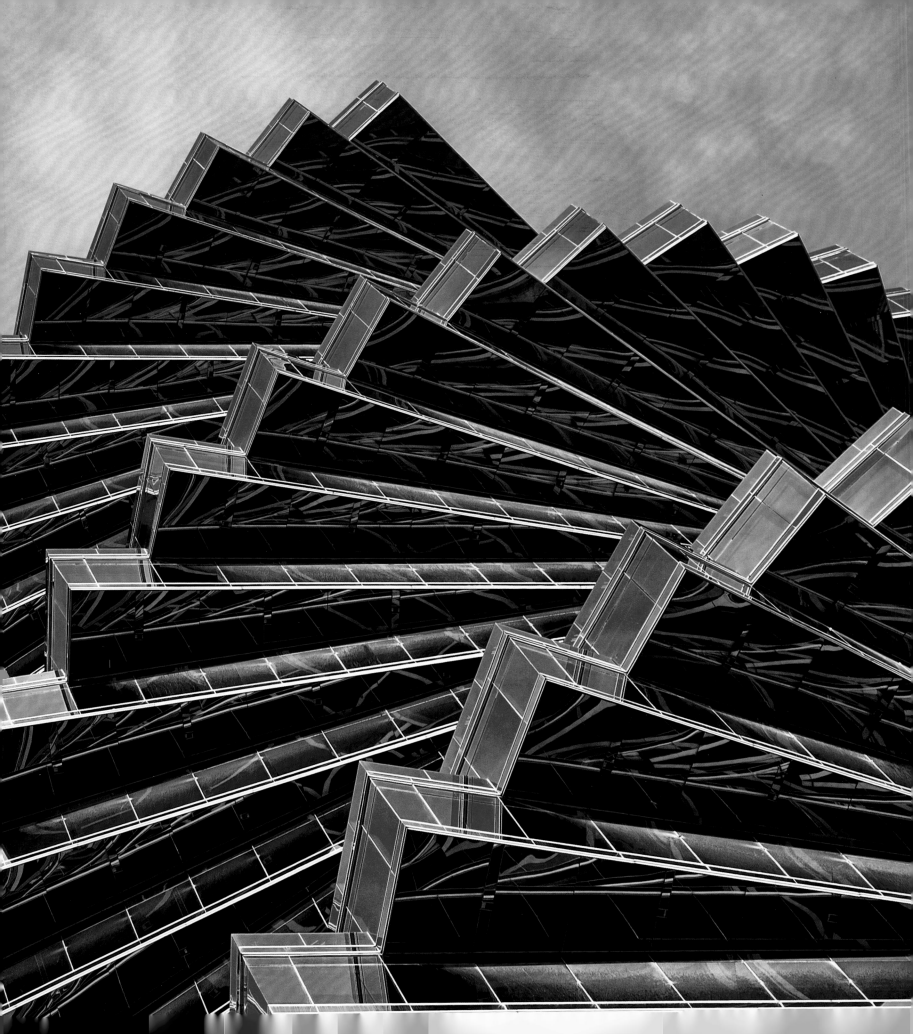

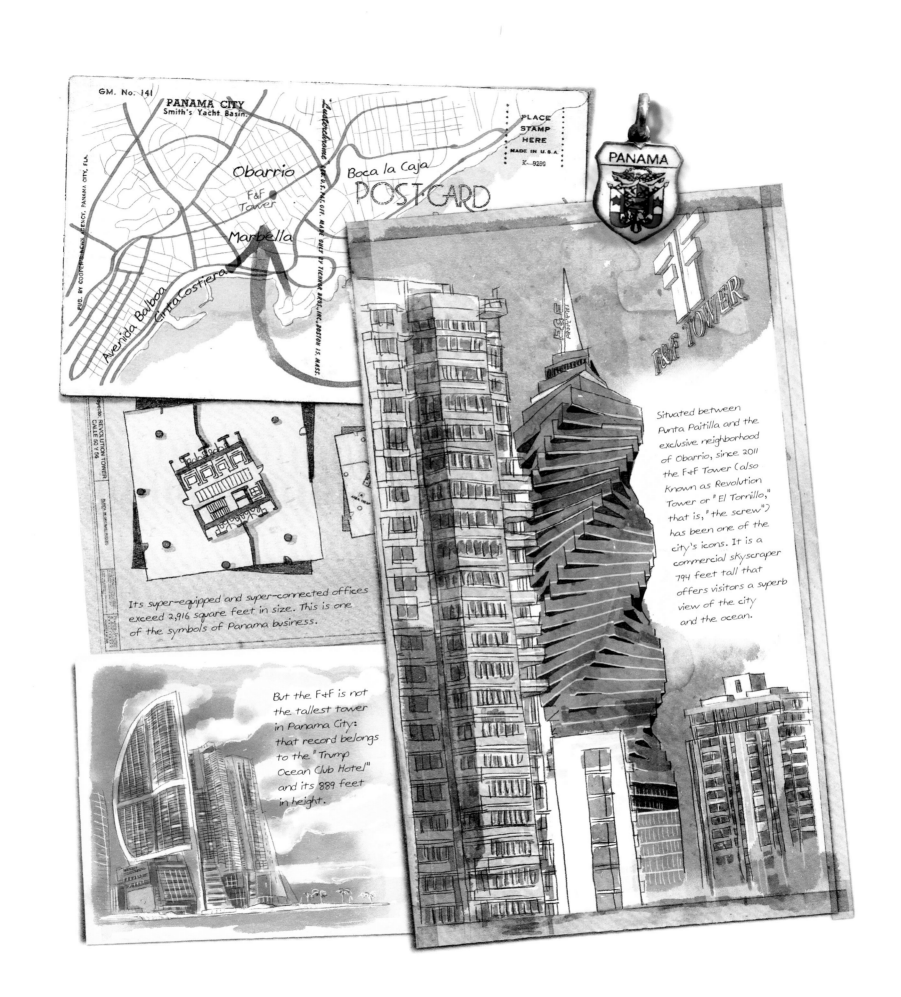

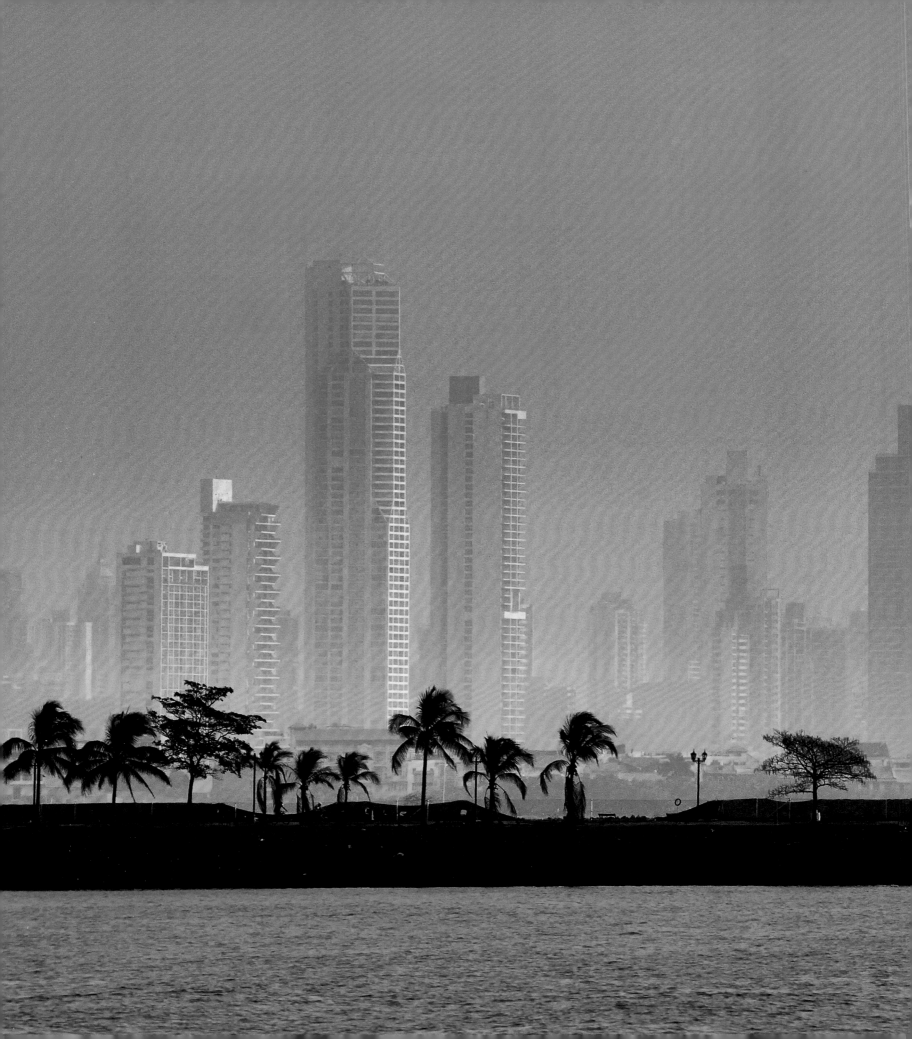

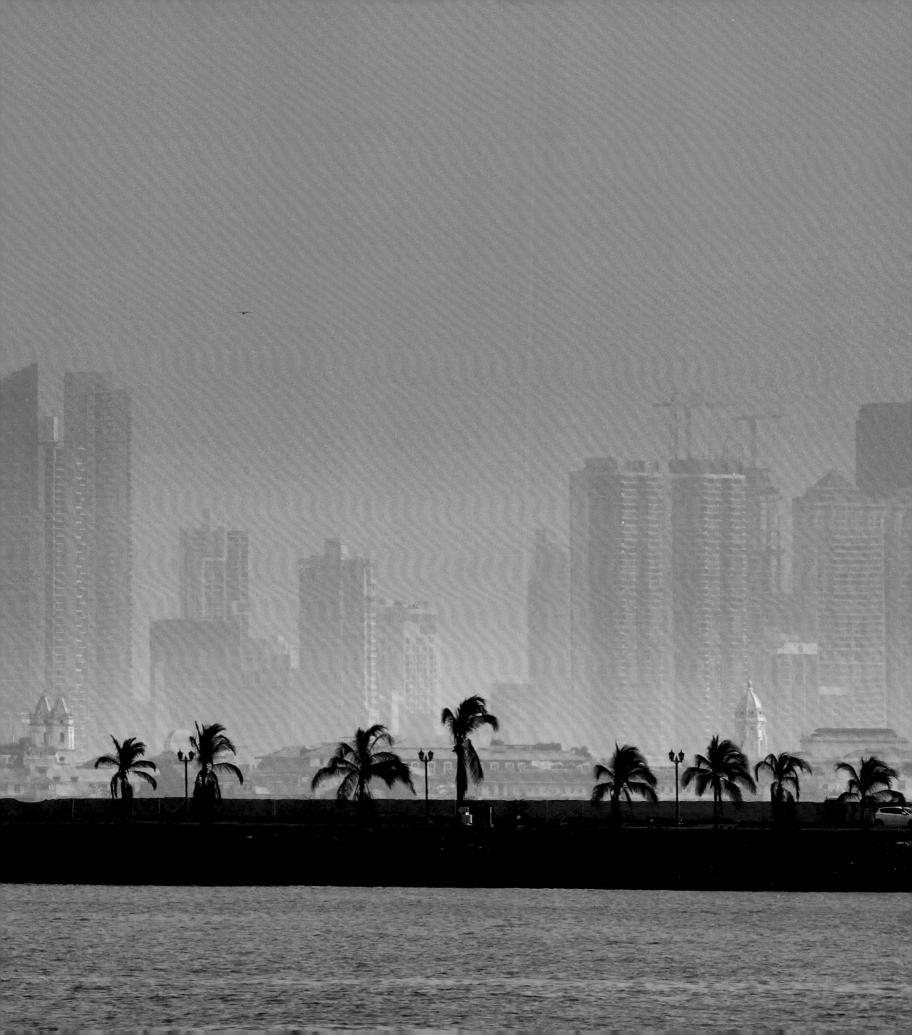

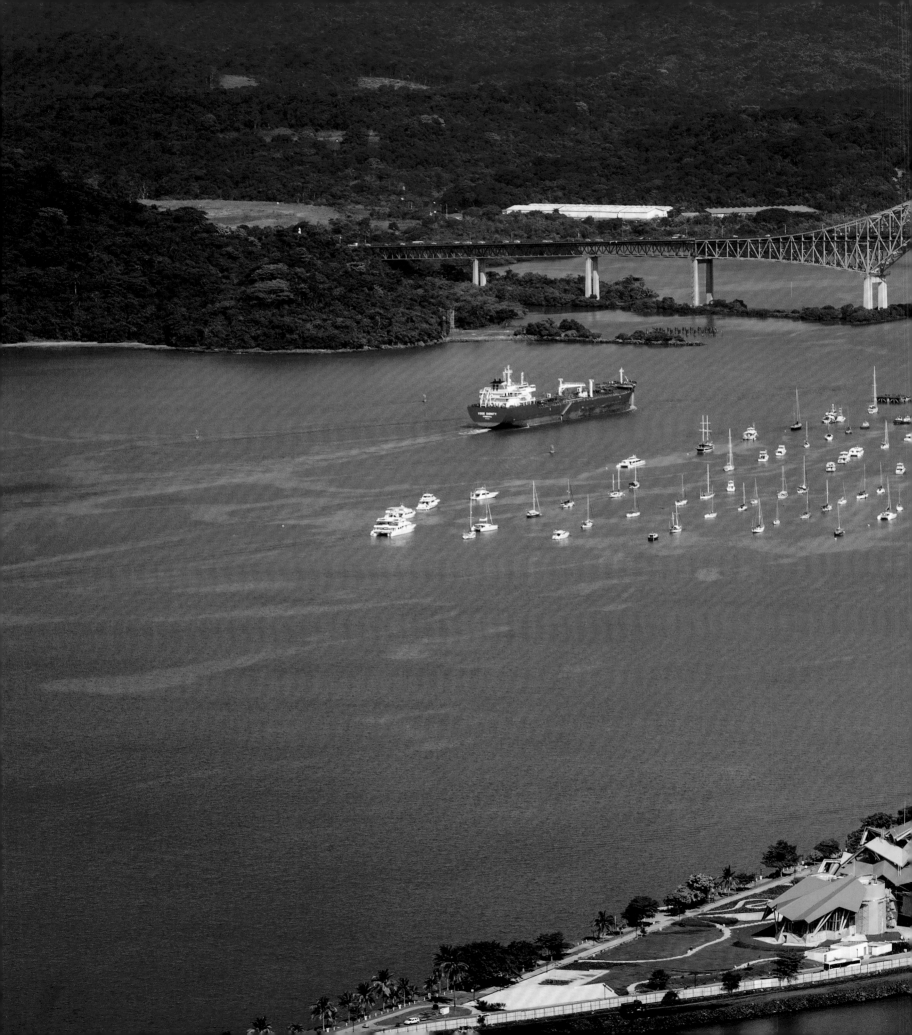

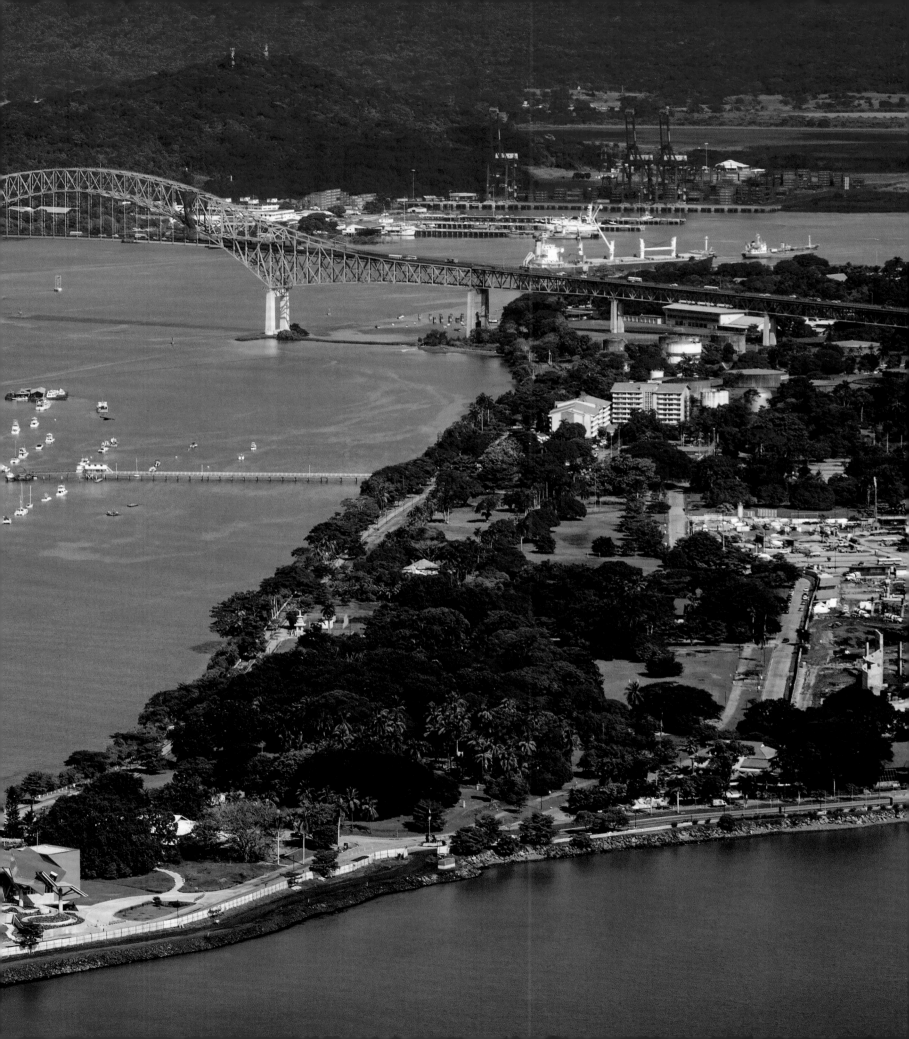

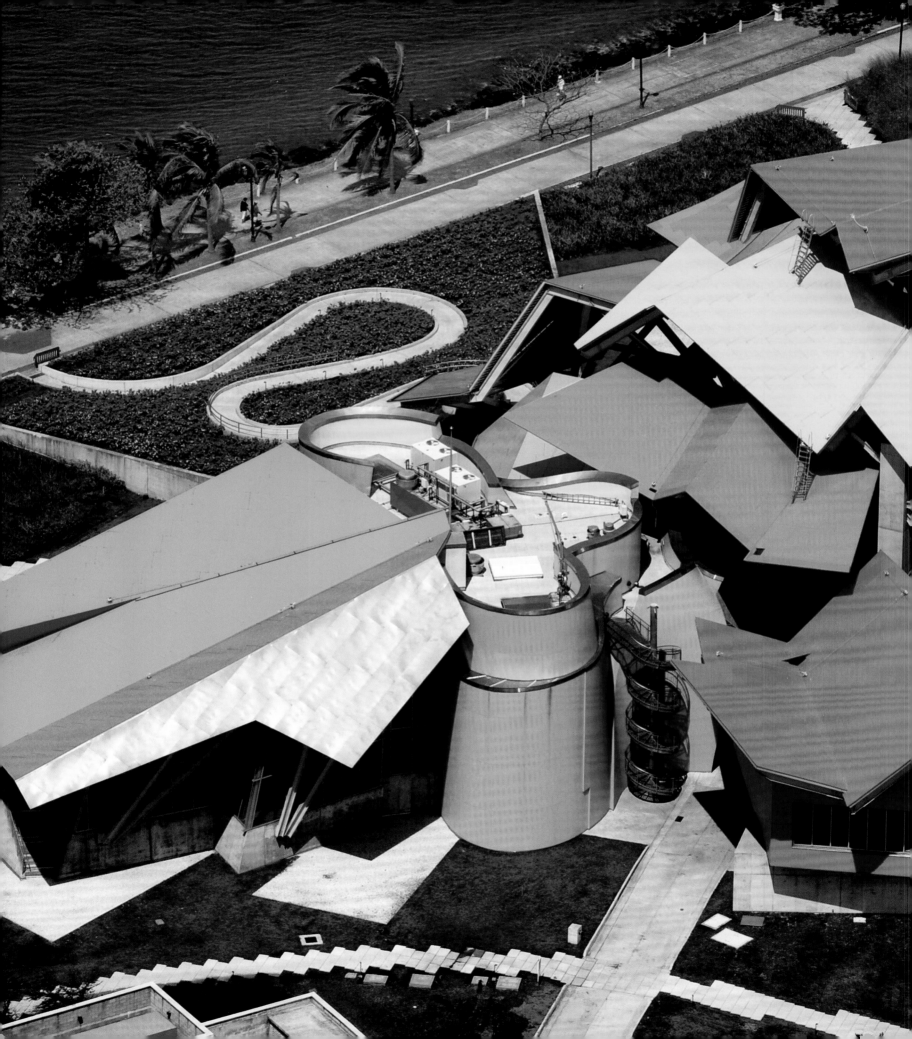

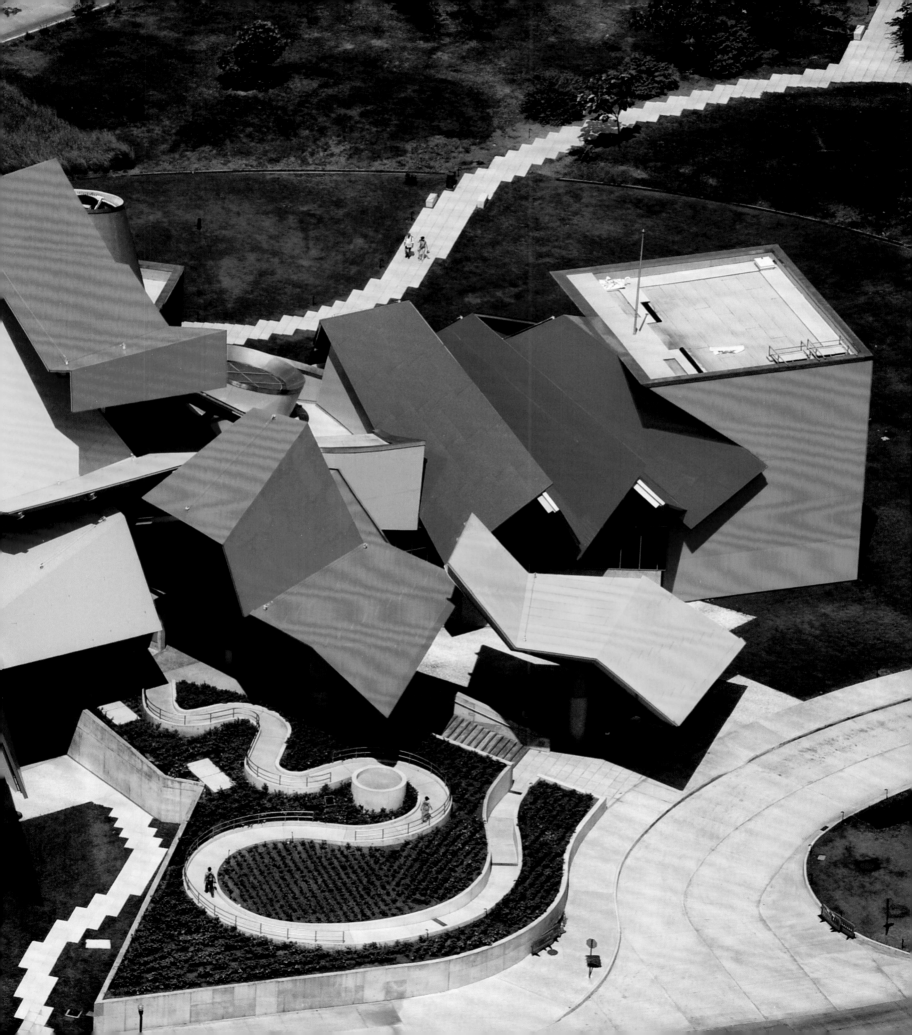

Located on Calzada de Amador (Causeway), the strip of land dotted with palm trees that connects Panama with the nearby islands of Naos, Perico, and Flamenco, is the Biomuseum, the architectural origami designed by Frank Gehry. At the start of the spectacular four-mile walk, made using recycled materials from Culebra Cut and from which one's gaze stretches from the Bridge of the Americas to the skyscrapers of Punta Paitilla, we entered this ode to nature, whose structure reminds us (at least, that was our impression) of the chaotic emersion of land that, three million years ago, gave rise to the isthmus of Panama.
In its eight rooms the museum tells the story of this creation and what was derived from it: the separation between the oceans and the natural bridge between North and South America that allowed for animals and plants to travel from one continent to the other. Which is what has made Panama an outstanding ecosystem, a haven for biologists. And not just for them.

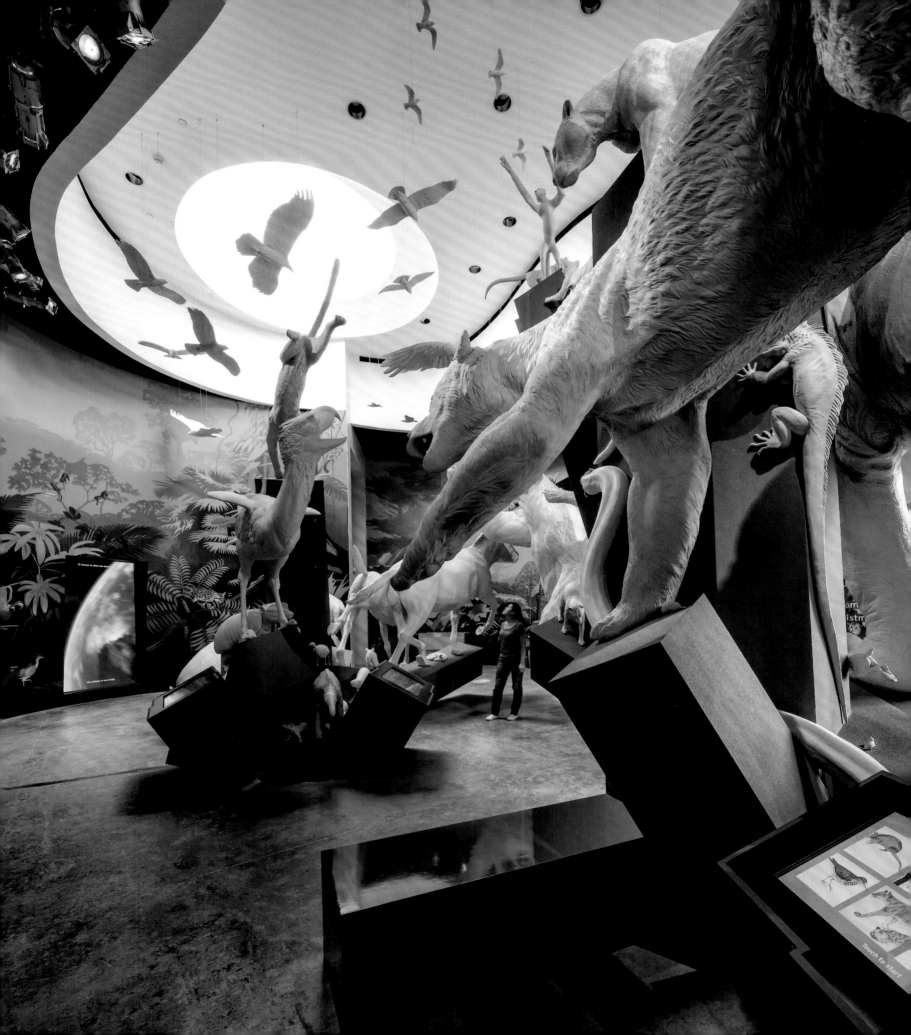

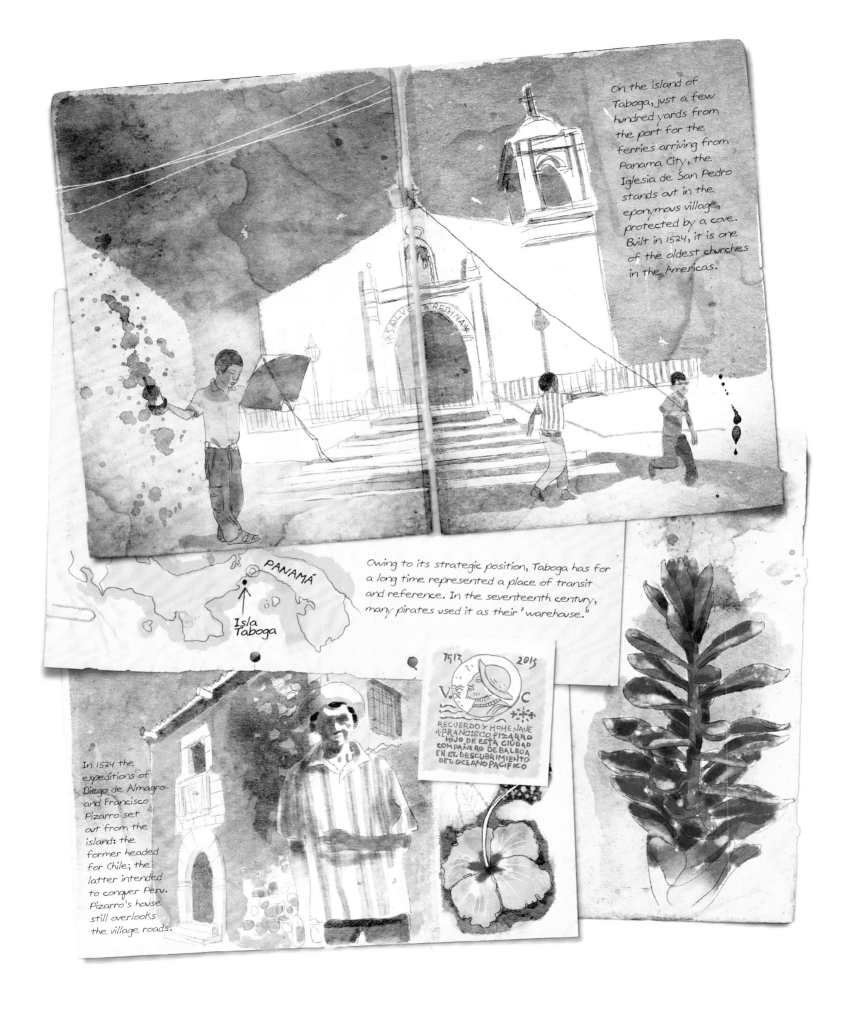

On the island of Taboga, just a few hundred yards from the port for the ferries arriving from Panama City, the Iglesia de San Pedro stands out in the eponymous village, protected by a cove. Built in 1524, it is one of the oldest churches in the Americas.

Owing to its strategic position, Taboga has for a long time represented a place of transit and reference. In the seventeenth century, many pirates used it as their "warehouse."

In 1524 the expeditions of Diego de Almagro and Francisco Pizarro set out from the island: the former headed for Chile; the latter intended to conquer Peru. Pizarro's house still overlooks the village roads.

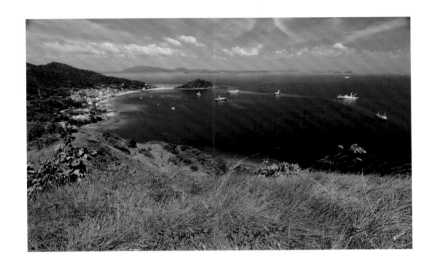

As we leave Panama City behind us, the last stop on our journey awaits us. It is Taboga Island. We chose to get this far because within the space of a few miles it is like crossing five centuries of history. We navigated the new Canal, one of the most grandiose works of the new millennium, and now visit on this island one of the oldest churches in the Americas, in what was once the "New World." We get as far as the intersection between two histories and two oceans, while in this same body of water a fleet of ships already awaits its turn to take the same route as we did but in reverse. Toward the Atlantic, toward another day. Farewell Panama.

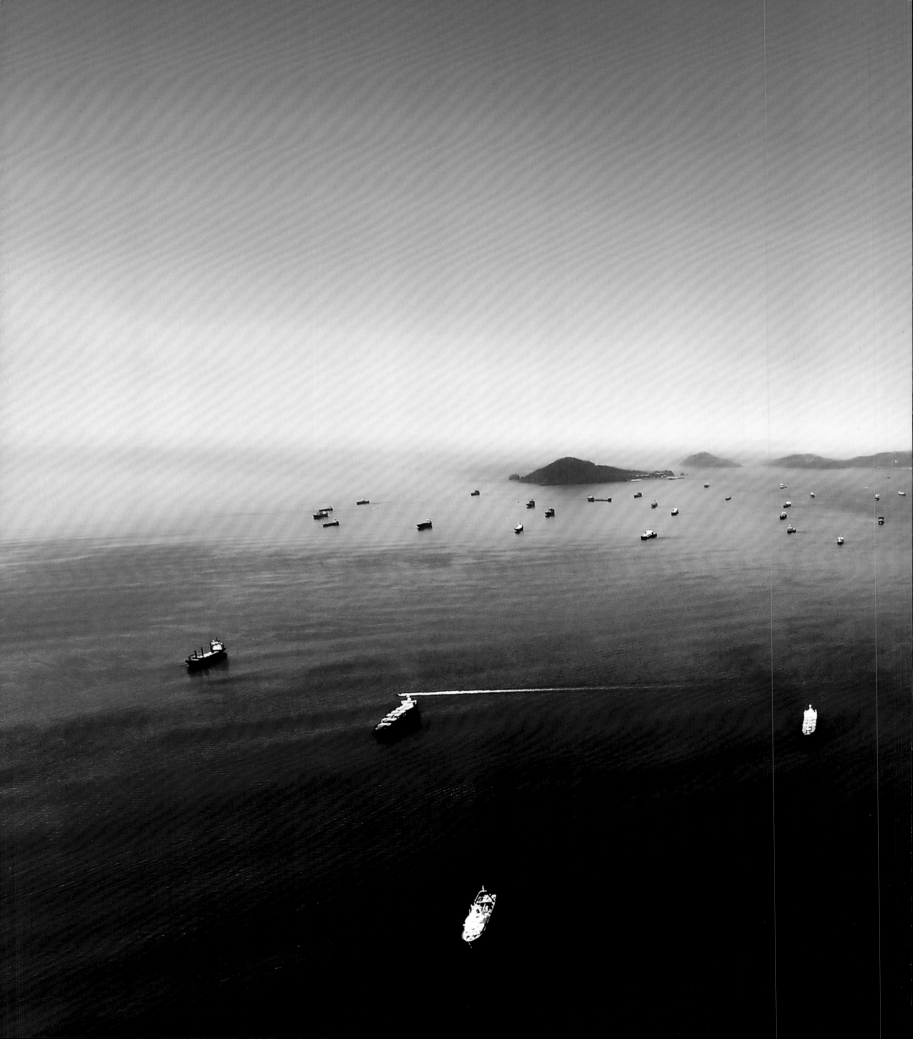

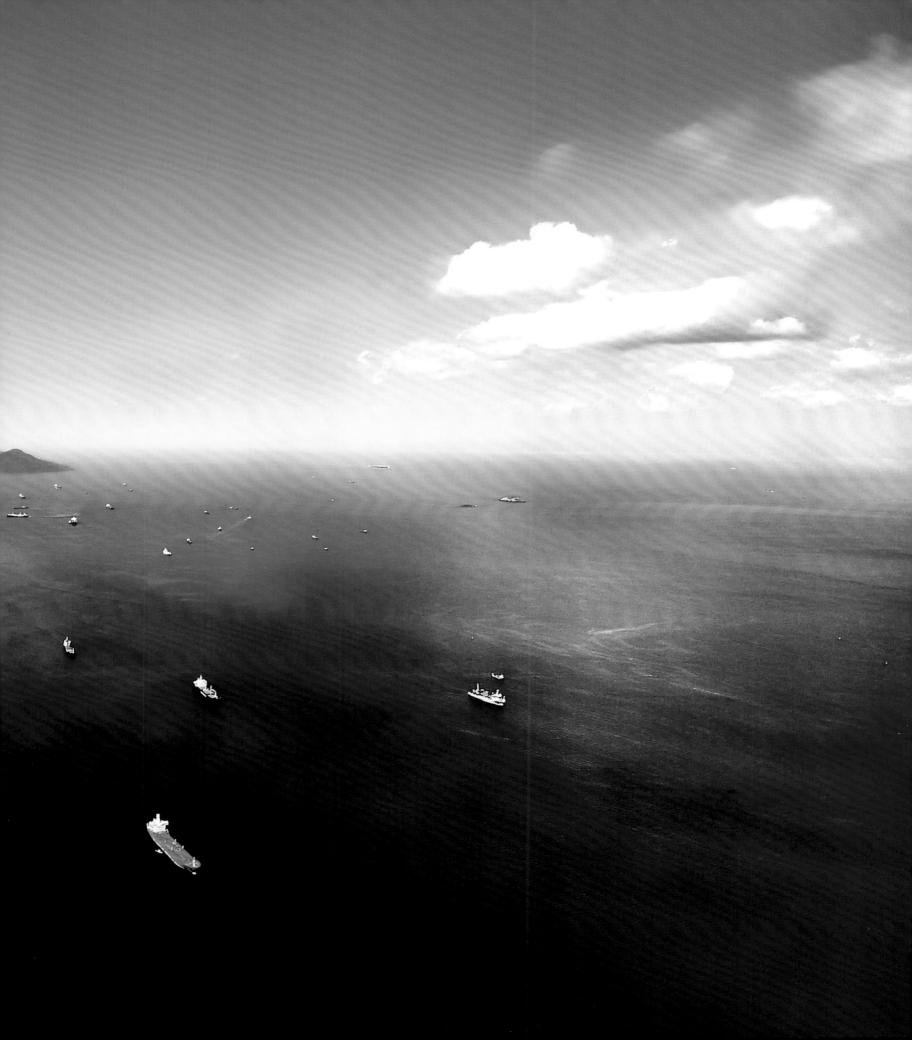

Picture Credits

© **Edoardo Montaina** by Salini Impregilo, except for:

© Anton Balazh / Shutterstock: p. 20

© BuyEnlarge / ZUMAPRESS / MONDADORI PORTFOLIO: pp. 23, 25

© Everett Historical / Shutterstock: pp. 24, 26, 32

© North Wind Picture Archives / Alamy Stock Photo: pp. 28-29

© Glasshouse / ZUMAPRESS / MONDADORI PORTFOLIO: pp. 30, 31

© KIKE CALVO / Age Fotostock / MONDADORI PORTFOLIO: p. 120

© Photo Fernando Alda: pp. 196-197, 200, 201

© Courtesy of Autoridad de Turismo de Panamá: p. 203

Printed in November 2016 by Graphicom, Italy